ANATOLE
DEMIDOFF
PRINCE OF SAN DONATO

(1812-70)

THE TRUSTEES OF THE WALLACE COLLECTION,
MANCHESTER SQUARE, LONDON, W1M 6BN

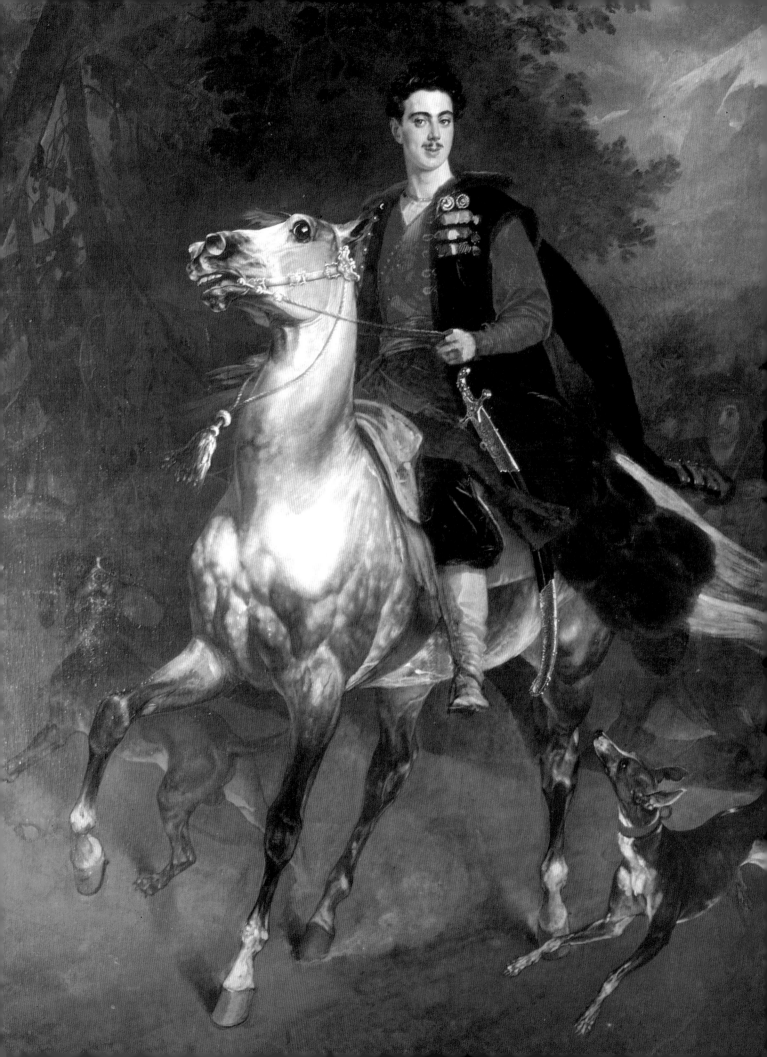

FRANCIS HASKELL

ANATOLE DEMIDOFF AND THE WALLACE COLLECTION

STEPHEN DUFFY

NINETEENTH-CENTURY PAINTINGS

SEVENTEENTH-CENTURY DUTCH AND FLEMISH PAINTINGS

EIGHTEENTH-CENTURY FRENCH PAINTINGS

ROBERT WENLEY

FURNITURE CERAMICS METALWORK

GOLD BOXES, MINIATURES AND JEWELLERY

PIPES AND SMOKERS' REQUISITES

DAVID EDGE

ARMS AND ARMOUR

PRODUCED ON THE OCCASION OF A SPECIAL EXHIBITION OF WORKS OF ART NOW IN
THE WALLACE COLLECTION FORMERLY OWNED BY ANATOLE DEMIDOFF

10 MARCH TO 25 JULY 1994

ISBN 0 900785 40 3

DESIGN BY DESIGN/SECTION
PRINTED AND BOUND IN GREAT BRITAIN BY BUTLER AND TANNER LIMITED, FROME

FRONT COVER Ary Scheffer, *Francesca da Rimini* (No.1, detail)
BACK COVER Design in medallic form from title page of [Anatole Demidoff],
Esquisses d'un Voyage dans la Russie Méridionale et la Crimée (Paris 1838).
The inscription, broadly translated, means 'With Actions, Not Words'.
FRONTISPIECE Karl Briullov (1799-1852), *Equestrian Portrait of Anatole Demidoff*
(begun c.1828, unfinished), oil on canvas, 314 x 227. Florence, Palazzo Pitti.

CONTENTS

PREFACE

Hertford House is the ideal place to study and enjoy the *history* of individual works of art. As each item passed from one collector to another, until finally being acquired by a Marquess of Hertford or Sir Richard Wallace, it accumulated an extra layer of interest. The diversity of routes is unending, the search a delicious exercise in sleuthing and, sometimes, patterns emerge: one of the most intriguing is the matrix of collectors in Paris between the restoration of the Bourbon monarchy in 1815 and the fall of the Second Empire in 1870. Many of these collectors, from as far apart as England and Russia, including the Hertfords and Demidoffs, have contributed, directly or indirectly, to the founding of the Wallace Collection. We propose to acknowledge them by having a series of small exhibitions devoted to their works of art in Hertford House today.

The most flamboyant of them all, Anatole Demidoff, has been chosen as the subject of this, the first exhibition in the series. He and the 4th Marquess of Hertford occasionally competed as collectors and died within a few months of each other in 1870. Luckily for Lord Hertford, he lived long enough to benefit from the last and greatest of Demidoff's sales in February to April that year. He had already bought from earlier auctions in the 1860s and his son Richard Wallace was to add one item later in the 1870s, bringing to about eighty the number of Demidoff works of art in the Wallace Collection today.

The exhibition shows Demidoff as a collector of paintings, furniture, porcelain, metalwork, goldsmiths' work and arms and armour, but these areas are only a fraction of his broad interests which included the animate as well as the inanimate. Since the Wallace Collection is constrained by the terms of Lady Wallace's bequest, that it 'should be always kept together, unmixed with other objects of art', we are, by tradition, unable by borrowing to augment our own resources. Perhaps in the case of Demidoff we should view this with relief, for we might otherwise have been persuaded to represent such aspects of his collecting as his unique display of orchids and his zoo. It must be conceded, however, that this exhibition is inevitably biased towards those aspects of Demidoff's collection that are represented at Hertford House: we are looking at Demidoff's taste reflected in that of the 4th Marquess of Hertford.

My colleagues, Stephen Duffy, Robert Wenley and David Edge, together with our Trustee, Professor Francis Haskell, are the inspiration for this exhibition, and this catalogue is their joint triumph of endeavour and scholarship. While they assure me that they have only scratched the surface of Demidoff studies, I would like to thank them for such a masterful sequel to John Ingamells' *Rembrandt 1892* exhibition in 1992. I would also like to thank the anonymous donor whose generosity has made it possible for us not only to produce this handsome catalogue, but also to turn a small display into a major event at the Wallace Collection.

ROSALIND SAVILL Director

ACKNOWLEDGMENTS

We would like to thank the many people whose advice and assistance have made an essential contribution to the exhibition and catalogue. The first of these must be Professor Francis Haskell, who readily agreed to write the introductory essay and who, together with Larissa Haskell, has ever since responded with unfailing kindness to our many pleas for help with information and Russian translations. We are immensely grateful to them both. We must also make a special point of thanking Bet McLeod, who has been a marvellously effective research assistant on our behalf; Silvia Meloni, without whom many key images in this catalogue would have remained inaccessible; and Diana Scarisbrick, whose discoveries in the Maison Chaumet archives and general encouragement have added real sparkle to the project.

At the Wallace Collection itself we have benefited greatly from the advice and support of the Director, Rosalind Savill, and the assistance of Richard Beresford, Kate Bomford, Peter Hughes, Colin Jenner, Alistair Johnson, Nick Norman, Robert Peace, Paul Tear, Andrew Smart and Belinda Webster. In addition, we are grateful for the help provided by Françoise Arquié, Philip Attwood, Étienne Breton, Charles Cator, Andrzej Ciechanowiecki, Alessandra Corti, Danièle Denise, Anne Dion-Tenenbaum, Ursula de Goude-Broug, Laurence Goupille, Mrs T. Igumnova, Christophe Leribault, Julia Lloyd-Williams, Anne Matejka-Ceccaldi, Edgar Munhall, M. Pantiel at Malmaison, Christopher Parsons, Joanna Richardson, Jean-Nérée Ronfort, Andrzej Ryszkiewicz, Susan Stronge, Louise Trodden and Anthony Wheatley.

STEPHEN DUFFY
ROBERT WENLEY
DAVID EDGE

ANATOLE DEMIDOFF
Family Tree: Principal Line

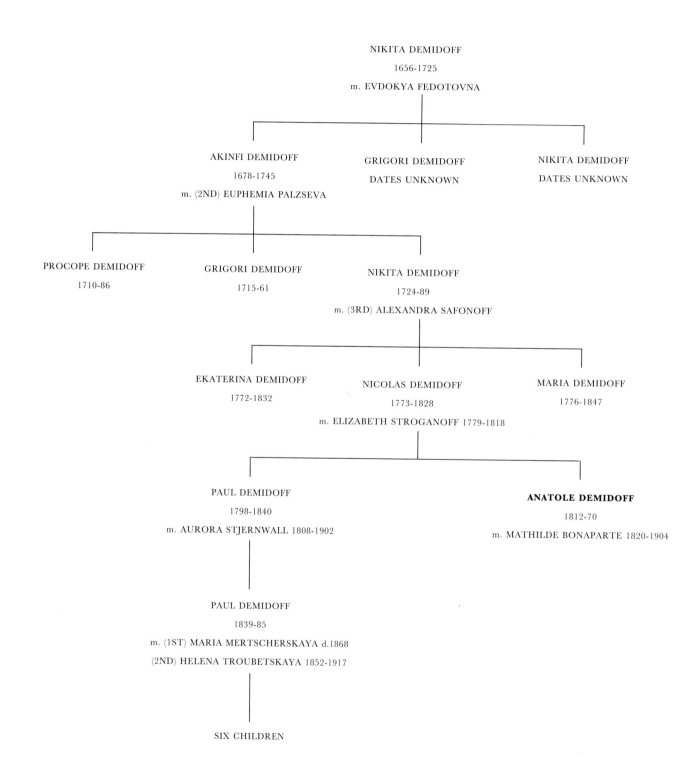

NIKITA DEMIDOFF

1656-1725

m. EVDOKYA FEDOTOVNA

AKINFI DEMIDOFF

1678-1745

m. (2ND) EUPHEMIA PALZSEVA

GRIGORI DEMIDOFF

DATES UNKNOWN

NIKITA DEMIDOFF

DATES UNKNOWN

PROCOPE DEMIDOFF

1710-86

GRIGORI DEMIDOFF

1715-61

NIKITA DEMIDOFF

1724-89

m. (3RD) ALEXANDRA SAFONOFF

EKATERINA DEMIDOFF

1772-1832

NICOLAS DEMIDOFF

1773-1828

MARIA DEMIDOFF

1776-1847

m. ELIZABETH STROGANOFF 1779-1818

PAUL DEMIDOFF

1798-1840

m. AURORA STJERNWALL 1808-1902

ANATOLE DEMIDOFF

1812-70

m. MATHILDE BONAPARTE 1820-1904

PAUL DEMIDOFF

1839-85

m. (1ST) MARIA MERTSCHERSKAYA d.1868

(2ND) HELENA TROUBETSKAYA 1852-1917

SIX CHILDREN

ANATOLE DEMIDOFF

AND THE

WALLACE COLLECTION

FRANCIS HASKELL*

On 21 and 22 February 1870 the first of ten projected sales by auction to be devoted to the 'Collections of San Donato' was held in Paris. It consisted of works of the modern school, and among the most highly priced pictures was Ary Scheffer's *Francesca da Rimini* (No.1) which was acquired for 100,000 francs by the 4th Marquess of Hertford (1800-70), who also outbid Agnew's by paying 83,000 francs for Bonington's oil of *Henri IV and the Spanish Ambassador* (No.3). Over the next weeks and months countless further works of art - including watercolours, sculptures, furniture and armour - were sold from the same source, and many of the finest of these were also bought by Lord Hertford. By August, however, both he and Prince Anatole Demidoff, the owner of the San Donato collections, were dead. Shortly after their deaths came a series of catastrophic defeats in the Franco-Prussian war, culminating in the abdication of Napoleon III, the siege of Paris and the Commune.

Although Lord Hertford and Prince Demidoff were the most lavish collectors of the period of the Second Empire (and among the most lavish of the century) and although both spent much of their lives in Paris, there is oddly enough no evidence to confirm the probability that these two absentee landlords and voluntary exiles ever actually met. But their collections have much in common, both in spirit and often as regards actual works, and it is surely appropriate that a few among the treasures accumulated by three generations of the Demidoffs which, after more than a century, have only recently been wholly dispersed,[1] should be commemorated in Manchester Square, alongside those of three generations of Lord Hertford's family, of which the bulk can still be seen intact.

Anatole Demidoff, who was born in St Petersburg in 1812,[2] inherited the fabulous wealth that had been amassed over the previous hundred years by his family of iron masters and suppliers of weaponry to the Imperial armies, and that was greatly increased by the exploitation of silver mines in the Urals and, as recently as 1835, by the discovery on their estates of rich seams of malachite (fig.1). And he also inherited an enthusiasm for buying art that had already been displayed by his grandfather and his father. The latter, Nicolas, had after a wild and spendthrift youth married into the aristocracy and, following the defeat of Napoleon (in which he played a conspicuous part) he moved from his estates at Tula to Paris, where he had already spent much time before the war. His taste for eighteenth-century painting can be looked upon as either very precocious or very old fashioned: it was certainly as eclectic as it was to be influential, for (among much else) he owned eleven pictures by Boucher and twenty-three by Greuze - some of which he may have inherited from his own father who had been a friend and patron of the artist - as well as Fragonard's *Fountain of Love*, now in the Wallace Collection (No.22). When his wife died in 1818 he decided to take up residence in Rome, where his lavish hospitality greatly impressed Stendhal, but - as we also learn from Stendhal - he was compelled to leave the city after less than three years because of the outrage inadvertently given to members of the papal court by some of the actors whom he employed to entertain his guests at Palazzo Ruspoli.[3] In a move that was to be of the

FIG.1. ISAAC KHUDOYAROV (1807-70), *VIEW OF NIJNI TAGUIL*, c.1840, OIL ON IRON, 53 x 70. MOSCOW, HISTORICAL MUSEUM. An idealized view of Nijni Taguil (in the Urals, c.150 miles east of Perm) which was the centre of the Demidoffs' industrial empire (see also Nos.32-3). Also in the Historical Museum, Moscow, are several paintings by Vasili Raev and Paul Vedenezki showing the Demidoff mines and factories at Nijni Taguil.

utmost significance for all his descendants, he settled in Tuscany, first in Pisa and Lucca and then, as from 1822, in Florence. He founded hospitals and many other charitable institutions, and bought some marshy and malaria-infested land at San Donato in Polverone just outside the city. In the short time that remained to him before dying in 1828 he commissioned a fine Villa and made plans to fill it with a striking collection of pictures, old and new, sculptures and furniture ordered both locally and from Paris. The Grand Duke was sufficiently impressed to nominate him Count of San Donato. Thus Anatole, his second son, was brought up in a cosmopolitan atmosphere - it was to be said that he could speak most European languages except Russian - of beauty and luxury. And it seems clear that for him (as also, probably for Lord Hertford) these two concepts were to remain inextricably linked.

Anatole Demidoff had been educated principally in Paris, and, as soon as his father died, he returned to spend much of his time there and on extensive travels elsewhere in Europe. But he also continued with the building of the Villa at San Donato, which was greatly increased in scale (figs.2-4). By the time that it was completed, the principal building, surmounted by a dome, was three storeys high and fifteen bays wide. At the centre

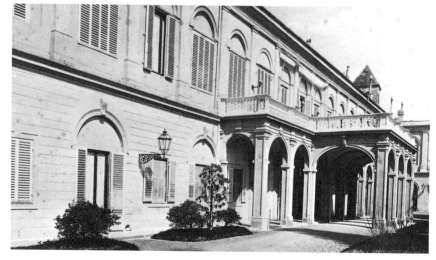

(ABOVE RIGHT) FIG.2. SOUTH (PRINCIPAL) FAÇADE OF THE VILLA SAN DONATO, PHOTOGRAPH, c.1870. The building was begun in the mid-1820s, to designs by G. B. Silvestri, although there were many subsequent alterations.

(RIGHT) FIG.3. EAST FAÇADE OF THE VILLA SAN DONATO, PHOTOGRAPH, c.1870. This was the public entrance. The Tapestries Room, where stood the malachite columns (Nos.32-3), was on the first floor, to the left of this entrance.

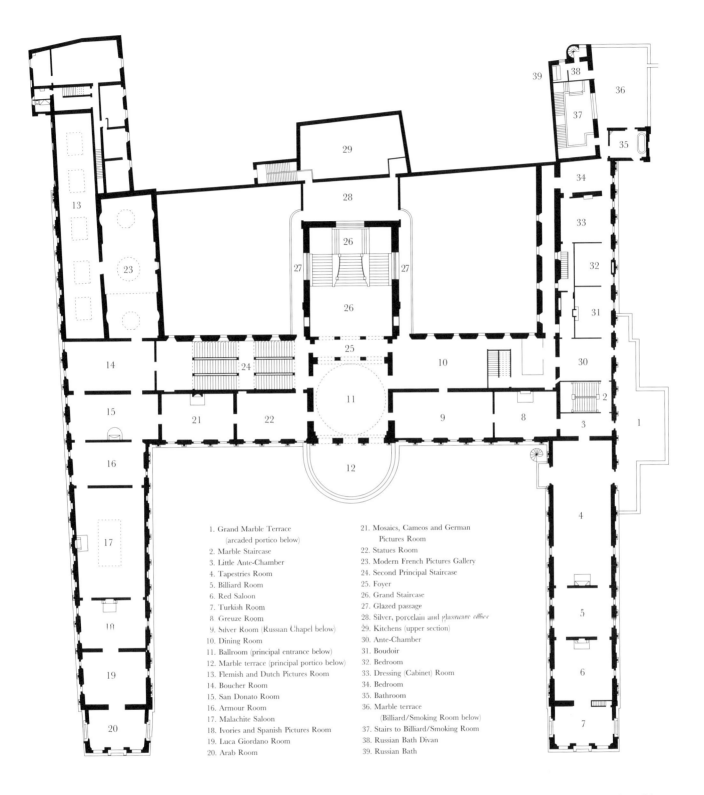

1. Grand Marble Terrace
 (arcaded portico below)
2. Marble Staircase
3. Little Ante-Chamber
4. Tapestries Room
5. Billiard Room
6. Red Saloon
7. Turkish Room
8. Greuze Room
9. Silver Room (Russian Chapel below)
10. Dining Room
11. Ballroom (principal entrance below)
12. Marble terrace (principal portico below)
13. Flemish and Dutch Pictures Room
14. Boucher Room
15. San Donato Room
16. Armour Room
17. Malachite Saloon
18. Ivories and Spanish Pictures Room
19. Luca Giordano Room
20. Arab Room

21. Mosaics, Cameos and German
 Pictures Room
22. Statues Room
23. Modern French Pictures Gallery
24. Second Principal Staircase
25. Foyer
26. Grand Staircase
27. Glazed passage
28. Silver, porcelain and glassware office
29. Kitchens (upper section)
30. Ante-Chamber
31. Boudoir
32. Bedroom
33. Dressing (Cabinet) Room
34. Bedroom
35. Bathroom
36. Marble terrace
 (Billiard/Smoking Room below)
37. Stairs to Billiard/Smoking Room
38. Russian Bath Divan
39. Russian Bath

FIG.4. THE VILLA SAN DONATO: PLAN OF FIRST FLOOR, c.1860. The numerical sequence and room descriptions are based on those found in contemporary guidebooks (nos.27-39 were not part of the public tour). The remaining, unnumbered rooms were for servants. Further domestic offices, guest bedrooms and the Library (situated between the Kitchens and the Billiard/Smoking Room) were on the ground floor.

a grand, semi-circular portico of arches supported by Doric columns led into the entrance hall, and at each end were rectangular wings placed at right angles to the main axis. In the grounds near the house were situated the administrative offices, servants' quarters, stables and an extremely austere 'Odeon' for the performance of music and plays; further away were temples, fountains, a magnificent collection of orchids blooming in immense greenhouses and a zoo with such exotic creatures as ostriches and kangaroos. Both the plan and the scale of the new Villa were alien to Tuscan traditions, and it did not even require a visit to the sumptuous interiors to be made aware of the fact that these unknown and flamboyant Russian industrialists who clearly had an immense enthusiasm for collecting objects of all kinds, animate and inanimate, were likely to make a notable impact on the region.

That impact was to be entirely beneficial, for the approaches to their adopted countries of the Demidoffs (whose huge wealth was grounded on the toil of generations of serfs in their homeland) and of Lord Hertford (whose comparable riches depended on the exertions of tenants in Ireland) differed very significantly. Anatole Demidoff continued to support, indeed he much amplified, the important charitable institutions which had been set in motion by his father and, to honour him, he and his brother commissioned a monument (fig.5) from the leading sculptor in Florence, Lorenzo Bartolini, who already enjoyed a reputation throughout Europe. A contract was drawn up in 1830, and it was specified that it would be completed within three years: it was not ready until 1870, by which time both patron and artist were dead, embittered by angry exchanges of letters and a lawsuit. Demidoff had originally planned to install the monument in the open air, at the centre of the park of the Villa San Donato. Then - to Bartolini's horror - he changed his mind and decided that it should be placed, on a base of lapis lazuli, inside a mausoleum lined with malachite, whose dome of gilded bronze would be visible from the hills surrounding Florence. It was to be opened to the public for a small fee which would be paid into a fund to be used to help the city's poor. Despite these new ideas the arrangement of the figures was not to be altered and they were eventually completed much as we can see them today. Nicolas Demidoff, in ancient costume, sits on a high pedestal and looks affectionately at the young, and almost naked, Anatole (whose brother Paul was quickly forgotten) while, on his other side, kneeling *Gratitude* turns back to gaze at both of them with admiration. At the base of the monument stand *Charity*, the *Muse of Society* ('la muse de la Société'), *Siberia with the young god Pluto* and *Truth revealing herself to Art*. Bas-reliefs portrayed *The Death of Nicolas Demidoff* and *The Beneficence of Anatole Demidoff*.

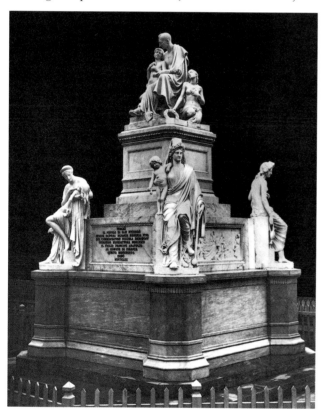

FIG.5. LORENZO BARTOLINI (1777-1850), *MONUMENT TO COUNT NICOLAS DEMIDOFF*, BEGUN c.1830, COMPLETED PRINCIPALLY BY BARTOLINI'S PUPIL PASQUALE ROMANELLI, 1871, MARBLE. FLORENCE, PIAZZA DEMIDOFF.

By 1863 the marble figures had been completed, and partly even designed, by Bartolini's pupils, and could be seen in the sculpture gallery at San Donato. Anatole had by then already moved definitively to Paris, but shortly before dying he presented them to the city of Florence and, a year later, the memorial was finally completed and transported to the Lungarno Serristori where it was inaugurated in 1871.[4] Despite the acrimoniousness which attended its creation, despite the tendentiousness (and even absurdity) of some of its imagery, it is one of the most

12

grandly-conceived monuments of the century - certainly the single most impressive testimony to the patronage of Anatole Demidoff. Would he have been pleased with such an assessment? Perhaps the most frustrating problem that faces anyone interested in the personality of this most elusive of men is the fact that it is impossible even to hazard a guess.

The young Anatole Demidoff enjoyed greater success in Paris, where he mostly lived in his early years, than in Florence. Indeed, in 1836 he transformed most of the Villa San Donato into a workshop for the manufacture of silk, and soon afterwards a French visitor was delighted to discover that this 'ridiculous' building, 'devoid of architecture', which had formerly been cluttered up with luxurious furniture, had now become 'respectable' because it was being used for a more worthwhile purpose.[5] It was therefore in Paris that Demidoff first chose to make himself very widely known, above all as a patron of contemporary art, and it is with this aspect of his interests that we must begin an investigation into his life. In 1834 he bought two of the most successful pictures exhibited in the Salon - *The Execution of Lady Jane Grey* (fig.6) by Delaroche and Granet's *Death of Poussin* (Reims, Musée des Beaux-Arts) - and (like other foreigners who moved to Paris and wished to flaunt their wealth and taste) he made sure that his acquisition of these celebrated works quickly became public knowledge by having his name as their owner printed in the catalogue. His stratagem was eminently successful,

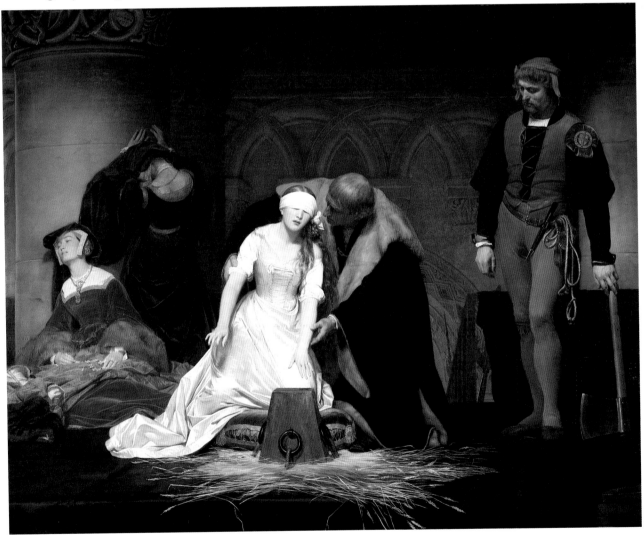

FIG.6. PAUL DELAROCHE (1797-1856), *THE EXECUTION OF LADY JANE GREY*, 1833, OIL ON CANVAS, 246 x 297. LONDON, NATIONAL GALLERY. Bought by Demidoff for 8,000 francs and exhibited at the Paris Salon of 1834; sold at the 1870 San Donato sale for 110,000 francs.

and in this same year (when he was still aged only twenty two) a leading journal commented that 'with every day that passes the name of Count Demidoff earns further claims to the gratitude and acclaim of French artists. Since this foreign nobleman has come to live in our country he has formed a gallery that promises to become one of the most remarkable of our times ... let us hope that he will settle among us and that the fine works which he is assembling so eagerly will not be lost to France, their country of birth'.[6] This hope was to be disappointed because it was not long before Demidoff was to send nearly all his acquisitions to his Villa at San Donato, where their possible impact on a younger generation of Italian painters has been much discussed in recent years.[7] However, French artists continued to benefit greatly from his patronage, although its nature became less showy once he had had the opportunity to familiarise himself with the wide variety of more intimate styles and genres being provided by lesser, but talented, practitioners.

FIG.7. EUGENE DELACROIX (1798-1863), *PORTRAIT OF CHARLES DE MORNAY AND ANATOLE DEMIDOFF*, 1833, OIL ON CANVAS, 78 x 65. PAINTING DESTROYED IN 1914.

Demidoff's interest in the 'high art' of his contemporaries lay chiefly with reconstructions made by leading Romantic painters of some of the more picturesque episodes chosen from earlier history - although he was always happy to extend this to any scene involving Napoleon, for whom his enthusiasm never waned. But he also liked many less ambitious works: watercolours, for instance, of similar scenes, and exotic views of towns and countryside in Europe and Asia Minor. Above all, he had an insatiable interest in what can loosely be called 'reportage' - especially insofar as it related to himself: elegant delineations of the fashionable life of his own circle, for instance, and of what he doubtless thought of as the fore-runners of that circle during the reigns of François Ier and, above all, Louis XV; and quick records of his travels throughout Europe. We will see that all these tastes were well catered for.

In general Demidoff's responses to modern art were widely shared by the wealthy Parisian *amateurs* of the July Monarchy and the Second Empire with whom he associated - his only concession to the country of his birth lay in the encouragement of 'documentary' drawings, of the kind already mentioned, and in the very occasional commission for some edifying historical scene chosen, with difficulty, from its not very edifying history. His ownership, for ten years, of Ingres' refined, indeed exquisite, *Antiochus and Stratonice* was unusual, but one gets the impression that he bought this masterpiece (which had been painted for the duc d'Orléans and which was later to be secured for the collection at Chantilly of his younger brother, the duc d'Aumale) more because of its provenance and because he was advised that it could be considered '*le tableau le plus célèbre de notre époque*'[8] than because it meant much to him: certainly Demidoff's other contacts with the art of Ingres were of a very different nature. An engraving of the famous portrait of Bartolini, now in the Louvre, was almost certainly dedicated to him because of his patronage of the sculptor rather than of the painter; and the unsuccessful attempts he appears to have made between about 1848 and 1853 to buy or commission a picture by Ingres of women in a Turkish bath show him to have been interested only in obtaining a nude by the master.[9]

He does not seem to have acquired a single Corot, and the presence in his gallery of just one *Landscape* by Théodore Rousseau reveals the limitations of his interest in the Barbizon masters.[10] It need hardly be said that Demidoff, whose taste was formed in the '30s, was not attracted by Courbet.

Demidoff's commitment to Delacroix was, however, notably greater than that of most other rich collectors of his generation.[11] It must surely have been stimulated by the marvellous double portrait (fig.7) that had been commissioned as early as 1833 by the comte de Mornay, who is shown as comfortable and relaxed in a pink dressing-gown in his Paris apartment, filled with books, pictures and armour, while the more formally dressed

Demidoff looks rather gauche and timid in a chair beside him. Four years later Demidoff seems to have returned the compliment by himself turning to Delacroix when he decided to have a portrait of Mornay painted for San Donato. In 1838 and 1839 Demidoff followed this up by commissioning two further paintings from Delacroix - this time of 'historical subjects', taken from the exploits of Christopher Columbus: still young and unknown in the first (Washington, National Gallery of Art) dreaming in front of a map in the austere monastery of La Rabida, and, in the second (Toledo, Museum of Art), being greeted by the King and Queen on his triumphant return to Spain surrounded by captive Indians and exotic treasure. In the 1850s Demidoff bought, and sometimes commissioned, three or four more paintings and a number of drawings by Delacroix, mostly of Arab scenes, but also including a reduced version of another episode taken from Spanish history - *The Emperor Charles V at the Monastery of Yuste* (present whereabouts unknown).

By virtue of size it was Delaroche, and not Delacroix, who reigned supreme at San Donato for no picture in the gallery was larger (or more popular and influential) than *The Execution of Lady Jane Grey* (fig.6), in which, however, the intrinsic painfulness of the subject is mitigated by the polished gentility of the treatment. The constantly repeated reproach that the artist has devoted more care to emphasising the virginal beauty and rich satin dress of the martyr, and even to the elegant stance of her executioner, than to inculcating fear of the act that is about to disturb their attractive poses, would have been meaningless to Demidoff who, like Lord Hertford, was doubtless happy to look at girls in distress, but hardly wanted to see them undergoing torture. Male suffering could be more easily contemplated - within limits. Demidoff's other pictures by Delaroche were mostly reductions of paintings showing some of the more unfortunate moments of English history which had been made for different collectors.

To the modern eye the most appealing of a number of artists who worked extensively for Anatole Demidoff was Eugène Lami whose 'dandyism' was also much admired by Baudelaire. For Demidoff the principal merit of this delightful watercolourist, 'one of my good friends and one of the most distinguished French painters of our times' lay in his possession of '*un des talents les plus frais et des plus gracieux, tout empreint d'un parfum aristocratique*'.[12] Lami produced large numbers of watercolours,

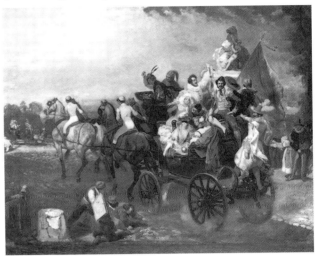

FIG.8. EUGENE LAMI (1800-90), *UNE VOITURE DE MASQUES*, 1834, OIL ON CANVAS, 69 x 110. PARIS, MUSÉE CARNAVALET. The scene takes place in the Champs-Élysées at the time of the Carnival. Demidoff is almost certainly the figure at the back of the carriage, dressed as Figaro. It has been thought that Lord Henry Seymour (1805-59), half-brother of the 4th Marquess of Hertford, is also represented, but this is unlikely. Demidoff and Lord Henry Seymour, however, were both founder members of the French Jockey Club in 1833.

and a few pictures in oil, for this keenest of all his patrons (whose closest rivals were King Louis-Philippe, Queen Victoria and the Rothschilds, for whom he also provided large-scale decorations). Although he had begun work on the sheets that comprised the *Histoire de mon temps* even before being introduced to Demidoff, it was for him that these scenes of contemporary life were principally painted: at least one nineteenth-century enthusiast eloquently compared them to Balzac's *Comédie Humaine*.[13]

Lami lived in London between 1848 and 1852, and his observations there were used for two further sets of watercolours for Demidoff.[14] Nine - devoted to some of the principal national contributions to the Great Exhibition of 1851, to which he had made sensational loans - were first commissioned as suitable presents for the Empress of Russia, but Demidoff was so impressed by them that he asked Lami to make another set '*exactement semblable*' for himself. A further group of forty-two watercolours - *Trois années à Londres* - laid special stress on

colourful military ceremonies and on locations connected with the exile of the French royal family: it also included some places which were particularly associated with Demidoff's own visits to London, such as Thomas's hotel, about which he wrote to the artist from San Donato that when looking at it he felt that he was back again in Berkeley Square. And in other watercolours and oils Lami portrayed Demidoff himself roistering with wild companions at the Carnival (fig.8) or at ease in the fashionable Salons of his friends. Lord Hertford bought only three drawings from *Trois Années à Londres* (see Nos.13-14) and seems to have shown little interest in Lami's many other very fine works in Demidoff's collection. He preferred to acquire some of the artist's later and more finished watercolours devoted to social life in the seventeenth and eighteenth centuries - a choice that was natural enough for a devotee of Meissonier's scenes of historical genre which (very surprisingly) meant little to Demidoff.

By far the closest to Demidoff of all the artists working for him was Denis-Auguste-Marie Raffet.[15] It seems clear that their relationship was based on real friendship and not merely on professional interest, and we know that Demidoff gave this minor, but talented, draughtsman a semi-official post as custodian of his pictures and relied greatly on his advice as regards purchases. He bought large numbers of drawings of military costumes - in which both men were obsessively interested - and, above all, he employed Raffet to keep detailed records of his travels: on the visit to the Crimea, which will shortly be referred to, Demidoff took Raffet with him in his own coach and they also visited Spain together, as well as museums in many other countries. In later years Raffet passed much of his life at San Donato. Hundreds, if not thousands, of sketchbooks, watercolours and drawings made by him on these and other occasions have been dispersed in successive sales - but their nature and quality can be gauged reasonably enough from the lithographs based on them for book-illustrations. Lord Hertford owned a handful of watercolours by Raffet but it is most unlikely that any of these had belonged to Demidoff.

Despite the broad similarity of their approaches to modern art, there were some significant differences between the collections of the two men. Whereas Lord Hertford was particularly enthusiastic about the Oriental and especially the military, paintings of Horace Vernet, by whom he owned not only the notable group to be seen in the Wallace Collection, but also the four large battle scenes in the National Gallery, Demidoff's interest in this artist was largely restricted to his depiction of Napoleonic themes.[16] He did, however, buy (or perhaps commission) an allegorical picture by Vernet of *Socialism and Cholera* (present whereabouts unknown), which was designed in 1850, 'an inauspicious period when these two scourges threatened France and the world', but which fortunately had not needed to be developed beyond a sketch, as 'better days have returned'.[17] Although Demidoff acquired (at the Orléans sale of 1853) a very celebrated Decamps of *Samson battling against the Philistines* (a picture, now in a private collection, which particularly impressed the Italian artists who visited his Villa at San Donato), his other works by this artist were much less significant, and he owned nothing by Thomas Couture, whereas both of these were represented by excellent pictures in Lord Hertford's collection. On the other hand Lord Hertford only bought his two paintings by Delacroix well after the artist's death and almost at the end of his own life, whereas we have seen that Demidoff was still in his twenties when he began his intermittent patronage of this greatest of Romantic painters. However, the contrast that would most forcibly have struck visitors interested in the modern works to be seen in these two collections in their heyday would naturally have been the abundance of Italian painting and sculpture at San Donato. Before considering this and the innumerable treasures of earlier periods assembled there by Anatole Demidoff we must look at the personality of the man himself.

Anatole Demidoff aroused violent and conflicting opinions in his contemporaries, and it is not easy to form a balanced opinion of a man who was himself somewhat unbalanced and who veered between extremes of generosity and avarice, arrogance, even brutality, and acts of kindness to those he chose to befriend. But we do at least know how he wished to present himself to the world. Not very long after the death of his father in 1828 he commissioned from the Russian painter Karl Briullov, who was then living in Florence, a lifesize equestrian portrait of himself in national costume (frontispiece). Such a pose - and such a scale - would have been unusual

for any patron other than a member of a royal family or an outstanding military commander. For a youth of less than twenty it argues a degree of audacity that is breathtaking, although it confirms the opinion of his own worth that, a few years later, he communicated to the venerable Chateaubriand when presenting him with an early draft of his first travel book: '*Ce que je fais là est bien hardi, mais à mon âge on ne doute de rien*'.[18]

Briullov roughed out the portrait, but soon abandoned it for other assignments. With the passing of years, and then decades, Demidoff became ever keener to possess this spectacular image of youthful pride. Could not the artist rely on his early memories in order to complete it, he wrote to him in 1850 and again in 1851, almost deferentially (having learned, perhaps, from his experiences with Bartolini, that rudeness does not always pay), so that it could be exhibited in Paris and Vienna and then made even more widely accessible through an engraving? Once more Briullov set to work, but by the time of his death in 1852 he had elaborated only part of the costume and the head of the horse. The picture then seems to have been touched up so that Demidoff

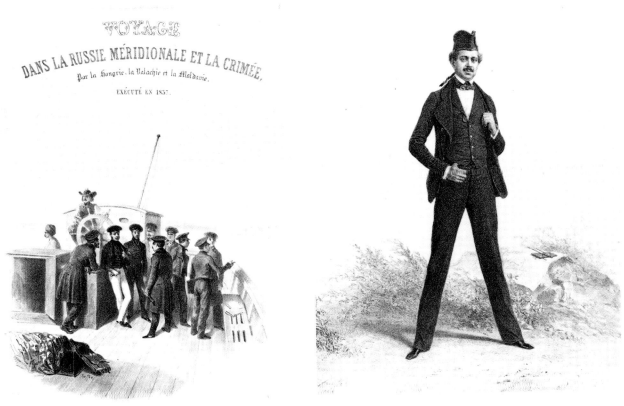

FIGS. 9-10. DENIS-AUGUSTE-MARIE RAFFET (1804-60), FRONTISPIECE (LEFT) AND *PORTRAIT OF ANATOLE DEMIDOFF* (RIGHT) FROM ANATOLE DEMIDOFF'S *VOYAGE DANS LA RUSSIE MÉRIDIONALE ET LA CRIMÉE*, FOLIO 1848. LITHOGRAPHS.

could at least be given recognisable features, but it remains unfinished - a testimony to high but unrealised and flawed ambitions.[19] Demidoff was far more successful with the other commission he gave to Briullov at much the same time. After seeing a compositional sketch (made for another patron but commissioned in the first place by his father Nicolas) of *The Last Day of Pompeii* he ordered the artist to paint the huge picture of this subject which is now in the Russian Museum in St Petersburg. It was exhibited to great acclaim in Paris and St Petersburg, and was then presented by Demidoff to the Tsar. He later regretted the 'patriotism' which had led him to deprive the collection at San Donato of a painting which, like *The Execution of Lady Jane Grey* by Delaroche, could - as he must certainly have recognised - only have been displayed on the wall of some splendid palace or public building. Moreover, Briullov's masterpiece was quickly acknowledged to be the most impressive of all modern Russian paintings, and the only one to attract the attention of the West - '*The Last Day of Pompeii*

was the first day of Russian painting', in the words of a Moscow poet;[20] but Demidoff's need to please the Tsar was very pressing.

Nicolas I strongly disapproved of this extravagant upstart who spent so much of his life abroad[21] - it is unlikely that he would have welcomed the sight of Briullov's outlines of a quasi-royal portrait - and on a number of occasions he seems to have threatened to confiscate Demidoff's Russian estates (and, hence, the source of his wealth). This was doubtless the reason for Demidoff's extended visit to St Petersburg in 1834, his gift of *The Last Day of Pompeii,* and his foundation in the Russian capital of various charitable institutions as well as a well-endowed literary prize to be administered by the Academy. These moves were only partly successful, but thanks to the intervention of the Empress he was granted an honorific post in the foreign service. He soon returned to Florence and Paris, but in 1837 he tried to appease the government of his native country by making an extremely ambitious, indeed prodigal, gesture. He organised an expedition to the Crimea and South Russia which was made up of twenty-two French artists, journalists, scientists and archaeologists (figs.9-10). Various publications resulted from their travels (and from a later - purely architectural - tour which he also subsidised), by far the most significant of which consisted of a set of six handsome volumes, dedicated to the Tsar, that appeared between 1840 and 1848. Demidoff himself (with some assistance) wrote the personal account of every aspect of the journey which made up the first volume and which was extensively illustrated by full page plates (the first of them an equestrian portrait of the Tsar) and vignettes by Raffet. Three more followed with specialised studies on geology, the racial characteristics of the inhabitants, natural history, minerals, and so on; and the set was completed by two folios, one with fine colour plates of the birds, animals, fish and snakes of the region, and the last consisting entirely of lithographs based on drawings elaborated by Raffet from the quick sketches he had made on the spot of the life and buildings he had been able to see with his patron, who had by now become his friend. These volumes constitute Demidoff's

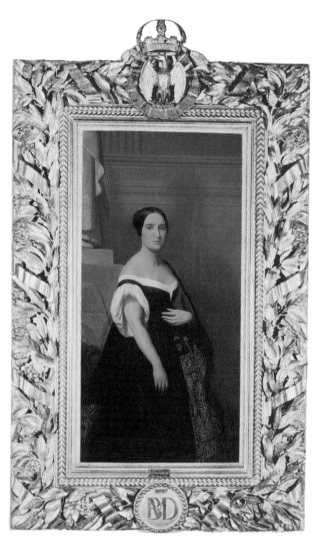

FIG.11. ARY SCHEFFER (1795-1858), *PORTRAIT OF PRINCESS MATHILDE,* 1844, OIL ON CANVAS, 176 x 89.5. FLORENCE, PALAZZO PITTI.

The frame was made for Demidoff in Florence by the carvers and gilders Fratelli Pacetti (see also No.1).

most valid contribution to scholarship, but they did not succeed in what had been one of their primary purposes. Although he did everything he could to emphasise the civilising mission to these (recently settled) territories of Nicolas I, who happened to be visiting his troops in the South and thus became the unenthusiastic recipient of Demidoff's courtesy calls and flattery, the fact that the team was exclusively French in composition merely aggravated his offences in the eyes of the Tsar. Nor was the Tsar any more impressed by a series of eulogistic articles on the Russian régime that Demidoff contri-buted to the *Journal des Débats* from 1838 until 1840, in which year the (Russian) government intervened to have them stopped.[22] And when the Grand Duke of Tuscany

Nicolas refused to recognise the title.

On 1 November 1840 Demidoff married Mathilde, daughter of the Prince de Montfort (fig.11):[23] the discarding of his current mistress and the complicated financial negotiations leading up to the grandiose ceremony that was held in Florence must count among the more squalid transactions of their kind. Montfort was the name that had been assumed by the exiled Jérôme, the youngest brother of Napoleon Bonaparte and the former King of Westphalia; his daughter was among the most cultivated members of the family, and was later to become famous as the patron and friend of some of the greatest French writers of the day, who would sometimes refer to her as 'Notre Dame des Arts'. In Italy she passed her time in a state of bored frustration with her spendthrift but insolvent father and his successive mistresses. It was the writer and journalist Jules Janin, friend of Demidoff and one of his companions on the Crimean expedition and collaborator on the ensuing book, who had urged on him the advantages that would accrue to everyone from the marriage. Demidoff would both strengthen his aristocratic status, because Jérôme's wife had been Princess of Würtemberg and a cousin of the Tsar, and at the same time be able to indulge his infatuation with the Bonaparte family - and here Janin's prophecy proved to be accurate for with marriage came his Tuscan princedom and, from his father-in-law, numerous relics associated with the Emperor which he was able to display at San Donato and on the island of Elba.[24] Mathilde, whose engagement with her cousin Louis-Napoléon had recently been broken off, would find happiness and wealth with a glamorous and well-established lover of the arts. And Jérôme would, by selling his daughter (and, incidentally, cheating on the provision of her dowry) be relieved of his financial problems and might even be allowed to return to France. Unfortunately no one had reckoned with the hostility of Pope and Tsar to a mixed marriage whose religious obligations as regards the education of any future children both parties were set on evading. Within weeks of the ceremony Demidoff was summoned to St Petersburg where the couple arrived, after a gruesome journey, on 3 March 1841.

It was not long before Princess Mathilde had so charmed Nicolas I (and been so charmed by him) that even her husband was reluctantly received at court and restored to qualified favour. Indeed by July they were given permission to leave Russia together for a limited period and to travel to Paris which Napoleon's niece was now able to see for the first time and where she enjoyed a dazzling social success. Their enforced return to St Petersburg led to less satisfactory results. The Tsar was indignant at the ostentatious friendship that had developed between Mathilde and the family of Louis-Philippe whose 'usurpation' of the French throne he deplored;[25] and even after he had once again succumbed to her attractions, he punished his own weakness by publicly humiliating Demidoff and refusing to invite him to receptions. It is hardly surprising in the circumstances that the arrogant Demidoff began to resent his wife's ascendancy and then to deceive her. By the time that they left St Petersburg in June 1843 their marriage was already in trouble, and their relationship was now made even more miserable by early and intermittent signs of the syphilis that, within less than fifteen years, was to re-emerge with terrible ferocity. Appearances were at first maintained in public, and at glittering soirées that were held in the splendidly decorated rooms of the Villa Matilda (as Demidoff now called the Villa at San Donato); but very soon both Demidoff and his wife, who had always been very susceptible to the appeal of handsome men, found new and compelling distractions. The insults and rages which followed and, above all, the blow with which he struck his wife at a fancy-dress ball after she had publicly insulted his mistress became legendary. The marriage struggled on for a year or two (but it was already in a bad way when in 1844 Ary Scheffer painted for Demidoff the most memorable of all the many images made of his wife (fig.11)). Some distraction was provided by a month's visit to London, but there ensued a series of incidents of the most degrading kind, until, in 1846, the Tsar (who, on a private visit to Florence, had coolly told his cousin that 'vous ne savez pas à quelle canaille vous vous êtes mariée') arranged the terms of their separation.[26] Demidoff was ordered back to St. Petersburg, and Princesse Mathilde was granted a very substantial alimony, which enabled her to settle in Paris with her lover, the comte de Nieuwerkerke (whose collection of arms and armour was later to be acquired by Sir Richard Wallace and remains in the Wallace Collection).

The reputation of Prince Demidoff never fully recovered from these events and the exaggerations that attended their (sometimes amused) retelling by the gossips of the day. 'Nothing more vile or more base can be imagined', wrote one of these. 'Insolent with his valets, cringing with those who stand up to him, deceitful, cowardly, he has every vice without a single quality'.[27] The boorish slapping of his wife was described in a way that implied that he spent his whole life doing absolutely nothing except knocking down women; his genuine interest in art and science was ridiculed as ignorant pretentiousness. Not everyone, however, was so censorious. Demidoff could attract genuine, and not merely interested, affection in the artists and writers who worked for him. Even when their relationship was at its worst Bartolini acknowledged that while Demidoff was 'a cossack', he also had a heart, and Demidoff wept bitterly when he heard of Bartolini's death.[28] To Raffet he showed real and prolonged kindness and in 1848 when Paris was in turmoil he invited him and his family to come and stay at San Donato.[29] His friendship with Jules Janin was sealed rather curiously after he had been found by Janin in bed with his (Janin's) mistress and thanked effusively for it.[30] And innumerable recipients of Demidoff's charities must have shared the sentiments of the Italian sculptor Giovanni Dupré, who remembered 'the pure and radiant beauty of his expression' and deplored 'the malice and injustice of some people who take pleasure in denigrating a person's character, falsifying facts and maligning motives'.[31]

Although Demidoff's friends in Paris feared that, following the débacle of his marriage, he was being forcibly detained in Russia, and wondered when (indeed, whether) he would be allowed to leave, he managed to return to Western Europe within less than a year.[32] By July 1847 he had embarked on a visit of four months to Spain, accompanied once again by Raffet. He bought a number of pieces of decorative art and of armour, but dismissed with contempt the 'Murillos' that were offered to him. It was during these years, following the break-up of his marriage, that his commitment to the collections at San Donato reached its peak, the silk manufacturers having been removed some time earlier.[33]

Demidoff's predilections were always eclectic, but there can be little doubt that the important place that he holds in the history of taste is due principally to four particular enthusiasms: for pleasing pictures painted by his contemporaries (which have already been discussed); for Old Masters of the Dutch school; for the decorative arts of eighteenth-century France and for '*objets de vertu*' and historical association. These enthusiasms were largely shared by Lord Hertford (whose favourite commendation of a painting was that it was 'pleasing'), and although both men ranged widely beyond these bounds - in the case of Lord Hertford, especially, with spectacular results - the ostentation and extravagance of their purchases in these fields were largely responsible for the creation of a novel and distinctive fashion in art collecting. Traditional collections had been based on paintings of the High Renaissance (Venetian, above all) and of the early seventeenth century in Italy and on masterpieces by Rubens, van Dyck, Claude and Poussin. During the lifetimes of Lord Hertford and Prince Demidoff (whose titles are of real importance in this context) at least two other models were being formed: one of these, which was centred on Italian and Flemish 'primitives', is particularly associated with selected private and, still more, public galleries in London and Berlin; the other, which concentrated almost entirely on contemporary painting, is very often attributed to the patronage of newly rich industrialists in most of the countries of Western Europe. The Hertford-Demidoff archetype (to adopt an even more simplified schema than those which have already been proposed in this paragraph, and one that omits the names of a few other significant collectors) offered an alternative that proved to be very popular with the Rothschilds of England and France and with many of the new millionaires of the United States: indeed, the display of wealth was integral to this taste as it was not, for instance, to that for the 'primitives'. And yet the more we look at this fashion the more clearly we realise that in essentials it was not so much a novelty as a return to that promoted by, among others, the fathers - literally the fathers - of Lord Hertford and Prince Demidoff.

The 3rd Marquess of Hertford (1777-1842) had been not only a perceptive artistic adviser to the Prince Regent (later George IV) but a remarkable collector for himself. Although he had bought a few wonderful Italian pictures, his main interests had lain in the fields of eighteenth-century French furniture and Dutch seventeenth-

century painting, and some of his acquisitions were inherited by his son and can be admired in the Wallace Collection today.[34] We have already seen that during the early years of the nineteenth century Nicolas Demidoff (1773-1828) had acquired many pictures by Greuze and Boucher and at least one by Fragonard; and we know that he had also bought others by Hubert Robert and Joseph Vernet, as well as by rather younger painters of Dutch-style genre such as the *'petit-maître'*, Demarne. Indeed, as far as numbers are concerned, Nicolas Demidoff had, during the period of the Restoration, probably been the most important collector in Europe of rococo painting. Although the majority of his Old Masters had belonged to the Dutch and Flemish schools, he had also owned many Italian (and especially Florentine) paintings of the seventeenth century, acquired locally, no doubt, in the last year of his life, to be hung in San Donato. And although the commissions he had given to Thomire, and other firms, for decorative bronzes to adorn his superb malachite urns and vases had led to the creation of works that would today be broadly classified as 'Neo-classical' or 'Empire',[35] we know that his visitors had been as dismayed by the wealth of their gilded ornamentation as they must have been by that on the actual eighteenth-century furniture which (together with porcelain and exotic weapons) he had also owned in significant quantities. When, therefore, his son Anatole began collecting on an extensive scale he was to a large extent following a tradition that was very familiar to him, even though it was only to appear fashionable, rather than eccentric, towards the end of his life.

Apart from pictures by his contemporaries, it was in fact the most conventional masters of the Dutch school who primarily attracted Demidoff during his early years as a collector, and he very quickly made a dramatic impact on the market by a group of extraordinary purchases. In April 1837 he was able to buy some of the most admired pictures from among those that had been assembled by the duc and duchesse de Berry. Their collection was a famous one and it included, alongside contemporary pictures of historical genre of the kind that were to be so eagerly sought after by Lord Hertford and Anatole Demidoff, many pieces that had once belonged to leading *amateurs* of the *ancien régime* and that were well known to dealers. The development had, however, been interrupted, and then halted, by the assassination of the Duke in 1820 and, ten years later, by the severe conflicts that arose between the Duchess and the Orléans dynasty which replaced the Bourbons on the throne of France. In 1834 the pictures were sent to England in an effort to raise money through a series of private sales, but these met with only a qualified success.[36] Three years later came the Paris auction, heralded by much publicity and many pleas to the government to buy the more important works for the nation[37] - and none was more important than lot 1, ter Borch: *The Swearing of the Oath of Ratification of the Treaty of Münster* (fig.12). This was immediately acquired for Demidoff at 45,500 francs - by far the biggest price of the sale, but comparatively insignificant compared to the 182,000 francs that Lord Hertford had to pay for it some thirty years later (for they were not alone in seeing in this

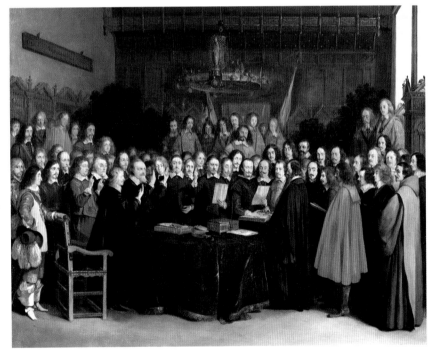

FIG.12. GERARD TER BORCH (1617-81), *THE SWEARING OF THE OATH OF RATIFICATION OF THE TREATY OF MÜNSTER, 15 MAY 1648*, 1648, OIL ON COPPER, 45.4 x 58.5. LONDON, NATIONAL GALLERY.

painting, now in the National Gallery, an early example of that domestic approach to historical events which so appealed to them in the reconstructions concocted by their own contemporaries). Demidoff always liked to be associated with royalty and by the time he set off two months later on his travels to the Crimea and his attempts to appease the Tsar, he was the owner of thirteen of the ninety-seven pictures that the duchesse de Berry had put up to auction - among them were celebrated works by Cuyp (No.17), Metsu, Teniers and Hobbema, as well as a second ter Borch.

In subsequent years Demidoff bought a number of other Dutch (and Flemish) paintings - though never with quite the same panache. He relied heavily on the advice of Raffet who would often visit the leading dealers in France, Belgium, Germany and Switzerland either together with Demidoff or on his behalf, and at the end of his life he owned works (most of which cannot now be traced) attributed to Rembrandt, Rubens, Ruisdael and other great masters.

He was less assiduous in his search for eighteenth-century French pictures - perhaps because he felt that he had been bequeathed enough of these by his father: indeed he clearly, and no doubt justifiably, had serious doubts about the quality of this bequest, for in 1839 he disposed of many of them - and of other items that he had inherited - by auction. Only Greuze (who remained very popular with collectors, even when work by most of his predecessors and contemporaries was comparatively neglected) continued to exert an appeal. In addition to some lesser - and equivocal - pictures, Demidoff may even have bought one very important subject piece by him, *La Dame de Charité* (Lyon, Musée des Beaux-Arts). This is one of the more austere of the artist's moralising compositions, but its theme of succour being offered to an old man lying on his sick bed and surrounded by his virtuous family bore a very obvious relationship to those acts of beneficence - in Paris, Florence, St Petersburg - which were genuinely promoted by the Demidoffs, and just as genuinely publicised.

Demidoff made no attempt to rival Lord Hertford in a field which had won him special notoriety - his readiness to pay very large sums for the pictures of Watteau - but he did buy (or at least, retain) a beautiful *Fête galante* by another of Lord Hertford's favourites, Watteau's pupil, Pater, which is certainly very close to similar scenes by his master (No.23).

It was, however, in the sphere of furnishings, decoration and porcelain that Demidoff's ventures into French art of the *ancien régime* proved to be most rewarding - especially to later owners, but also probably to him, for (unlike Lord Hertford who seems to have lived in conditions of some simplicity) Demidoff loved to surround himself with every kind of luxury so that even his pictures were often framed with the utmost splendour. However, it is only very rarely that we have any reliable information about the sources from which he bought such objects, about the prices he paid for them, about the dates at which they entered his collections, and (most important of all) about their exact appearance, quality, condition and authenticity. We are, for the most part, forced to depend on the brief descriptions to be found in sale catalogues of the 1870s - and, perhaps, of the 1880s - which are hardly ever illustrated with photographs; and the situation is made more difficult by our frequent inability to be certain whether some object had been inherited from his father, purchased by Anatole himself, or, after his death, by his nephew Paul. These difficulties are compounded by the reluctance of the Rothschilds, who certainly bought quite extensively at the San Donato sales, to keep any records of their acquisitions.[38] This lack of information is especially regrettable because the status of eighteenth-century decorative arts was changing very significantly during Demidoff's lifetime. Let us consider, for instance, the two large *bombé* cabinets (lot 274 in the 1870 sale, one now at Waddesdon Manor), dating from the reign of Louis XV, made up of marquetry inlays on satinwood 'very richly adorned with beautiful rococo ornaments of gilded bronze'. To have acquired these for a collection in the 1830s when Demidoff first established himself in Paris would have been adventurous (but not unique), although Balzac's Cousin Pons would have been dismayed to come across a very rich man attracted to what had hitherto been accessible enough; ten years later Demidoff would already have found a number of rivals in the sale-rooms; by the '50s he would have been in the height of fashion; and by the '60s he might just have shuddered momentarily at the realisation of what he had been

required to pay. He is said, by someone who had once known him well, to have heard the news of the 'prodigious' sums fetched by his possessions in 1870 *'avec calme, presque avec froideur'*,[39] but by then he was already nearly dead - and in any case this report is no more likely to be accurate than any of the other stories told about him at this time. It was, however, these prices that ensured that the dispersal of the collections of San Donato would be recognised as marking something of a turning point in the history of taste.

Many of the eighteenth-century furnishings brought from San Donato to Paris to be sold on behalf of Prince Demidoff (as he lay on his deathbed in March and April 1870) were very similar to others which already belonged to Lord Hertford, who did, however - in what must have been among the very last purchases he ever made - acquire two very elaborate clocks, one from the early, and the other from the late, eighteenth century (Nos.24, 31) which can at least offer us a suggestion of the exquisiteness of some of Demidoff's possessions; as too can one of his most highly esteemed pieces of Sèvres porcelain, the apple-green, white and gilded *'vase à médaillon du roi'*, which probably had been given by Louis XV to King Christian VII of Denmark and which was also bought by Lord Hertford - for the astonishing sum of 40,000 francs (No.34). But our inspection of these few items certainly from San Donato cannot bring back to us the overwhelming (and perhaps oppressive?) opulence that must have been conveyed by the *'deux grands et magnifiques meubles du temps de Louis XIV'*, the *'grande et belle armoire ... époque Louis XIV'*, the *'grande et magnifique commode, en laque noir, à décor d'or ...'*, the *'joli cabaret en porcelaine de Saxe, fond bleu de roi'*, the *'magnifique service (dit de Rohan) en ancienne porcelaine de Sèvres'*, the *'porcelaines anciennes de la Chine et du Japon'*, the mere enumeration and brief descriptions of which fill some 300 pages of the 1870 sale catalogues.

One of the most spectacular objects in Demidoff's collection dated from the sixteenth rather than the eighteenth century. This was the circular embossed shield of hammered iron, inscribed by Giorgio Ghisi of Mantua and dated 1554. Its surface was richly covered with figured reliefs which were damascened with gold and plated with silver and it was widely acknowledged to be a work of major artistic significance 'which could be compared to the rarest specimens of the kind to be seen in the private and public collections of Europe'. In the auction of April 1870 it was bought by Baron Ferdinand de Rothschild against stiff competition from Lord Hertford, and he bequeathed it to the British Museum eighteen years later.[40] Indeed, many other of the arms and sets of armour owned by Demidoff belonged to the epoch of the Renaissance. There was much less difficulty about acquiring objects of this kind than sumptuous eighteenth-century pieces of furniture, for the market in weapons had been well-developed during the Romantic period and had been flourishing ever since. It is true that the appeal of such weapons had depended as much on their historical associations as on the intrinsic quality of their decoration, but by the 1840s this attitude was gradually becoming modified in some quarters. In one celebrated Parisian collection of the applied arts,[41] for instance, virtually all the guns belonged to the sixteenth century or the reign of Louis XIV, but a single exception was made for an elaborately chased pair of pistols from the 18th century which were clearly admired only for their beauty.[42] It is perhaps significant that the owner of these pistols had begun his activities as a collector in the 1830s not - as was so usual at this time - because of his attachment to an artistic and historical patrimony which had been ravaged by the Revolution, but because he had been 'seduced by the beauty of execution and the exquisite delicacy of the products of the artistic industry of the peoples of the East, and had begun by buying a large number of objects from China, India and Persia'; only later, under the influence of some of the leading Paris *amateurs* and scholars did 'he turn to the furnishing of the Middle Ages and the Renaissance'. Indeed, it was not at all unusual for collectors at this period to begin with an enthusiasm for Oriental arms and armour,[43] but whether or not this was the case with Demidoff - and we know too little about the chronology of his acquisitions even to hazard a guess - he did not, like so many of his contemporaries, later move decisively in the direction of the Middle Ages. In this, as in so much else, he differed radically from such other extravagantly rich Russian collectors living in Paris as Alexander Petrovich Basilevsky and Prince Soltikoff, with whom, very surprisingly, he seems to have had few if any contacts. His pistols and swords belonged mostly to the seventeenth and eighteenth centuries - as did even his

ivories - and it is not surprising that Lord Hertford was able to buy a few fine examples of these as well as some superb Oriental swords and daggers. It is, however, certain that the agents who made these acquisitions cannot have appreciated the very special significance of the nineteenth-century sabre (No.51) that was among their cheaper bids at the sale: and yet this was the very weapon that Anatole Demidoff was wearing in the equestrian portrait by Briullov.

The great majority of Demidoff's purchases were made in Paris, but much of his life was spent in and around Florence, where he was able to buy some outstanding pictures (and commission copies of others). Many of these came from dealers: in particular, a number that were assigned - with varying degrees of optimism - to most of the greatest masters of the Venetian High Renaissance. They included genuine and major portraits by Veronese ('*La belle Nani*', now in the Louvre) and Titian ('*The Duke of Urbino and his Son*', whose present whereabouts are unknown), but it was his, as yet unidentified, '*Souper Venitien*' improbably - and controversially - attributed to Giorgione that attracted most attention on account of the 'ferocity of the animal instincts it displayed: drinking, eating and love-making of diabolical intensity'.[44] He also owned twenty-three very large views of Venice, whose attribution to Marieschi was probably not to be taken more seriously in the middle of the last century than it would be today. It was, however, the old patrician collections of the city that supplied him with some of the works which may have appealed most to his personal taste - and not only because of these aristocratic associations. In 1853, for instance, when the Rinuccini were forced to auction many of their possessions, he bought superb pictures by Carlo Dolci and Francesco Furini, those masters of the sumptuous and the sensuous in seventeenth-century Florence, and it was in Florence (as well as in Paris) rather than in Spain that he was able to obtain satisfactory paintings by - or attributed to - Murillo and some of his contemporaries. Rather more surprisingly (given the nature of his tastes) he also acquired some Flemish 'primitives', which were later to be much admired but to attract low prices at auction.

Like many other collectors of his day Demidoff was more interested in modern than in Renaissance sculpture, and in Italian rather than French sculptors: nor did he (or Lord Hertford) inherit from the aristocracy of the eighteenth century any feeling for the art and civilisation of classical antiquity. He did, however, enjoy the suggestive and sentimental figures of the American Hiram Powers, by whom he owned a version of *The Greek Slave*, and the more frankly licentious ones of the Swiss-born James Pradier (whose *Satyr and Bacchante*, now in the Louvre, was bought by Lord Hertford) and Auguste Clésinger.[45] And it was from Pradier that he commissioned a huge marble *Christ on the Cross* for the tomb of his brother in St Petersburg.[46] The monument to his father Nicolas that the two brothers ordered from Luigi Bartolini has already been mentioned, and he acquired other works by him[47] and some of his younger contemporaries, most notably Giovanni Dupré. But most of these, as well as the pictures that he bought from modern Florentine artists, were essentially used for decorative purposes rather than to be displayed in their own right.

Demidoff distributed his possessions among a number of residences in and around Florence. In one of his Villas he kept a very large collection of prints by Hogarth and other English and French engravers which were mounted in specially made wooden frames,[48] but it was in the Villa San Donato that his most important works were to be seen. A few written descriptions and watercolours are all that remain to remind us of its magnificence in its heyday, but they are sufficient to indicate how misleading (at least as far as the interior was concerned) is the impression conveyed by the word 'Villa'. In all essentials this was a town palace transferred to the countryside. The central saloon was surmounted by a large dome, lined with ribs of malachite, which - together with the pendentives and the semi-circular arches beneath it - was covered in frescoes of the story of Cupid and Psyche by the modern Roman painter Carlo Morelli (figs.13-14). Light streamed in through the high windows and was reflected below from a series of giant mirrors fitted into the surrounding walls. The most conspicuous piece of sculpture was a copy, that had been made for his former father-in-law, of Canova's statue of the seated Letizia Bonaparte ('*Madame Mère*'), of which the original, then as now, belonged to the Duke of Devonshire at Chatsworth. Other Napoleonic portraits were on display, above all the large marble standing

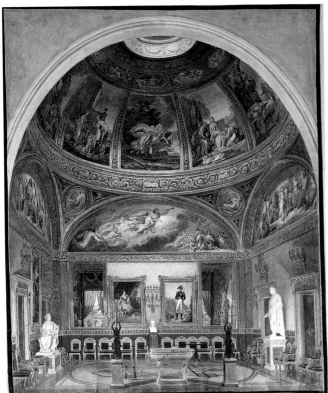 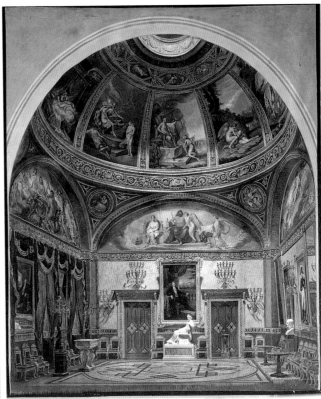

FIGS.13-14, JEAN-BAPTISTE FORTUNÉ DE FOURNIER (1798-1864), *THE BALLROOM AT SAN DONATO*, 1811, GOUACHE ON PAPER, 70 x 58.5 (A PAIR). FLORENCE, PALAZZO PITTI.

The Ballroom was situated on the first floor, above the portico of the principal façade. Fig.13 shows the north wall; Fig.14 the west wall. By 1860 Canova's *Madame Mère* had been moved to the Statues Room.

figure of the Emperor in Roman costume by Chaudet[49] - for not even Demidoff's personal experiences of the Emperor's family and his bitter separation from Princess Mathilde could cure him of his cult of the Bonapartes: indeed in 1851 he was able to buy from them the Villa S. Martino on Elba and to install in it an opulent Napoleonic museum. Other rooms at San Donato, some of them even more lavish, scintillating with silver and with coloured marbles and porcelain or closely hung with French and Netherlandish pictures of all sizes, were named after their principal contents or the style of decoration which characterised them: the Greuze Room, the Ivories and Spanish Pictures Room, the Arab Room, the Malachite Saloon (which also contained many animal bronzes by Barye originally commissioned by the duc d'Orléans), the Tapestries Room, the Red Saloon, the Turkish Room (containing among much else, a huge collection of exotic pipes - some of which were to be acquired by Lord Hertford (see Nos.46-8)), the armoury, and so on. There were two chapels, one Orthodox and one Catholic, and it was for the latter that, in 1852, he bought from the Rinuccini, the one picture for which he will always be remembered by art lovers, despite the fact that it is so uncharacteristic of his taste, the so-called 'Demidoff Altarpiece' by Carlo Crivelli, particularly coveted by Eastlake and Boxall for the National Gallery[50] where it now hangs (fig.15). But apart from this, how modern, how gaudy, how *foreign* the Villa and its contents must have seemed to the gentlefolk of Florence, familiar with the shabby and old-fashioned gentilities of their own palaces and country properties, who as from 1856 were allowed in groups to visit San Donato![51] And how exciting to the artists of what was now a provincial backwater, kept alive by memories of earlier glories, must have been this glimpse of Second Empire Paris with its Delacroixs and Delaroches and Lamis and Raffets! But the experience was to be short-lived.

Prince Demidoff was no liberal or enthusiast for the Risorgimento - despite the fact that, after his death, he was described by one of his former secretaries as *'démocrate par réflexion et par logique'*.[52] During times of Austrian

repression he remained in close and friendly contact with the occupying troops.[53] And when Grand Duke Leopoldo II, with whom he had been on terms of real friendship and exchanged magnificent gifts, abdicated in 1859, and (not long afterwards) Florence was annexed by the Kingdom of Sardinia, he felt that the time had come for him to leave Tuscany and return to France. This he was able to do thanks to the goodwill of the new Tsar, Alexander II, to whom during the Crimean War he had cunningly offered a million roubles as a token of loyalty.[54] The Villa San Donato was closed, although from Paris Demidoff continued to send pictures there from time to time and although it could still be visited by appointment, as if - like so many victims of revolution at all periods in history - he felt that the old order would soon be restored. He was by now seriously ill (fig.16). Even four years earlier a visiting doctor had written (with some exaggeration) that 'although he is aged 44, he looks 60. He has the beginnings of a lesion on the brain and half his body is paralysed. He is weak, blasé and bored - a living proof of the old truth that money does not bring happiness ... He can no more enjoy the sun than a beautiful picture ... The unfortunate man cannot even eat ... he spends twenty minutes at table, gulps down the same food every day, gets up to sit in a large armchair, yawns, goes to sleep, and then retires to bed without finding rest ...'[55] In Paris the Goncourts were to describe with malicious glee the squalid farce to which his once vigorous sexual activities had now been reduced.[56]

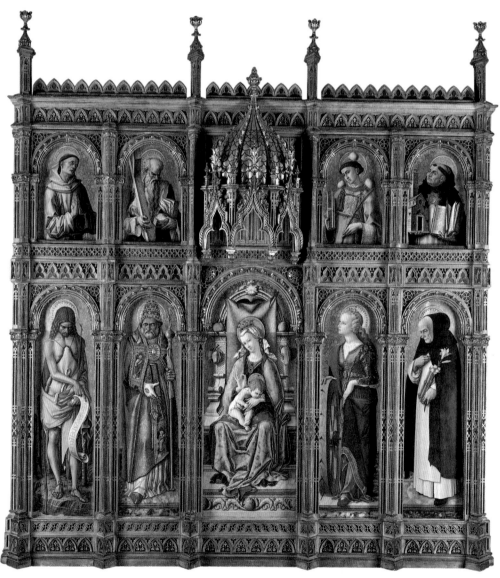

FIG.15. CARLO CRIVELLI (EARLY 1430s-1494(?), 'THE DEMIDOFF ALTARPIECE', 1470s, OIL ON WOOD PANELS, LEFT PANEL, LOWEST TIER, 138.5 x 40; LEFT PANEL, MIDDLE TIER, 61 x 39.5. LONDON, NATIONAL GALLERY. The panels (perhaps originally in a different arrangement) come from the high altar of the church of San Domenico at Ascoli Piceno. They were put together, in the elaborate frame, for Demidoff after he had bought them in 1852. An upper tier with four panels each showing a saint has been removed. The altarpiece was in the Catholic chapel at San Donato, but was bought by the National Gallery in Paris in 1868 from G.H. Philips.

FIG.16. ANATOLE DEMIDOFF, PHOTOGRAPH, 1860s.

The strengthening, but fitful, hold of syphilis increased the instability of purpose that had always marked his character. He was still buying works of art, and between 1861 and 1862 he proclaimed his nostalgic devotion to Tuscany by sponsoring the publication of a handsomely illustrated album of views of Elba, Florence, Pisa, Lucca and other towns which he had known since his early childhood:[57] to his great distress Raffet had died in 1860, but he continued to employ writers and artists to whom he had given his patronage ever since the expedition to the Crimea a quarter of a century earlier. It was, however, not long before he began to divest his Florentine residences of the treasures with which he had filled them, as if he had at last reached the conclusion that this hallmark of his life - perhaps life itself - was coming to an end. The first major sale was held in January 1863.[58] Demidoff's name was nowhere mentioned in the catalogue, but was not a secret. Of the thirty-four oil paintings disposed of, major works by Greuze, Decamps and, above all, Ingres fetched especially high prices. The Rothschilds, the Pereires, and the duc d'Aumale were among the extremely rich purchasers. So too was Lord Hertford who bought Pater's *Fête galante* (No.23) and a little genre scene of *Robbers in a Cornfield* by a modern Austrian painter, August Xaver Karl Pettenkoffen (No.2). Lord Hertford also acquired six of the seven watercolours by Bonington (and others by Decamps and Delaroche) at the sale (Nos.4-8, 11-12), as well as some superb eighteenth-century snuff-boxes, adorned with gold, enamel, cameos and jewels (Nos.38-42).

Further sales followed in 1868, enabling Lord Hertford to buy some fine Dutch pictures (figs.12 & 17), and, above all, during the closing months of the Second Empire. As if to symbolise the end of an era, paintings and sculptures, porcelain and furniture, silverware and costumes, weapons and toiletry, many created for sovereigns and their courtiers and all now having gained added lustre through their connection with Demidoff, were stripped from fourteen rooms in San Donato[59] and sent to the Paris sale-room where they attracted huge publicity and huge prices. Some items had particularly close associations with him - the sketches by Raffet, for instance, made on their travels together in Russia and Spain, and (posthumously) the watercolours of Eugène Lami which mirror so faithfully his taste for luxury and ease. It was at these sales that Lord Hertford, himself now so close to death, was able to acquire many of the finest items which are to be seen in the present exhibition: paintings by Ary Scheffer and Bonington, eighteenth-century furnishings, above all, arms and armour (fig.18). And the treasures from San Donato were soon to be found in public and private collections elsewhere in Europe: for, in this respect too, their dispersal seems to have a certain symbolic significance - these were surely the last sales of their kind that attracted no bids from the United States of America.

Anatole Demidoff died at the age of 57 on 29 April 1870, just a day after the last of these epoch-making sales which, by a strange coincidence, were held in premises on the Boulevard des Italiens belonging to Lord Hertford. The Princesse Mathilde at once put on mourning, and the funeral, which took place in

FIG.17. 'THE BATTLE OF SAN DONATO'. A CARTOON FROM *L'ILLUSTRATION*, 23 MAY 1868. A caption to the cartoon read: 'Many thousand-franc notes remain on the field of battle. Some living artists would not have minded picking up some of the wounded, but the rules of engagement forbid this.'

sweltering heat in the Greek church near the Place de l'Etoile almost a month later, was well attended, but newspaper obituaries[60] competed, in the cruelly facetious manner of the time, in the retailing of colourful and sometimes lurid rumours about the last years of the man who was nicknamed '*Prince Décomposition*'. Many of these were clearly inaccurate, but they give us some indication of the sort of reputation he enjoyed after his final return to Paris: a man as caustic and lecherous (with a seemingly endless supply of actresses at his disposal) as he was devout, loyal to his friends and charitable (his bedroom hung with religious pictures, his family vault open to intimates and servants, his pockets crammed with notes to distribute to the poor). Eccentric also - the swing in the garden of the mansion that he had rented in the rue de la Pépinière between the Gare St. Lazare and the Boulevard Haussmann was reserved not, as sightseers expected, for children but for his pet monkey.

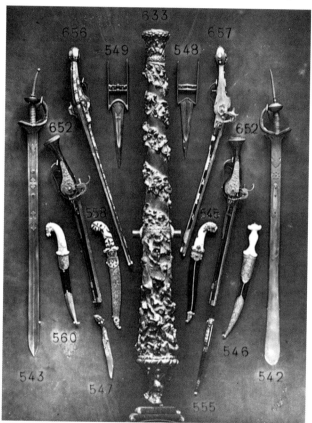

FIG.18. PHOTOGRAPH FROM THE 1870 SAN DONATO SALE CATALOGUE SHOWING THE MAZZAROLI CANNON BARREL (NO.67) REMOVED FROM ITS CARRIAGE, TOGETHER WITH FOUR EUROPEAN WHEEL-LOCK PISTOLS (INCLUDING NO.57) AND ORIENTAL SWORDS AND DAGGERS (INCLUDING NOS. 68-70, 72 AND 76-7).

Above all, perhaps even above his fondness for rich food,[61] there was his insatiable passion for the theatre to which, so it was said, he would go every single night of the year, seeing the same play again and again, though always leaving before the last act. At fashionable first nights the audience would stare in derision as he sat in his box - silent, brooding, hardly conscious of his surroundings - half hidden behind his bejewelled mistress (an actress, of course), sucking sweets or gulping down ten, fifteen, twenty swigs of the mysterious liquid - or was it, as some said, only water? - with which his footman, standing in the background, constantly replenished his silver goblet.

Anatole was childless, and his heir was the son of his elder brother Paul (who had died thirty years previously), also called Paul, to whom he was said to have made over most of his fortune some years earlier in return for annual rental so as to avoid the Tsar's threat of confiscation. Paul too was a fanatical collector - 'the most indefatigable ... since the days of Lord Hertford' as an English journal was to point out fifteen years later[62] - and it is often very difficult, and sometimes impossible, to distinguish his possessions from those of his uncle. Moreover, he too had sold some of his pictures on various occasions during the 1860s - to the satisfaction of Lord Hertford, who was enabled to buy a few of his modern works. During the decade following Anatole's death collecting took the upper hand again and he was soon able to restore the

Villa at San Donato, which he had probably never visited before,[63] to much of its former glory; but in 1880 he suddenly stripped it of most of its pictures and furnishings in what proved to be an even more sensational sale than those held ten years earlier: he and his family had already settled in the Medici property of Pratolino which he had bought in 1872 and where he was to die in 1885.

The Villa at San Donato remained empty for six years and was then acquired by a Russian princess who kept it until the Revolution of 1917. Thereafter neglect, war and land speculation slowly put an end, at first to its grandeur, and then, after 1945, to its very existence. Yet, until recently, remnants of Anatole Demidoff's possessions in the Villa, which he had made one of the most famous in Europe, still remained with his collateral

descendants at Pratolino. A sale held there in 1969 (ninety-nine years after the ones that had taken place while he was lying on his deathbed) brought to light further drawings by Raffet as well as various portraits, including the one of Princesse Mathilde painted by Ary Scheffer, which he must have retained until the end of his life (fig.11), and a particularly absurd one of himself, aged six or seven, as a naked Cupid awkwardly seated astride a tiger which he is presumably hoping to tame, or at least to charm - although the animal's bared teeth suggest, prophetically, that the bestial passions may not always be controlled so easily (fig.19). This has vanished once more, but there remains visible - though much degraded by mutilation and pollution - on the appropriately named Piazza Demidoff in Florence, the superbly conceived monu-ment to his father commissioned from Bartolini and, in the Museo d'Arte Moderna in Palazzo Pitti, the unfinished portrait by Briullov and two watercolours of the interiors of the San Donato Villa.

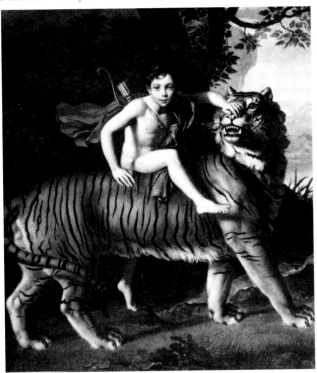

FIG.19. RENÉ THÉODORE BERTHON (1776-1859), *THE YOUNG ANATOLE DEMIDOFF*, c.1010, OIL ON CANVAS, 162 x 144 (PRESENT WHEREABOUTS UNKNOWN) Demidoff is shown as Cupid climbing onto a (Siberian) tiger, i.e. personifying 'Love overcoming Strength'.

In 1886 a rather sycophantic Italian writer claimed of Anatole Demidoff that he had been 'one of those great men who belong to world history'.[64] This is something of an exaggeration; but so too is the view, widely current in his own day and since, that he was no more than a brutal and boorish millionaire who used his patronage and collections only in order to assist his social climbing. There is, on the contrary, decisive evidence to prove that he was a man of intelligence and curiosity whose love of art was genuine and well-informed.[65] Since his death the style of decoration and belongings with which he is so closely associated has not only fallen out of favour but has come to be looked upon as characteristic of unimaginative and parvenu tastelessness. Moreover, neither Demidoff nor Hertford showed the remotest interest in the 'advanced' currents of their own national cultures: the 'Wanderers' and the 'Pre-Raphaelites' meant absolutely nothing to them. This may (or may not) be regretted - but to dismiss their achievements on these grounds is to ignore the fact that when they began collecting, the choices they made were far from unimaginative and that an appreciation of eighteenth-century furniture was not, in the middle of the nineteenth century, common among men of no taste. It is true that for most of us today a visit to a revived San Donato in its full glory would probably prove to be a lowering experience: but to see a small sample of its contents, all of them selected by a man whose over-riding passion for art cannot possibly be questioned, can only be an intensely pleasurable occasion which will surely inspire a feeling of respect (as well as envy) for the dissolute Russian entrepreneur who brought them, and very many more, together in Paris and Florence.

* It would not have been possible for me to write this Introduction without the close collaboration and important researches of Stephen Duffy and Robert Wenley. I am also most grateful to my wife for her help in coping with the Russian sources for Demidoff's life, and to Maurizio Bossi and Lucia Tonini for providing me with much information from Florence.

1. The last major sale of works of art from the Demidoff family collection was the Pratolino sale in April 1969 (which contained portraits and furnishings that were once owned by Anatole). A further small group of paintings was sold in Monaco in December 1992. See Appendix II for a list of Demidoff art sales.

2. Demidoff's date and place of birth cannot be determined with complete confidence. Although most contemporary commentators said that he was born in Moscow or Florence, his death certificate (Archives de Paris, et/LV/482) records his birthplace as St Petersburg. Similarly, the year of his birth is disputed between 1812 and 1813: the death certificate only gives his age, 57, which would make 1812 the more likely (as he died in April 1870). This uncertainty extends to many aspects of Demidoff's life and collecting, compounded by the innumerable rumours that surrounded him and, on many occasions, the difficulty of defining precisely which works of art were acquired by him and which by other members of his family. Although my account sometimes differs from them, I must nevertheless make clear my great debt to the fundamental studies by Fabia Borroni Salvadori and Fabio Bisogni: references to their articles should really appear on almost every page but have been largely excluded for the sake of legibility.

3. Salvadori, p.938.

4. Tinti, II, pp.47-54.

5. Valery 1842, II, pp.328-9.

6. *L'Artiste*, I/7 (1834), p.72.

7. E.g. Boime, p.65; Spalletti in an article shortly to be published in the Acts of the Demidoff conference recently held in Florence. I am most grateful to the editor (Lucia Tonini) for permission to consult this.

8. Raffet, p.120. The phrase is from the 1863 San Donato sale catalogue.

9. Vigne, pp.60-1.

10. This lack of interest in the Barbizon painters was noted by Henry Renet at the time of the 1870 sale (*Revue Internationale*, 1870, p.93). The Rousseau was in the 1863 San Donato sale.

11. See Johnson, III, pp.38-9, 49, 84-6, 163, 201 & n., 205 & n., 273, 283; also Delacroix, *Correspondance*, I, pp.364n., 408, 440; II, 269.

12. Lemoisne, p.122.

13. Lemoisne, pp.93ff.

14. Lemoisne, pp.123-4.

15. See particularly Bry, pp.35, 59, 74, 80-2, 86-7, 88, 89, 99, 109, 111; and Raffet, *passim*.

16. Although in 1826 Vernet had painted a charming equestrian portrait of the young Anatole, presumably commissioned by his father (sold Monaco, December 1992 (see Appendix II), now with Richard Green, London). Its size (63.5 x 80) and character are modest compared with the portrait Anatole himself was soon to commission from Briullov.

17. 1863 San Donato sale catalogue (lot 14); also *Gazette des Beaux-Arts*, I/15 (1863), p.461.

18. Cadot, p.53. There was, however, a precedent for Briullov's picture in the dashing equestrian portrait which Gros painted in 1809 for Prince Youssoupoff showing the Prince's son, with sabre and bow and arrows, dressed in native costume (Moscow, Pushkin Museum).

19. *Russkaya Starina*, pp.149-54; Florence, Palazzo Pitti, 1972, p.132.

20. Quoted in A. I. Leonov (ed.), *Russkoe Isskusstvo* (Moscow 1954), II, p.502.

21. Cadot, p.53; Pellegrini, pp.71-2.

22. Cadot, *ibid.*; Demidoff was to own a number of newspapers and journals including *Le Nord* and *Le Petit Journal* (Archives de Paris, et/LV/482).

23. A copy of the marriage contract is in the Archives de Paris (et/LV/482).

24. Pellegrini, p.75; Salvadori, p.957.

25. Cadot, p.145.

26. Viel-Castel, I, p.66; copies of documents relating to the separation are in the Archives de Paris (et/LV/482).

27. Viel-Castel, I, pp.66-7; see also Janin, I, p.219.

28. Tinti, II, p.53; Dupré, in Pellegrini, p.99.

29. Raffet, p.58.

30. Mergier-Bourdeix, p.114.

31. Pellegrini, p.77.

32. Janin, I, pp.186-7.

33. Bisogni, p.77.

34. Hughes 1992, pp.15ff.; and Ingamells, 1993.

35. Remington; Zeck in an article shortly to be published in the Acts of the Demidoff conference recently held in Florence (see note 7).

36. Whitley, II, p.272.

37. *L'Artiste*, I/13 (1837), p.121.

38. Bellaigue, p.9.

39. Gallet de Kulture in *Le Moniteur Universel*, 18 May 1870.

40. *Revue Internationale*, 1870, p.304; *Waddesdon Bequest*, 1899, no.5.

41. The Debruge Duménil Collection (see Labarte; and Arquiè).

42. Labarte, p.720, no.1430.

43. Kryzanovskaya, p.143

44. *Revue Internationale*, 1870, p.99. The Venetian pictures were in the 1870 San Donato sale.

45. Spalletti (see note 7).

46. Pradier, II, p.252n.

47. Bartolini, pp.58, 84, 88, 129, 265, 288.

48. Sold in London, 1 June 1863; they had been kept at the Villa di Quarto.

49. Spalletti (see note 7).

50. The National Gallery archives contain notes kept by Charles Eastlake on visits to San Donato in 1858, 1862, 1863 and 1864. Besides the Crivelli, the painting which most interested him as a possible acquisition for the National Gallery was Velázquez's portrait of Philip IV of Spain. This was duly purchased by way of a dealer in Paris in June 1865 (now National Gallery no. 745). Boxall wrote to the Trustees of the Gallery recommending the acquisition of the Crivelli in May 1866 (letter in Gallery archives).

51. Salvadori, p.969.

52. Gallet de Kulture in *Le Moniteur Universel*, 18 May 1870.

53. Raffet, pp.76-7.

54. Du Perron, p.218.

55. See Janin, III, p.146.

56. *Journal*, 25 January 1863 (Goncourt, I, pp.1219-20).

57. Pellegrini, pp.81-2.

58. Although this sale had been preceded by one of gold boxes in February 1861; see below (p.78) and Appendix II.

59. Salvadori, p.977.

60. E.g. *L'Eclipse*, 15 May 1870; *Galignani's Messenger*, 1 May 1870; *Le Gaulois*, 1 May 1870; *Le Moniteur*, 1 May 1870; *The Times*, 2 May 1870. Most of the foregoing is taken from these reports.

61. Demidoff was a notable gourmet who gave his name to several dishes in which truffles formed a conspicuous part (Fitzgibbon, p.129). The dissolute character of Prince Orlofsky in Strauss' *Die Fledermaus* was also partly based on him.

62. *Art Journal*, 1885, p.93.

63. Bisogni, p.79.

64. Prato, p.67.

65. See for example Raffet, p.64.

CHRONOLOGY

1812 Birth of Anatole Nicolaievich Demidoff in St Petersburg (but see p.30, n.2). He will be brought up and educated in Paris, under the tutelage of the Jansenist priest abbé Brandt (Gallet de Kulture, pp.139-52; *Nouvelle Biographie Générale*).

1818 Death of Elizabeth Stroganoff, mother of Anatole Demidoff.

1822 Nicolas Demidoff moves to Florence with his two sons Paul and Anatole (Pellegrini, p.67).

1828 Death of Nicolas Demidoff, father of Anatole Demidoff.

1830 Demidoff signs a contract with Lorenzo Bartolini for a monument in Florence to his father, Nicolas Demidoff, finally inaugurated in 1871 (Tinti, II, p.49).

1831 Demidoff writes (January 9) from Paris to Bartolini to say that he has received two portrait busts of himself and his father, but that they are not good likenesses (Tinti, II, p.55).

1833 Acquires Granet's *Death of Poussin*.

1834 Meets Eugène Lami and orders oil paintings from him (Lemoisne, p.49). Owns the two most successful pictures at the Paris Salon, Granet's *Death of Poussin* and Delaroche's *Execution of Lady Jane Grey*. Stays in St Petersburg, from where he writes to Briullov concerning the successful exhibition of *The Last Day of Pompeii* (*Russkaya Starina*, p.152). Exhibits malachite temple in Paris.

1837 Meets Raffet in Paris. Acquires thirteen Dutch and Flemish paintings at the duchesse de Berry sale. Visits south-eastern Europe, the Crimea and Constantinople with twenty-two artists, journalists, scientists and archaeologists, including Raffet.

1838 Begins publishing articles on Russia in the *Journal des Débats* (17 December).

1839 Visit to Russia (Salvadori, p.953). Sale in Paris of works of art mostly inherited from Demidoff's father, Nicolas. Birth of Paul Demidoff (9 October), Demidoff's nephew and eventual heir.

1840 Death of Paul Demidoff, brother of Anatole Demidoff (5 May). Marries Mathilde Bonaparte in Florence (1 November) and shortly after they visit Rome (Richardson, p.39).

1841 Demidoffs visit Vienna, Cracow, Warsaw, St Petersburg and Paris (Cadot, p.54 and Richardson, pp.40-1).

1842 Demidoffs return to St Petersburg (Cadot, p.54).

1843 Demidoffs return to Florence (Cadot, p.55). Demidoff is elected to the Institut de France (Richardson, p.29)

1845 Demidoffs spend a month in London and also visit Spa with Prince de Montfort (Salvadori, p.962 and Janin, I, p.127n.).

1846 Demidoffs visit Paris and Anatole is summoned to St Petersburg (Richardson, pp.51-2). Separates from Mathilde.

1847 Demidoff visits Marseille (Raffet, p.34) then travels to Spain (July to November). Returns to Florence (Raffet, p.52).

1848-9 Visits Belgium, Switzerland and Germany (Raffet, pp.58, 63-9). Returns to Florence in May 1849 (Raffet, p.76). Visits Naples in September (Raffet, p.88).

1850 Visits Rome in April (Raffet, pp.103-4). In November visits Bologna, Modena, Verona, Venice and then leaves for Vienna and Russia (Raffet, pp.107-8).

1851 Exhibits at the Great Exhibition in London. Visits Paris and returns to Florence (Raffet, p.115). From the Bonaparte family Demidoff buys the Villa S. Martino on Elba which he visits and which he will convert into a Napoleonic museum (Pellegrini, p.79).

1852 Visits Dresden and Carlsbad where he takes the waters. Then visits St Petersburg (Raffet, p.119).

1853 Attends with Raffet the duchesse d'Orléans' sale in Paris where he buys five pictures (Raffet, p.120).

1855 Probably visits Vienna (Raffet, p.126).

1856 San Donato open to groups of visitors (Salvadori, p.967). Probably visits Paris (Janin, III, p.63).

1859 Fall of the Grand Duke of Tuscany, leading to Demidoff taking up residence in Paris.

1860 Death of Raffet. Comes to Paris where he visits the tomb of Raffet (Bry, p.111).

1861 Sells some gold boxes in Paris. Exhibits plants and horticultural methods at the National Exhibition in Florence (Boime, p.201).

1863 Sells paintings, gold boxes and other works of art from San Donato in Paris (13-16 January).

1868 Sells twenty-three Dutch and Flemish paintings in Paris (18 April).

1870 Sells principal contents of San Donato in Paris (21 February - 28 April). Dies in Paris (29 April) and is buried in Père Lachaise.

CATALOGUE

FURTHER DETAILS OF NEARLY ALL THE OBJECTS IN THE EXHIBITION WILL BE FOUND IN THE
RELEVANT CATALOGUES OF THE WALLACE COLLECTION (SEE BIBLIOGRAPHY UNDER HUGHES,
INGAMELLS, LAKING, MANN, NORMAN, REYNOLDS AND SAVILL).

MEASUREMENTS ARE IN CENTIMETRES; HEIGHT BEFORE WIDTH (THEN DEPTH WHERE
RELEVANT). WEIGHTS ARE IN GRAMMES.

INFORMATION ON THE LOCATIONS OF WORKS OF ART AND THE APPEARANCE OF THE ROOMS
AT SAN DONATO IS TAKEN FROM DANDOLO AND PRATO (SEE BIBLIOGRAPHY).
DURING THE PERIOD 1830-70 £1 STERLING WAS WORTH ABOUT 25 FRANCS. IT WAS ALSO
WORTH ABOUT 25 LIRE AT THE TIME OF THE 1880 SAN DONATO SALE.

NO.3 DETAIL

NINETEENTH-CENTURY PAINTINGS

In 1834, when he was only twenty-two years old, Demidoff owned the two most successful pictures exhibited that year at the Paris Salon, Delaroche's *Execution of Lady Jane Grey* (fig.6) and Granet's *Death of Poussin*. Both were hugely popular with the crowds and, with few exceptions, greatly admired by the critics. By then he had also commissioned his equestrian portrait from Briullov (frontispiece) as well as the Russian artist's monumental painting *The Last Day of Pompeii*.

Demidoff's later collecting activity, however, was much more subdued: the total number of pictures he acquired was large but the drama of his youthful emergence as a collector was never repeated. In the late 1830s he bought many examples of contemporary or historic genre, including pictures by Delaroche (though none comparable to *Lady Jane Grey* in size and renown), Delacroix and Bonington (No.3). For San Donato he imaginatively ordered a decorative scheme in fresco from the Roman artist Carlo Morelli (figs.13-14); and he was also to commission further frescoes from the Tuscan view painter Giovanni Signorini and oils from such local artists as Bezzuoli and Emilio Lapi. In the early 1840s, however, his enthusiasm for buying modern paintings seems to have waned, though it was at this time that he obtained from his father-in-law, Jérôme Bonaparte, many of the pictures with Napoleonic themes, particularly portraits of the Emperor and his family, that were to be displayed at his museum on the island of Elba. Royal portraits (whether Russian, French Imperial or otherwise) were also a prominent feature of the collections at San Donato and, apart from the Napoleonic pictures, it was there that he hung all his major modern paintings together with earlier works of similar importance. Very few pictures seem to have been kept at his other homes in Florence, Paris and Russia.

In 1853 he bought six paintings, including Ingres' greatly admired *Antiochus and Stratonice* and Scheffer's hardly less popular *Francesca da Rimini* (No.1), from the collection of the late duc d'Orléans, who had been the son and heir of King Louis-Philippe. These pictures, however, were unusual in their cost and celebrity. His other purchases in the late 1840s and the 1850s were more modest: a few historical works, including two by the Belgian painter Louis Gallait, but mostly genre scenes, still lifes and souvenirs of his travels such as views of the Crimean coast by Aivazoffski and picturesque episodes of Spanish life by Joaquin Becquer. In his last decade he bought very little.

Perhaps above all Demidoff enjoyed drawings depicting picturesque and antiquarian subjects. The three sets of watercolours painted for him by Eugène Lami (see Nos.13-14) are characteristic of this taste, as were his innumerable commissions to Denis-Auguste-Marie Raffet (1804-60), his friend, artistic adviser and the greatest beneficiary of his patronage. Demidoff was himself the author of travel books illustrated by Raffet and fully shared the nineteenth century's delight in assembling albums of prints and drawings, particularly topographical scenes. These he stored at San Donato in large cupboards in the Ivories Room where he also kept Spanish paintings, Chinese vases and his collection of Renaissance and modern ivories. Assembling such albums was a popular pastime with the rising middle classes but was also much enjoyed in aristocratic circles (both Louis-Philippe and Queen Victoria, for example, were notable enthusiasts). However, Demidoff's employment of Raffet as a personal artist to record his travels was exceptional: one of the last instances of a

practice which had been common in the eighteenth century but which photography made largely redundant in their own lifetimes. Unfortunately, the five watercolours by Raffet in the Wallace Collection were probably not owned by Demidoff and he is therefore unrepresented in this exhibition.

Demidoff's collection was unparalleled in Italy, and among Russian collectors no one of his own generation bought modern French pictures on a comparable scale. The extraordinary collection assembled by Count Nicolas Koucheleff-Bezborodko (1834-62) in the last four or five years of his short life was as large, but he had been born more than twenty years after Demidoff. It was also more eclectic, being, for example, rich in works of the Barbizon school as well as pictures by Decamps and Delacroix. But while there were a few other admirers of the Barbizon school among Russian collectors, including the writer Turgenev, most seem to have shared Demidoff's preference for artists who had come to prominence in the 1820s and the early 1830s. The small collection sold by a Prince Troubetzkoy (at present unidentified) in Paris in 1862 included a smattering of Barbizon pictures by Daubigny, Diaz and Rousseau and differed from Demidoff's collection in its lack of historical genre scenes, but otherwise it was broadly similar in its character and the artists represented, such as Bonington, Decamps, Gudin and Scheffer. Even the collection of Anatole's much younger nephew Paul was similar to his uncle's; and though decorative panels for Paul's Parisian *hôtel* were commissioned in 1865 from Rousseau, Corot, Dupré and Fromentin the scheme was broken up within three years. It was as a collector of Dutch pictures (see p.51) that Paul was to show more adventurous tastes.

Much work remains to be done on the history of Russian collecting but it appears that collectors who stayed at home were also conservative in their taste. This at least was the view of Théophile Gautier, who visited Russia in 1858-9. Describing a typical St Petersburg salon he wrote:

> If the host considers himself to be a connoisseur the walls of his room will be covered in red Indian damask ... [and on them will hang] an Horace Vernet, a Gudin, a Calame, a Koekkoek, sometimes a Leys, a Madou, a Tenkate, or, if he wishes to demonstrate his patriotism, a Briullov and an Aivazoffski; these are the painters most in fashion; our modern school has not yet penetrated here. We have seen two or three Meissoniers and almost as many Troyons but the manner of our painters seems too unfinished to the Russians.

Neither collector acquired many pictures from dealers (whose influence within the art market was increasing rapidly), but in giving many commissions Demidoff differed greatly from the 4th Marquess of Hertford who seems to have had few contacts with artists and preferred to buy at auction. In general, however, their tastes in nineteenth-century painting were broadly similar and unexceptional among collectors of their time. Both bought scenes from early modern history and literature, topographical watercolours and pictures with Napoleonic themes: the subject of a painting was probably their first consideration when making a purchase. Apart from Lord Hertford's addiction to Orientalist pictures, both, moreover, showed little interest in other aspects of French painting such as themes from classical history and the 'realist' developments that took place in and after the 1840s.

In 1863 thirty-two watercolours and thirteen oils from San Donato, including Ingres' *Antiochus and Stratonice*, were sold in Paris. These were followed seven years later by many more: ninety-three oils, including the best-known modern pictures, more than one hundred watercolours and countless drawings and studies by Raffet. By the time of the 1870 sale the leading painters of the Romantic era, including Delaroche, Scheffer and Delacroix, were all dead and several observers commented on the old fashioned Romanticism of Demidoff's pictures (what Jean Ravenel of the *Revue Internationale* termed 'ce monde de l'agitation et du malaise'). Yet their continuing appeal for rich collectors of conservative taste like Lord Hertford was demonstrated by their high prices at the sale. Pictures with Romantic subjects continued to be painted in large numbers after Lord

Hertford's death, but many of the contemporary artists who had been admired by him and Demidoff were soon to pass into obscurity, their work condemned as contrived and remote from modern life. It is only in recent years that interest in them has begun to revive.

REFERENCES: Berezina, p.10-11 (Koucheleff-Bezborodko); Broude; Sensier, p.324 (Paul Demidoff's *hôtel*); Gautier, p.215; Levinson-Lessing, p.206 (collectors); *Revue Internationale*, 1870, p.224.

1 Ary Scheffer (1795-1858)
FRANCESCA DA RIMINI P316

Signed, bottom left: *Ary Scheffer./1835*
Oil on canvas, strip-lined 166.5 x 234
PROVENANCE: bt. from the artist by Ferdinand-Philippe, duc d'Orléans, 1835; Hélène, his duchesse; her sale, Paris, 18-20 January 1853 (52), bt. Barthélemy Vastapani, 43,600 fr.; Anatole Demidoff (bt. in January 1853); his (San Donato) sale, Paris, 21-22 February 1870 (84), bt. Mannheim, 100,000 fr., for the 4th Marquess of Hertford.

Scheffer was one of the leading young painters in France in the 1820s and 1830s, specializing in scenes from medieval and modern literature. From the time of its first exhibition at the Paris Salon in 1835, *Francesca da Rimini* was among his most admired and popular works. George Eliot was one of many to be deeply moved by the picture's pathos, saying that she 'could look at it for hours'.

The subject is taken from Dante's *Inferno*. While on their passage through Hell, Dante (on the right) and Virgil watch the tragic figures of Paolo and Francesca, condemned with the souls of the lustful to the stormy darkness of Hell's second circle. The lovers had been stabbed to death in 1285 by Francesca's jealous husband who was also Paolo's elder brother. Although Scheffer's choice of this passage from Dante's text was unusual, the subject of the lovers' murder had been painted before by many artists including Ingres and Delacroix.

The first owner of the picture, Ferdinand-Philippe, duc d'Orléans, who employed Scheffer as his family's art teacher, built up a superb and varied collection of contemporary French painting which was dispersed at auction in 1853, eleven years after he had been killed in a carriage accident. Demidoff and the 4th Marquess of Hertford probably knew his widow, and this may have influenced them to bid at her sale (where Demidoff, using Raffet as his agent, was the single biggest purchaser, buying five pictures, while Lord Hertford bought three). Although Demidoff did not acquire *Francesca da Rimini* at the sale itself, he seems to have bought it immediately after from the original buyer, Vastapani, a wine grower from Bordeaux.

Dante's Florentine birth made the picture entirely appropriate for San Donato where it was duly sent after its purchase. There it hung in the Malachite Saloon with six other modern French paintings, including Delaroche's *Execution of Lady Jane Grey*, all of which were provided with elaborate frames decorated with suitable allegories.

The Wallace Collection's picture fortunately retains its magnificent pinewood frame. It shows, top centre, a model of Dante's inferno and, bottom centre, the towers of Rimini (where the murders took place); the corners show the crossed arrows and flaming torches of love, an open book (a reference to the romance of Sir Lancelot that Paolo and Francesca were reading when they were discovered by Francesca's husband) and a chain ring (for eternal union); these features are connected with oak leaves, acorns, pomegranates, doves and a winding scroll revealing (discontinuous) parts of Dante's text (*Inferno*, v, lines 80-137). The frame may have been made in Florence by the carvers and gilders Fratelli Pacetti, who made the similar and equally splendid frame for Scheffer's portrait of Princess Mathilde (fig.11), the only other painting by the artist known to have been owned by Demidoff.

The 4th Marquess of Hertford had two opportunities to buy the picture. Having passed it over in 1853 at the Orléans sale, in 1870 it cost him more than any other nineteenth-century painting he ever bought. He also acquired three other (much less important) oils by Scheffer and one watercolour.

REFERENCES: Robert 1991, 1993; Richardson, p.45 (Mathilde and the duchesse d'Orléans); Florence 1972, p.133 (Scheffer portrait).

2 August Xaver Karl Pettenkofen (1822-89)
ROBBERS IN A CORNFIELD P338

Signed, bottom right: *Pettenkofen 1852*

Oil on millboard 29.5 x 23.4

PROVENANCE: Commissioned by a Viennese collector; Anatole Demidoff; his [San Donato] sale, Paris, 13 January 1863 (33, *Le Partage du butin*, '... *le costume délabré indique des échappés de quelque band de reîtres du dix-huitième siècle ...* '), bt. by the 4th Marquess of Hertford, 5,000 fr.

Pettenkofen was a Viennese illustrator and cartoonist who became better known for his paintings of military scenes and Hungarian peasant life. His early pictures were influenced by French military draughtsmen such as Raffet and Horace Vernet which may in part explain his appeal to Demidoff. The picture is said to have been commissioned in Vienna and completed on a visit to Paris in 1852. Demidoff acquired at least five more of Pettenkofen's paintings: there were three oils and two watercolours in the San Donato sale in 1870. The 4th Marquess of Hertford, on the other hand, is not known to have owned any other work by him and this low-life, rather disquieting scene is an unexpected purchase which differs markedly from his customary taste.

3 Richard Parkes Bonington (1802-28)
HENRI IV AND THE SPANISH AMBASSADOR P351

Oil on canvas, relined 38.4 x 52.4

PROVENANCE: Louis-Joseph-Auguste Coutan (d.1830); his sale, Paris, 19 April 1830 (7), 3,050 fr.; Gendron, from whom acquired in 1837 by Anatole Demidoff; his (San Donato) sale, Paris, 21 February 1870 (4), bt. Mannheim, 83,000 fr., for the 4th Marquess of Hertford.

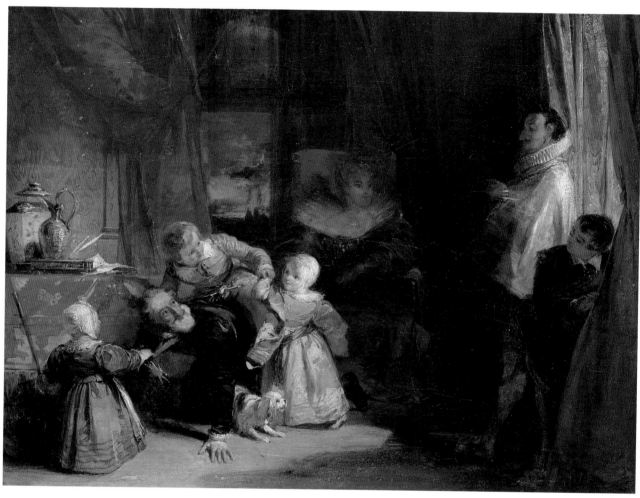

Bonington, English-born but long resident in France, produced landscapes and scenes of historic genre, of which this picture, first exhibited at the Paris Salon in 1828, became one of the most celebrated. Henri IV, King of France (1589-1610), is discovered by the visiting Spanish ambassador in an undignified position, happily playing piggy-back with his children. Queen Marie de Médicis is seated in the background.

Scenes like this showing the French monarchy in an attractive, human light were frequently painted in the Restoration period and the subject had earlier been treated by Révoil and by Ingres, whose version (Paris, Petit Palais) exhibited at the Salon of 1824 undoubtedly influenced Bonington's composition. By the time that Demidoff purchased the picture in 1837 the enthusiasm of artists and patrons for medieval and Renaissance subjects had begun to wane, though Bonington's influence on other painters remained strong and the large Anglo-French market for his pictures helped to inflate prices. At San Donato Demidoff hung the picture in the Modern French Gallery with, among other works, his scenes from the life of Christopher Columbus by Delacroix and Ingres' *Antiochus and Stratonice*.

It is notable that all but one of Demidoff's eight Boningtons were acquired in the same year, 1837, either, as in this instance,

from the Gendron collection or, in the case of his watercolours, at the sale of the Bordeaux wine merchant Lewis Brown. The purchases may therefore have been the product of only a passing enthusiasm on Demidoff's part, though like Lord Hertford he also bought pictures by artists who shared and were influenced by Bonington's gentle charm. For Lord Hertford, however, Bonington was a particular favourite: between 1843 and 1870 he bought forty one of his oils and watercolours.

REFERENCES: Whiteley, pp.12, 56; Noon, p.43, 68.

4 Richard Parkes Bonington (1802-28)
THE ANTIQUARY P672

Watercolour and bodycolour with gum varnish over the darker areas, on paper 20.7 x 16 laid down on paper
PROVENANCE: Lewis Brown sale, Paris, 17 April 1837 (1) bt. Anatole Demidoff, 1,140 fr.; his [San Donato] sale, Paris, 14 January 1863 (42, *L'Antiquaire*), bt. by the 4th Marquess of Hertford, 5,100 fr.

This picture was probably painted in about 1827 when Bonington was producing a large number of 'costume pieces' in watercolour and bodycolour. For the compilers of albums of prints and watercolours and the readers of historical novels such scenes had immense appeal. No specific literary reference is probably intended in this instance, though it was engraved by S. W. Reynolds in 1829 as *The Antiquary*, the title of one of Sir Walter Scott's novels. A late echo of Scott's enormous European fame and influence, which was at its height in the 1820s and 1830s, can be seen in the Scottish costumes and arms collected by Demidoff (see Nos.53-4). The 4th Marquess of Hertford, whose taste was much influenced by the Romanticism that had been an inspiring and controversial force in his youth, acquired several pictures with subjects derived from Scott.

Lewis Brown's collection of watercolours by Bonington was the finest ever assembled by one person. The auction of the major part in 1837 was remembered by Delacroix more than twenty years later. 'I don't think it possible to assemble ever again the likes of this splendid group ...', he wrote to the critic Théophile Thoré in 1861, 'enormous prices were paid for those works.'

REFERENCE: Noon, pp.12, 43, 65.

5 Richard Parkes Bonington (1802-28)
OLD MAN AND CHILD P698

Signed, bottom right: *R P Bonington 1827*
Watercolour and bodycolour with gum varnish over the darker areas, on paper 19.2 x 14.2 laid down on paper
PROVENANCE: Lewis Brown sale, Paris, 18 April 1837 (62), bt. Anatole Demidoff, 3,700 fr.; his [San Donato] sale, Paris, 14 January 1863 (43, *Le vieillard*), bt. by the 4th Marquess of Hertford, 9,100 fr.

Another 'costume piece', in which the sixteenth-century Venetian figure of the old man is similar to that in *The Antiquary* (No.4); the girl's dress also occurs in *Henri IV and the Spanish Ambassador* (No.3). Demidoff was to own a number of Venetian pictures, including works by (or attributed to) Titian, Veronese and Giorgione.

No specific literary allusion is probably intended, though an old man with his armour inevitably recalls Don Quixote. There are two other known versions of this sentimental scene contrasting childhood with old age - a testimony to the contemporary appeal of such pictures.

REFERENCE: Noon, p.260.

6 Richard Parkes Bonington (1802-28)
MILAN: INTERIOR OF S. AMBROGIO P714

Signed, bottom right: RPB 1827
Watercolour and bodycolour with gum varnish over the darker areas, on buff paper 22.1 x 28.6
PROVENANCE: [Possibly Bonington sale, Christie's, 30 June 1829 (207), bt. Hull, 11 gn., and Lewis Brown sale, Paris, 17 April 1837 (2), £29.10]; Anatole Demidoff, his [San Donato] sale, Paris, 14 January 1863 (38, *Intérieur d'une église*), bt. by the 4th Marquess of Hertford, 4,150 fr.

For eleven weeks between April and June 1826 Bonington made a tour of Northern Italy with his friend and patron Charles Rivet. They were in Milan between 11 and 14 April. Many of Bonington's sketches of Italian scenes (particularly those of Venice, the city which affected him most deeply) were to serve as preparatory material for later works. This watercolour was probably painted, using a sketch made on the spot, after his return to Paris. It may show the influence of Rembrandt and the shadowy monastic scenes and church interiors of François-Marius Granet (1775-1849), one of whose best-known pictures, *The Death of Poussin*, was to be owned by Demidoff.

REFERENCE: Noon, pp.72-3.

7 Richard Parkes Bonington (1802-28)
BOLOGNA: THE LEANING TOWERS P701

Pencil, watercolour and bodycolour with touches of gum varnish, on paper
23.4 x 16.9 laid down on paper
PROVENANCE: Lewis Brown sale, Paris, 12-13 March 1839 (64); Anatole
Demidoff; his [San Donato] sale, Paris, 14 January 1863 (37, *Une place à
Bologne*), bt. by the 4th Marquess of Hertford, 3,650 fr.

During their trip to
Italy in 1826 Bonington
and Rivet passed
through Bologna shortly
after 19 May on their
way from Venice to
Florence. Probably this
watercolour was
painted, using a pencil
sketch made on the
spot, soon after his
return to Paris.
Bonington's beautifully
delicate touch is
entirely personal but
the watercolour is a
characteristic example
of the views of familiar
tourist sites produced
by many artists in the
nineteenth century,
often with the intention
that they should later
form the basis of oil
paintings or prints.

8 Richard Parkes Bonington (1802-28)

SUNSET IN THE PAYS DE CAUX P708

Signed, bottom right: R P.B. 1828

Pencil, watercolour and bodycolour with gum varnish over the darker areas, on paper 19.8 x 26.3

PROVENANCE: Lewis Brown sale, Paris, 18 April 1837 (66), bt. Anatole Demidoff, 2,382 fr.; his [San Donato] sale, Paris, 14 January 1863 (40, *Plage à marée basse*), bt. by the 4th Marquess of Hertford, 8,780 fr.

Bonington, who moved with his parents from Nottingham to Calais in 1817, frequently depicted the Channel coast. This is one of his last watercolours, an unusually dramatic and intense inter-pretation of evening light, reminiscent of Turner, whom he greatly admired. It is perhaps based on a study made four years earlier on a sketching trip to the Pays de Caux (near Dieppe) with his fellow watercolourist Newton Fielding. Its exceptional qualities are reflected in the high price, particularly for a landscape, paid by Lord Hertford in 1863.

REFERENCE: Pointon, p.77.

9 David Roberts (1796-1864)
MAINZ: THE CATHEDRAL FROM THE SOUTH-WEST P689

Signed, bottom centre: *D. Roberts 1832*

Pencil, watercolour and bodycolour with varnish on the foreground figures, on paper 22.8 x 31 (sight)

PROVENANCE: Anatole Demidoff; his [San Donato] sale, Paris, 14 January 1863 (70), bt. by the 4th Marquess of Hertford, 2,420 fr.

Like Bonington, Turner and many other landscape artists of his time, Roberts was an inveterate traveller who produced drawings and watercolours for collectors and for use by publishers as the basis of reproductive prints. This watercolour is probably derived from a sketch made during his Rhineland tour in the summer of 1830. Roberts was particularly noted for his skill at describing architectural features and this is a characteristic example of his abilities as a delineator of Gothic forms animated with colourful foreground figures. The prints after his works gave him a wide European reputation. His lithographs of Spain were particularly admired (twelve hundred sets being sold in only two months after their publication in 1837) and they were probably known to Demidoff at the time of his visit to that country in 1847.

REFERENCE: Guiterman and Llewellyn, p.65 (Spanish Lithographs).

10 Jacques-Raymond Brascassat (1804-67)
DOGS ATTACKING A WOLF P721

Signed, bottom right: *J-R. Brascassat/1838.*

Watercolour and bodycolour with some gum varnish, on paper 42.2 x 55.5 laid down on paper

PROVENANCE: Anatole Demidoff; his [San Donato] sale, Paris, 14 January 1863 (44), bt. by the 4th Marquess of Hertford, 10,100 fr.

Brascassat began his career as a painter of classical landscapes, turning to animal subjects after his return to France in 1829 following a period of study in Italy. Later he was to become closely associated with the Barbizon school of landscape painters.

Painted and sculpted hunting scenes were a feature of San Donato (with, in particular, many fine bronzes by Barye). Yet the stark ferocity of this watercolour's subject is unusual in the collections of Demidoff and Lord Hertford, who both had a genuine fondness for animals.

11 Alexandre-Gabriel Decamps (1803-60)
AN ALGERIAN WOMAN *(UNE ODALISQUE)* P666

Watercolour and bodycolour with some gum varnish, on paper 44.6 x 36.3

PROVENANCE: Anatole Demidoff; his [San Donato] sale, Paris, 14 January 1863 (46, *Une odalisque*), bt. by the 4th Marquess of Hertford, 1,420 fr.

Decamps, who visited the Middle East and North Africa in 1828, was the leading specialist painter of Orientalist scenes and an artist much admired by Lord Hertford. Twenty eight of his oils and watercolours are now in the Wallace Collection. Decamps was also a favourite of Russian collectors. Demidoff bought at least nine watercolours by him and two oils, a scene of hunting dogs and *Samson battling against the Philistines* (private collection), a renowned picture in the nineteenth century, which he bought at the sale of the duc d'Orléans' collection in 1853. Demidoff's visit to Constantinople in 1837, eight years after Lord Hertford had stayed in the city, did not stimulate a comparable enthusiasm for Orientalist pictures. Probably painted c.1830-2, this watercolour exemplifies the exotic sensuality that is characteristic of many European paintings of Oriental scenes. Odalisques, Eastern slaves or concubines, were particularly popular with artists and their patrons.

12 Hippolyte (Paul) Delaroche (1797-1856)
THE DEATH OF THE DUC DE GUISE P738

Signed, bottom left: *P. Delaroche 1832*

Watercolour and bodycolour with some gum varnish, on paper 14.3 x 24.8

PROVENANCE: Anatole Demidoff; his [San Donato] sale, Paris, 14 January 1863 (56), bt. by the 4th Marquess of Hertford, 6,200 fr.

At the 1834 Paris Salon Delaroche's *Execution of Lady Jane Grey* (fig.6), owned by Demidoff, had been a popular sensation. The following year Delaroche repeated his success with another, although much smaller, scene from sixteenth-century European history, *The Death of the duc de Guise* (Chantilly, Musée Condé). The picture had been commissioned by Ferdinand-Philippe, duc d'Orléans, soon to be the owner of Scheffer's *Francesca de Rimini* (No.1), and for whom Ingres' *Antiochus and Stratonice* was painted as a pendant to Delaroche's painting. All three pictures were included in the Orléans sale in 1853 when *The Death of the duc de Guise* was bought by the duc d'Aumale, Orléans' younger brother.

This is a watercolour version of Delaroche's 1835 Salon picture, very similar in composition but with variations in the costumes and furnishings. The duc de Guise, leader of a Catholic faction against Henri III of France and a rival for his throne, lies murdered by followers of the king after being lured to the king's bedroom in the château de Blois. Henri III is seen nervously entering the bedroom to be shown the corpse. The murder took place on 23 December 1588.

Demidoff was on very friendly terms with Delaroche in the 1830s and had a special fondness for the artist's small scale versions of his popular pictures, particularly those with English historical subjects. Watercolours of *Charles I insulted by the Soldiers of Cromwell* and *The Last Farewell of Charles I* were in the 1863 San Donato sale; and he owned a watercolour and a small oil of his own *Execution of Lady Jane Grey* as well as oil versions of *Cromwell* and *Lord Strafford* (1870 sale). He also commissioned a historical portrait of Peter the Great (Hamburg, Kunsthalle, dated 1838).

Delaroche's combination of Romantic subject matter with careful finish was entirely to the taste of the 4th Marquess of Hertford. He owned several watercolours and at least ten oil paintings (including one of his rare commissions, *The Virgin and Child* (P286), ordered from Delaroche in 1844).

13 Eugène-Louis Lami (1800-90)

LONDON: THE STATE OPENING OF PARLIAMENT P710

Signed, bottom right: *Eug. Lami 1855*.

Pencil and watercolour on paper 14.4 x 31.4

PROVENANCE: Anatole Demidoff; his (San Donato) sale, Paris, 8-10 March 1870 (277, *Le Cortège de la Reine Victoria passant dans Saint-James-Park et se rendant à Westminster*), bt. by the 4th Marquess of Hertford, 4,900 fr.

Lami was a fellow pupil of Bonington and Delaroche (with whom he remained on close terms) in the studio of the history painter Gros. He produced many oil paintings, including battle scenes for Versailles, but he became better known as a lithographer and watercolourist of aristocratic society. Appointed an official painter to King Louis-Philippe, he remained close to the Orléans family even after their exile in 1848. He also acted as artistic adviser to the duc d'Aumale, younger son of Louis-Philippe, at Chantilly in 1845-8 and to baron James de Rothschild at Ferrières from 1856.

For Demidoff, whom he met in 1834 (see fig.8), he made three sets of watercolours: *L'histoire de mon temps*, c.1835-40, sixty-one watercolours (1875 San Donato sale); *L'Exposition Universelle à Londres*, 1851, nine watercolours and *Trois années à Londres*, 1849-55, forty-two watercolours (both sets in the 1870 San Donato sale).

This watercolour is from the series, *Trois années à Londres*, a commission given during Lami's stay in England in 1848-52. Demidoff visited London several times, on one occasion probably to see the Great Exhibition in 1851. Co-incidentally it was in this period that the 4th Marquess of Hertford was obliged to make one of his few extended stays in London after being dislodged from Paris by the 1848 Revolution. Although the city was by no means free of political disturbances, it must have seemed a remarkably tranquil contrast to Paris and, in accordance with the conservatism of his patron, Lami appears to be celebrating the solidity of British institutions in watercolours like this.

14 Eugène-Louis Lami (1800-90)
A MILITARY REVIEW AT WOOLWICH P723

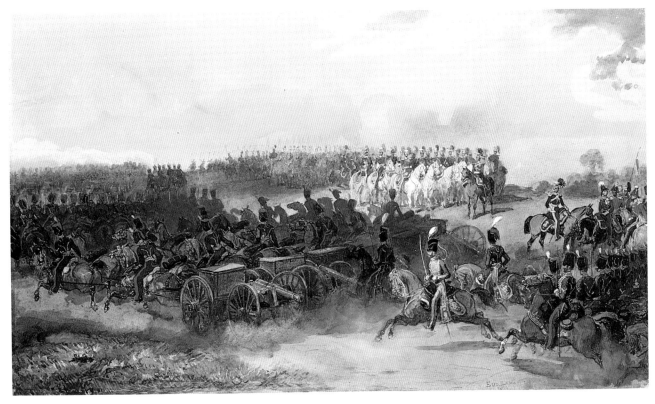

Signed, bottom right: EUG.LAMI./1852

Pencil, watercolour and bodycolour, with touches of gum varnish, on paper 28.8 x 49

PROVENANCE: Anatole Demidoff; his (San Donato) sale, Paris, 8-10 March 1870 (296), bt. by the 4th Marquess of Hertford, 5,100 fr.

Demidoff had a special fondness for military uniforms, as shown by the examples in his own collection and the innumerable drawings with military themes provided for him by Raffet. Lord Hertford in his youth had held an army commission which may explain the particular attraction for him of this watercolour from the series *Trois années à Londres*. In all Lord Hertford acquired twelve watercolours by Lami, including several idealized scenes of life in seventeenth and eighteenth-century France which accorded well with his taste for furnishings from the same era. Lami had also been a favourite of the duchesse de Berry at whose sale in 1837 Demidoff bought thirteen Dutch and Flemish pictures collected by her late husband. For her Lami produced a souvenir album of hand-coloured lithographs recording a ball she had given in 1829 with the theme of the visit of Mary, Queen of Scots to the French court. A considerable collector of modern paintings in her own right, her taste was similar to Demidoff's, with a marked preference for historic genre scenes and views of places she had visited on her travels.

REFERENCES: Scott; Pointon, p.64 (duchesse de Berry).

SEVENTEENTH-CENTURY DUTCH AND FLEMISH PAINTINGS

Russian collecting of seventeenth-century Dutch and Flemish paintings in large numbers began with Peter the Great (1672-1725). His enthusiasm was fully shared by his successors; indeed Catherine II (1729-96) was indisputably the greatest collector of the eighteenth century, buying hundreds of Dutch and Flemish pictures from some of the finest collections of Western Europe. Both monarchs were determined to integrate Russia into the mainstream of European culture and the collecting of paintings was an important part of this policy. In emulation of Catherine's example, aristocratic families such as the Orloffs, the Youssoupoffs and the Stroganoffs also built up significant collections, though on a much smaller scale.

As with contemporary Salon paintings, Demidoff made his mark as a collector of Dutch and Flemish pictures when still a very young man. In 1837 he bought thirteen at the sale of the duchesse de Berry (using his secretary Octave Jaunez as his agent), including major works by Cuyp (No.17), Hobbema, Metsu, Potter and Teniers. Most significantly, he also acquired ter Borch's *The Swearing of the Oath of Ratification of the Treaty of Münster* (fig.12), which records the ceremony in 1648 at which Dutch independence from Spain was finally recognized. With its combination of historical reportage and the meticulous depiction of seventy-seven persons on a copper panel less than two feet wide, this was for the nineteenth century one of the greatest of all Dutch paintings. At 45,500 francs it was by far the most expensive picture in the Berry sale.

Also in 1837 he purchased a biblical subject by Jan Steen, *Moses striking the Rock* (Philadelphia, Museum of Art), from C.J. Nieuwenhuys of Brussels, one of the leading dealers in Europe. Thereafter, however, he bought Dutch and Flemish paintings only in a piecemeal manner. From the 1863 and 1868 San Donato sale catalogues we learn that he acquired at least seven more pictures from Nieuwenhuys, including a Berchem (No.16), a Hobbema (No.18) and a still life by Jan Weenix (No.21) and six more pictures at the sale of Baron Nagell van Ampsen in the Hague in 1851 (including No.19). But he seems never again to have bought Dutch and Flemish paintings with the determination he had shown in 1837, when perhaps the prestige of the Berry collection inspired him to unwonted enthusiasm. In 1863 he included sixteen Dutch and Flemish pictures in a group of works of art sent from San Donato for auction in Paris and five years later these were followed by nearly all the rest, the cream of his collection, sold together in one sale of twenty-three lots.

At the 1863 sale the 4th Marquess of Hertford bought four Dutch and Flemish pictures at moderate prices (Nos.15, 19-21) but in 1868, with much finer pictures on offer, he made five major purchases. He bought works by Berchem (No.16), Cuyp (No.17) and Hobbema (No.18), an Isack van Ostade (*Travellers outside an Inn,* now in The Hague, Mauritshuis) and ter Borch's *The Swearing of the Oath of Ratification of the Treaty of Münster* which again was the most expensive picture in the sale. Indeed at 182,000 francs it was the most expensive work of art ever bought by Lord Hertford. It is not in the present exhibition because in 1871 Sir Richard Wallace presented the picture to the underbidders, the National Gallery in London. The success of the sale in 1868 ('one of the most extraordinary sales in the annals of Fine Art ... remarkable by character, and for the large prices realised' proclaimed the *Art Journal* (see also fig.17)) may have encouraged Demidoff's later decision to auction much more of his collection two years later. By then, however, there was only a

handful of minor Dutch and Flemish works left.

It is interesting to contrast the Dutch and Flemish pictures collected by Anatole and his father Nicolas. To judge from the 1839 sale - and it is necessary to be cautious in using it as a guide to Nicolas' taste (see Appendix II) - it appears that he bought his pictures principally to furnish his rooms economically. The sale was broad enough to include landscapes attributed to artists who would be collected by his son such as Cuyp, Hobbema and Aert van der Neer (although suspiciously they failed to sell or were bought very cheaply), but it also included works by artists such as Brouwer and Pieter van Laer whose robust scenes of everyday life never appealed to Anatole. (In this respect there are interesting similarities between Nicolas Demidoff and Lord Hertford's father, the 3rd Marquess (1777-1842), who was also a notable collector of Dutch and Flemish pictures, sometimes - as in the case of Jan Steen's *The Village Alchemist* (P209) - of a more disquieting nature than would have been acceptable to his son). The 1839 sale also included pictures by little known artists such as the landscapists Decker and Rombouts or the genre painters Bega and Slingelandt, whereas Anatole preferred grander names (and also, it is fair to say, better paintings).

Anatole's Dutch paintings were broadly of the kind most admired in the late eighteenth century: attractive cabinet pictures, particularly landscapes and domestic interiors. (In origin this was a French taste but it was also fashionable in Germany, Russia and England). Cuyp and Hobbema were his preferred artists for landscapes; Metsu, ter Borch and Frans van Mieris for genre scenes. He also owned at least three pictures by David Teniers (see No.20) who had been highly esteemed in the eighteenth century. Although Rembrandt and Rubens did not fit easily into this essentially decorative taste, their acknowledged genius made their pictures collectable and Demidoff bought several works attributed to them, although only one can now be certainly identified, Rubens' *Entombment of Christ* (Malibu, J. Paul Getty Museum), which was in the 1868 San Donato sale. Van Dyck, however, seems to have had no appeal for him, either as a history painter or as a portraitist.

At San Donato most of the Dutch and Flemish pictures were displayed together in a gallery (described by Charles Eastlake in 1862 as 'full of treasures') which was top-lit and decorated in an appropriately unpretentious manner, though the presence of a bust of Queen Victoria by Gibson and eighteen bronzes by T.-J.-N. Jacques of Russian figures in regional costume added a characteristically eccentric touch. The paintings presumably all had the rich gilt frames currently to be seen on Nos.15-19 and No.21. A guide to the pictures in the gallery in which each work was described in laudatory terms was published in 1850.

The expressed preference of the 4th Marquess for 'pleasing pictures' would have made almost all Demidoff's Dutch and Flemish paintings acceptable to him, though he would probably have drawn the line at such a profoundly tragic subject as Rubens' *Entombment*. That he was a conspicuous purchaser at the 1863 and 1868 sales is therefore hardly surprising. But his collection was far larger than Demidoff's and his taste was broad enough to embrace works of a kind little represented (if at all) in the Russian's collection, such as large gallery pictures, still lifes and townscapes. He could even, on at least one occasion, anticipate changes in taste, as he did in 1865 when he bought *The Laughing Cavalier* for a considerable sum, an early and important step in the rise of Hals' reputation to its present eminence.

Essentially, however, Lord Hertford's collection of Dutch paintings was characteristic of its time. Representative of the next generation were the pictures acquired by Anatole's nephew, Paul Demidoff, though he seems to have been a collector who was quite as fond of selling as of buying. With his landscapes by van Goyen, Koninck and Salomon van Ruysdael as well as his three portraits by Hals and, remarkably, three works by Vermeer, the rarest of the great Dutch masters, his pictures are an almost comprehensive expression of 'advanced' taste in Dutch paintings from the mid-1860s to his death in 1885.

REFERENCES: Dijon 1993 (Russian collectors); marked copy of 1837 duchesse de Berry sale catalogue in National Gallery; *Art Journal* 1868, p.119; Eastlake notebooks in National Gallery archives.

15 Ludolf Bakhuizen (1630-1708)

SHIPS IN A STORM P248

Signed, on the ensign of the boat in the left foreground: LB...

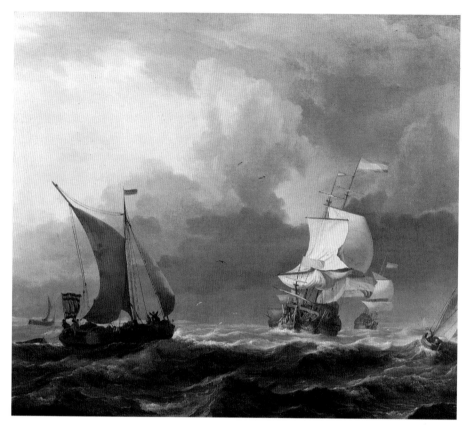

Oil on canvas, relined 51.5 x 61.1 (The stretcher bears the Demidoff ink label: *Tableaux/346*; for the frame see No.18)

PROVENANCE: The 'comte d'Aussone' until 1851 (according to the Demidoff sale catalogue); Anatole Demidoff; his [San Donato] sale, Paris, 13 January 1863 (15), bt. by the 4th Marquess of Hertford, 9,100 fr.

Bakhuizen was the leading marine painter in Amsterdam after the departure of the van de Veldes for England in 1672/3. Peter the Great was one of his patrons.

Demidoff bought few Dutch and Flemish marines. Besides this picture, there was only one other (by Cuyp) in the 1863 San Donato sale and one (by Willem van de Velde the younger) in the 1868 sale. The 4th Marquess of Hertford, on the other hand, acquired seven paintings by Willem van de Velde the younger, an artist who (partly for historic reasons) was particularly popular with English collectors, though this was his only Bakhuizen.

16 Nicolaes Berchem (1620-83)

A SOUTHERN HARBOUR SCENE (*L'ANCIEN PORT DE GÊNES*) P25

Oil on canvas, relined 82.9 x 103.7 (The stretcher bears the Demidoff seal, for which, and for the frame, see No.18)
PROVENANCE: Miotte de Ravanne by 1767; Servat sale, Amsterdam, 25 June ff. 1778, bt. Fouquet [or Foucquet]; the comte de Merle sale, Paris, 1 March ff. 1784, bt. Sausay (?); anon. sale, Christie's, 30 April 1785; Lespinasse de Langeac; his [anon.] sale, Paris, 18 January 1809; Charles-Ferdinand, duc de Berry; his duchesse; her sale, Paris, 5 April 1837 (15), bt. Naudet, 13,200 fr. for the comte de Magnoncourt; Nieuwenhuys; Anatole Demidoff; his (San Donato) sale, Paris, 18 April 1868 (11, *L'ancien port de Gênes*), bt. Durlacher, 42,000 fr.; the 4th Marquess of Hertford.
Probably painted in the late 1650s, this is one of the finest of several exotic harbour scenes by Berchem. Although the setting is vaguely Mediterranean, the improbable suggestion that the port of Genoa is depicted is due to Jacques

Aliamet who engraved the picture under this title in 1766.

Berchem was one of the Dutch 'Italianate' landscapists whose pictures were much admired in the eighteenth century. Later their place was gradually supplanted by the less idealized paintings of artists like Hobbema and Ruisdael who preferred to depict their native land and Northern Europe. Surprisingly, Demidoff seems to have had little interest in the Dutch Italianate artists and owned no other example of Berchem's work.

The distinguished collection of Dutch and Flemish pictures assembled by the duc de Berry (the younger son of King Charles X) - which included both this picture and Cuyp's *Avenue at Meerdervoort* (No.17) - was dispersed at auction by his

widow in 1837. The pictures were very familiar to connoisseurs, having been formerly on display at the Elysée Palace where they could be visited by apxent. A well-established provenance was important to collectors when considering a picture for purchase, because it would enhance the standing of their own collections and because it was regarded to a limited degree as a guarantee against forgery. Both Demidoff and Lord Hertford, however, appear to have been particularly attracted by pictures from prestigious aristocratic collections of their own time. It is tempting to see this partly in terms of social one-upmanship.

REFERENCE: Scott.

17 Aelbert Cuyp (1620-91)

THE AVENUE AT MEERDERVOORT P51

Signed, bottom right: *A.cuyp.*

Oil on canvas, relined 69.8 x 99 (The old stretcher bore the Demidoff seal, for which, and for the frame, see No.18)

PROVENANCE: [Possibly P. de Smeth van Alphen, Amsterdam, 1800]; de Serreville sale, Paris, ff. 22 January 1812 ; Charles-Ferdinand, duc de Berry; his duchesse; her sale, Paris, 6 April 1837 (46), bt. Octave Jaunez, '*Intendant du Prince Demidoff*', 18,000 fr.; Anatole Demidoff; his (San Donato) sale, Paris, 18 April 1868 (2, *L'Avenue de Dordrecht*), bt. Mannheim, 140,000 fr.; the 4th Marquess of Hertford.

Cuyp was a native of Dordrecht whose later pictures were influenced by the Italianate views of the Utrecht landscapists, particularly Jan Both. He seems rarely to have left Dordrecht which appears in many of his paintings. Here it can be seen on the right, viewed from the south across the river Maas.

The picture may have been commissioned by Cornelis van Beveren (1591-1663), the two boys in the distance being Michiel (1638-53) and Cornelis Pompe van Meerdervoort (1639-80), van Beveren's eldest grandchildren. Their father Pompe van Meerdervoort lived in the Huis te Meerdervoort seen on the left.

Although in the twentieth century this picture has generally been regarded as among Cuyp's less successful works

(and was even attributed by the historian and connoisseur Hofstede de Groot to his imitator, Abraham van Calraet (1642-1722)), in the nineteenth century its reputation was much higher. Nevertheless, the sum paid for the picture by Lord Hertford in 1868 was astonishing: at 140,000 francs it was perhaps the most expensive landscape sold at auction up to that time. Such a high price reflects in part both the prestige of the picture's provenance and the appeal of its subject matter, an idyllic vision of a patrician family at home on its estate.

18 Meindert Hobbema (1638-1709)

A RUIN ON THE BANK OF A RIVER P60

Signed: *m.Hobbema/1667/[f]*

Oil on oak panel 60.3 x 84.4 x 0.8 (The panel bears, *verso*, the Demidoff seal: a nine-petalled flower surrounded by eight radial bars, each made up of four parallel lines and separated by what seems to be a leaf; also the Demidoff ink label *Tableaux //2/4*. The (Demidoff) frame, and those of Nos.15-17, 19 and 21, is of pinewood, with carved and gilt limewood friezes of S-scrolls divided alternately by diapered panels with oak leaves and pierced panels with foliate scrolls; at each corner a shield. There is scumbling under the scroll-work and (in the case of Nos.16-18) on the projections).

PROVENANCE: J. B. van den Bergh, Amsterdam; his sale, Amsterdam, ff. 15 July 1833; bt. Engelberts, 4,200 fl.; with de Roothan; with Nieuwenhuys, Brussels from whom bt. in 1840 by Anatole Demidoff; his (San Donato) sale, Paris, 18 April 1868 (5, Site aux environs de Haarlem), bt. Petit, 98,000 fr.; the 4th Marquess of Hertford.

Hobbema, baptized in Amsterdam, was a pupil of Jacob van Ruisdael. He specialized in wooded landscapes and river bank scenes, his most characteristic work being produced between c.1662 and 1668. In the latter year he married and found employment as a wine gauger after which his painting activities substantially decreased.

Although described in the 1868 sale catalogue as near Haarlem with the ruins of the castle of Brederode on the left,

the site shown in this picture cannot be identified. Hobbema was a great favourite with English collectors in the nineteenth century and Lord Hertford acquired four of his pictures, all of splendid quality. Demidoff owned a second painting by Hobbema (*A Forest Scene*), also sold in the 1868 sale.

19 Aert (Arnout) Van der Neer (1603/4-77), after
SCENE ON A CANAL P184

Oil on oak panel 14.2 x 24.4 x 0.9 (The panel bears, *verso*, the Demidoff ink label: *Tableaux/355*; for the frame see No.18)
PROVENANCE: Stevens sale, Antwerp, 9 August 1837 (111), bt. Gruyter, 280 fl.; A.W.C. Baron van Nagell van Ampsen sale, The Hague, 5 September 1851 (42), bt. Roos, 455 fl.; Anatole Demidoff; his [San Donato] sale, Paris, 13 January 1863 (23, *Clair de lune*), bt. by the 4th Marquess of Hertford, 3,020 fr.

Van der Neer's first dated work is from 1632, but his finest landscapes date from c.1645-60 when he exploited with great subtlety the luminous effects of sunset, fire and winter skies. This, however, is a weakly executed picture, probably painted after van der Neer's death by an imitator. The composition relates closely to that of a lost painting by van der Neer engraved in 1763. Demidoff had few 'mistakes' of this kind in his collection and the 4th Marquess of Hertford usually had a very sure eye for quality in Dutch paintings.

20 David Teniers the younger (1610-90)
THE WOMAN TAKEN IN ADULTERY *(AFTER TITIAN)* P637

Oil on oak panel 16.9 x 22.5 x 0.5 (The panel bears, *verso*, the Demidoff ink label: *Tableaux/268*)
PROVENANCE: Joseph Bonaparte, King of Spain, 1808-13, and later comte de Survilliers; Anatole Demidoff; his [San Donato] sale, Paris, 13 January 1863 (22, as Teniers after Giorgione), bt. by the 4th Marquess of Hertford, 4,000 fr.

One of a series of small copies made by Teniers of the Italian pictures in the collection of the Archduke Leopold Wilhelm, Governor of the Spanish Netherlands, 1646-56. Two hundred and forty-three, including this one copied from an unfinished picture by Titian (Vienna, Kunsthistorisches Museum), were engraved and published in Antwerp in 1660.

Joseph Bonaparte, the first known owner of the picture, was one of the uncles of Princess Mathilde, Demidoff's wife, and the picture may have passed to Anatole as part of the complex financial arrangements that attended and followed his marriage. No other example of Teniers' copies is known to have been owned by Demidoff. He did, however, acquire a *Temptation of St Anthony* and also *Le Déjeuner de jambon*, one of Teniers' genre scenes which were greatly admired in the eighteenth and nineteenth centuries.

21 Jan Weenix (1642-1719)
DEAD GAME P91

Signed: *J. Weenix. f/ 169*[*1* or *6*]

Oil on canvas, relined, 89.8 x 101.5 (The stretcher bears the Demidoff ink label: *Tableaux/ 191;* for the frame see No.18)

PROVENANCE: [Probably Gerrit Muller sale, Amsterdam, 2-3 April 1827 (78), bt. Brondgeest, 1,190 fl.]; Nieuwenhuys, Brussels; Anatole Demidoff; his [San Donato] sale, Paris, 13 January 1863 (29), 17,500 fr.; the 4th Marquess of Hertford.

Jan Weenix's game pieces and still lifes were greatly admired at the German courts of the early eighteenth century and between 1702 and 1714 he worked for the Elector Palatine and Count Schönborn, producing many pictures of this kind, particularly to decorate country houses. Later in the century they were enthusiastically collected in France, England and Russia.

The animals shown here include hare, partridge, swallow and a diving goldfinch; an iceland poppy hangs over the urn which is decorated with a scene of antique sacrifice; two falconhoods are in the centre of the picture.

This is the only Dutch still life known to have been acquired by Anatole Demidoff. Lord Hertford, however, bought many game pieces and still lifes, though the fact that he once referred to two such works by Desportes as 'a little rubbish for the country ... perfect for my shooting place' indicates the slight importance that he attached to them. There are thirteen works by Weenix now in the Wallace Collection.

EIGHTEENTH-CENTURY FRENCH PAINTINGS

French painting was well known and highly esteemed at the Russian court and in Russian aristocratic society in the eighteenth century. Particularly sought after were the pictures of Greuze, Claude-Joseph Vernet and Hubert Robert, but a wide range of contemporary French painting was represented in Russian collections. The Academy of Fine Arts in St Petersburg was modelled on its older counterpart in Paris and there was a steady stream of French painters who visited Russia, including Perroneau, Le Prince, Tocqué (who painted two portraits of Demidoff's grandfather Nikita, one of which is now in the Pushkin Museum, Moscow) and Vigée Le Brun (who painted a portrait of Demidoff's mother). Only the more austere forms of Neo-classical painting were little appreciated in Russia, partly for political reasons, as the style came to be identified with the French Revolution and republican politics.

With the assistance of Diderot, Nikita Demidoff acquired works of art in Paris for Catherine II. His son Nicolas, who also lived in Paris and later bought San Donato, owned numerous pictures by Greuze (twenty two in the 1870 and 1880 San Donato sales were said to have been from his collection) and there were many other eighteenth-century French paintings in his posthumous sale in 1839, including five Bouchers, five Lancrets and no less than nineteen Dutch-inspired genre scenes by Demarne. His taste seems to have been marked by a distinct preference for decorative pictures but once he had also owned a sketch for David's *Andromache mourning Hector* (Pushkin Museum). In Russia his collection was perhaps only matched by that of Prince Nicolas Youssoupoff (1750-1831) who also owned pictures by Boucher and Greuze and who used his visits to France to buy or commission paintings (often with similarly erotic themes) from, among others, David, Guérin, Boilly and Gros.

Even after the 1839 sale, many of the eighteenth-century French pictures in Anatole's collection can be identified as having been inherited from his father. All but two of the nineteen paintings by Greuze sold in 1870 were described in the catalogue as previously owned by Nicolas, as were two marines by C.-J. Vernet and Fragonard's *Fountain of Love* (No.22). Without these pictures, Anatole's collection would have lacked much of its substance; the other pictures in the 1870 sale were eleven mythological and allegorical scenes by Boucher, four decorative mythologies by Schall and two landscapes by Hubert Robert. In the 1863 sale there had been only three paintings by Greuze, Pater (No.23) and C.-J. Vernet, with no indication in the catalogue as to how they had been acquired. Demidoff's collection was therefore a very narrow one: confined to only seven artists, it comprised, with the exception of some of Greuze's pictures, eighteenth-century French painting at its most urbane and decorative. At San Donato the pictures were complemented by furniture and porcelain of the same era. Those by Boucher (which in reality were mostly studio works) and by Greuze were displayed in rooms named after the artists.

The 4th Marquess of Hertford's paintings of this kind were quite compatible with those of the Demidoffs, though both in number and quality his collection was far superior. Its character was similarly marked by a preference for those artists such as Boucher and Lancret whose pictures had fallen out of favour during the Revolution but rose rapidly in reputation and price in the period 1840-70 when they became fashionable with

collectors who were attracted, like Lord Hertford himself, by the luxury and refinement of the *ancien régime*. Both collections were also marked by an unbounded enthusiasm for the works of Greuze, particularly his languid and sentimental studies of heads (*têtes d'expressions*) but also his subject pictures, exemplified by *Les Oeufs cassés* (New York, Metropolitan Museum), which was bought by Lord Hertford at the 1870 sale for the huge sum of 126,000 francs but sold by Sir Richard Wallace to Lord Dudley in 1875.

The sale of Paul Demidoff's possessions at San Donato in 1880 included thirty eighteenth-century French pictures, at least five of which (by Greuze, identified in the catalogue as from the collection of Nicolas) had probably been owned by Anatole. Familiar names like Boucher and Fragonard were again represented, but the sale also included several fine portraits by, among others, Nattier, F.-H. Drouais and Maurice Quentin de la Tour as well as a mythology by N.-N. Coypel, *The Birth of Venus*. Probably they had all been bought by Paul himself.

REFERENCES: Nemilova; Paris 1986-7, p.173 (portrait of N. Demidoff); Vigée Le Brun, II, p.370; London 1988.

22 Jean-Honoré Fragonard (1732-1806)

THE FOUNTAIN OF LOVE P394

Oil on canvas, relined 63.5 x 50.7

Signed, bottom right: *fragonard.*

PROVENANCE: C.-N. Duclos-Dufresnoy, notaire; his sale, Paris, 20 August 1795; Villeminot, *payeur générale de la marine*; his sale, Paris, 25 May 1807; Nicolas Demidoff; Anatole Demidoff; his (San Donato) sale, Paris, 26 February 1870 (106), bt. by the 4th Marquess of Hertford, 31,500 fr.

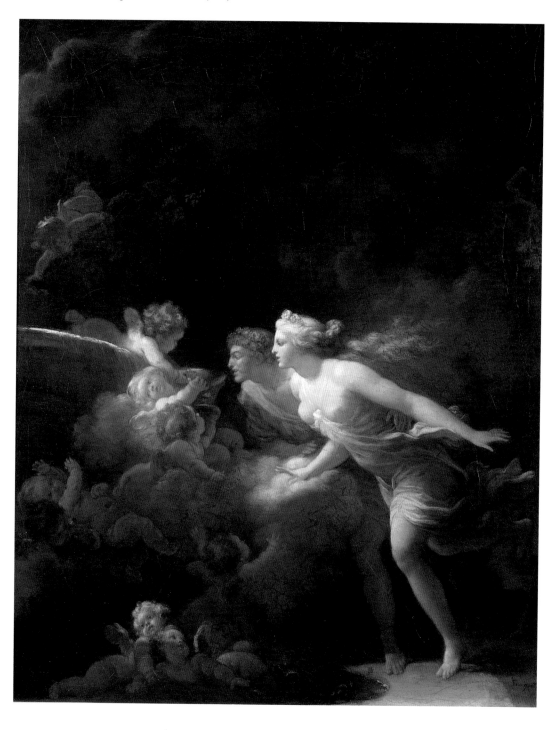

From the late 1760s Fragonard turned to painting genre scenes, landscapes and portraits after a brilliant career as a history painter. This is a late work, probably dating from c.1784, and is characteristic of the new style that he adopted at this time. Most of his earlier pictures showed the influence of his master Boucher's painterly touch but the profile heads and the firm, sculptural figures in this work reveal the fashionable influence of Neo-classicism.

Love is frequently the subject of Fragonard's pictures. Here he shows two lovers drawn to a fountain, the source of love, where their thirst will be quenched by the waters offered by the cupids.

The picture was engraved in 1785 and soon became one of Fragonard's best-known works. Demidoff's affection for it is demonstrated by an extraordinary clock which stood on a chimneypiece in the Malachite Saloon at San Donato. Its case had silver and gilt-bronze mounts with figures based on those in the painting (see also p.64).

Although Anatole kept *The Fountain of Love* from his father's collection (and it is the only work of art now in the Wallace Collection that is known to have been inherited by him from Nicolas), the 1839 sale included four works by Fragonard (including *Girl making her Dog dance on her Bed*, Munich, Alte Pinakothek). The 4th Marquess of Hertford acquired six of Fragonard's pictures (one as a Boucher), including his most famous work, *The Swing* (P430).

REFERENCE: 1880 San Donato sale, lot 77 (clock).

23 Jean-Baptiste Pater (1695-1736)
FÊTE GALANTE P460

Oil on canvas, relined 53 x 64.2 (The stretcher bears the Demidoff ink label: *Tableaux/90*)
PROVENANCE: [Possibly Gévigney sale, Paris, 1 December 1779]; Anatole Demidoff; his [San Donato] sale, Paris, 13 January 1863 (10, *Les loisirs champêtres*), bt. by the 4th Marquess of Hertford, 17,800 fr.

As with nearly all Pater's paintings, this *Fête galante* (literally 'courtship party', in which elegantly dressed figures disport themselves amorously in a parkland setting) depends for its subject and style on the works of his far more talented teacher Watteau. Pater's pictures were avidly collected in the mid-eighteenth century (Frederick the Great owned forty one) but after the French Revolution his reputation declined with that of other artists associated with the *ancien régime*. At the height of the nineteenth-century revival his pictures were as expensive as those of Watteau, partly because they are often better preserved. Yet he was seldom considered to be his teacher's equal. When Lord Hertford bought this work both the price and the artist were ridiculed. 'What! 17,000 francs for such a picture!', wrote Philippe Burty in *La*

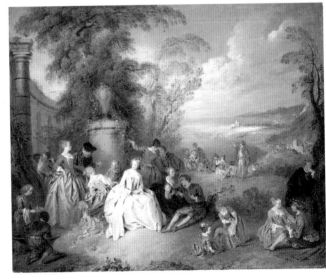

Chronique des Arts, 'this is to mistake a piece of shining glass for a star! ... Just as Watteau is a poet and an artist ... Pater is false and ignorant, bloated and empty'. Pater, however, was a great favourite of many rich collectors of the Second Empire and Lord Hertford bought at least fourteen of his pictures. Anatole Demidoff was less enthusiastic: two Paters were included in the 1839 sale of paintings which had mostly been inherited from his father and the picture exhibited here was the only one by Pater in the San Donato sales.

REFERENCE: *La Chronique des Arts*, 18 January 1863, pp.82-3.

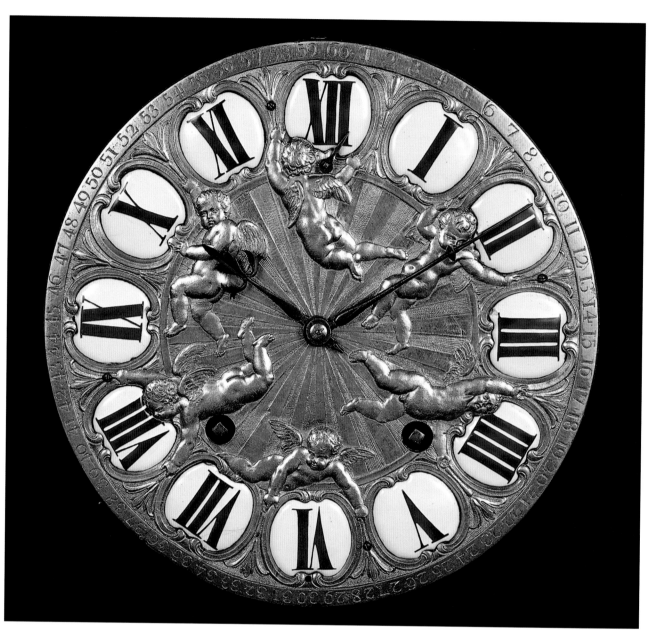

NO.26 DETAIL OF CLOCK DIAL

FURNITURE

By 1860, the countless rooms at San Donato had been filled with a vast quantity of furniture assembled by Anatole Demidoff over the previous twenty-five years. The most important part was the French furniture of the *ancien régime* and Empire periods, the taste for which was shared by several other very wealthy Russians of his own and preceding generations. Interest in French furniture among Russian collectors had begun with Peter the Great in the early eighteenth century, spread to the aristocracy under his successor Empress Elizabeth, and reached a peak in the 1780s and 1790s during the reigns of Catherine II (1762-96) and Paul I (1796-1801). Catherine herself preferred German and English furniture, but prominent aristocrats such as Count Stroganoff ordered items for their palaces from Paris. Grand Duke Paul Petrovich (later Paul I) actually visited the city in 1782, and sent back cartloads of acquisitions for his palace at Pavlovsk. Even more important were the many Neo-classical pieces bought by him c.1800 for Michailovsky Castle, from such makers as P.-P. Thomire (1751-1843) and Adam Weisweiler (1744-1820). The latter were supplied by the *marchand-mercier* Daguerre, who also sold numerous items to Prince Alexander Bezborodko (1742-99), Grand Chancellor of the Empire under Catherine II. During the nineteenth century, while patronage of contemporary French makers declined as the quality of Russian products improved, cosmopolitan aristocrats continued to acquire furniture of the *ancien régime*. Although much more a feature of the late nineteenth century, there had been earlier collectors of importance, a fact which did not escape Lord Hertford. In February 1866 he advised the dealer Frederick Davis, who was visiting St Petersburg, that, 'Count Koucheleff Bezborodko - Prince Youssoupoff - Countess Koucheleff - Prince Sauwaroff - Princess Kolchaubey - have, I know, very fine things'; Davis then sent back sketches and photographs of the most interesting pieces, which inspired Richard Wallace himself to visit St Petersburg, on his father's behalf, in the autumn of 1867. Several pieces ultimately were acquired, including a pair of cabinets (F388-9) probably from the Koucheleff-Bezborodko collection, and the green *vernis* writing-table, *cartonnier* and inkstand by Dubois (F330, F178 and F287), which had once belonged to Prince Alexander Kourakin (1752-1818), Ambassador to the French Imperial Court.

The first identifiable collector among the Demidoffs was Anatole's father, Nicolas. His taste for the contemporary Empire style gave the furnishings at San Donato their most distinctive character - particularly in the Malachite Saloon. Since the days of Nikita, the Demidoffs had been fascinated with the decorative potential of minerals, and their extensive mining interests in the Urals, developed by Nicolas in the 1800s, enabled them to order many lavish pieces using precious or semi-precious stones from their lands. Nicolas especially enjoyed the combination of malachite, *the* favoured stone of the Empire period and the most Russian of minerals, with superb gilt-bronze mounts by Thomire. It was not a taste shared by every vistor to Nicolas' Palazzo Serristori in Florence; the Countess Anna Potocka, who went there in the 1820s, recalled: 'those numerous over-rich pieces of malachite weighed down with ornamentation created an effect that was little pleasing to the eye. It was the palace of Pluto; the gold shone everywhere, the gold was the only valuable part of it ...'

The pieces were certainly of extraordinary proportions. In 1806, Nicolas ordered (at vast expense) a splendid three-metre high *guéridon*-table, with mounts by the Parisian goldsmith Henri Auguste (1759-1816) of dancing nymphs surmounted by a figure of Zephyr, and supported by four matt-bronze chimeras on a Russian grey granite base. It passed to Anatole and was ultimately sold in 1880 (Florence, Museo Stibbert). In 1819, he

commissioned a huge malachite vase - over three metres tall with pedestal - with exquisite mounts by Thomire, which again was sold in 1880 (New York, Metropolitan Museum of Art). Also in 1819, Nicolas ordered from Paris a two-metre long malachite console table, elaborately mounted by Thomire with each leg in the form of Nike, which he gave at once to Grand Duke Leopoldo II of Florence (Florence, Pitti Palace). But the most remarkable work by Thomire, with the assistance of the Roman stonecutter Francesco Sibilio, was surely the nine-metre high temple conceived and commissioned by Nicolas in the last months of his life (but only completed after his death). In its final form, it consisted of eight malachite columns supporting a cupola of gilt-bronze, enriched with malachite and lapis lazuli, and crowned by a trophy of the Arms of Russia. Nicolas had intended it to contain a bust of the Tsar by a leading sculptor such as Thorvaldsen or Tadolini; this was never executed and although Anatole seems to have considered using it to house the Bartolini monument (see p.12), it was exhibited on its own at the 1834 Industrial Exhibition in Paris and, in this form, accepted (reluctantly) by the Tsar himself in 1836 as a gift from Anatole (now St Petersburg, Hermitage Museum).

The Grand Ducal workshop (*Opificio delle Pietre Dure*) used Anatole's personal courier from St Petersburg to obtain lapis lazuli and jasper from Siberia, and Anatole further gave the Grand Duke over 1,200 superb specimen minerals from the Taguil mines. In exchange, he received several items with local *pietra dura* work, including two tables once owned by the Medici, seventeenth-century relief panels for the chimneypiece in the Tapestry Room (Florence, Museo Stibbert) and, on his marriage in 1840, modern mosaic medallions for the chimneypiece in the Mosaics Room (Florence, Museo Stibbert).

Anatole followed his father in exploiting the Demidoff quarries, and brought craftsmen from Russia to work the malachite in Florence. The mineral was fashioned into small items, such as the paperweights and specimens sold in 1870, and also much larger malachite furniture, numerous examples of which featured in the 1880 sale (this may have included objects made for Paul as well as for Nicolas and Anatole). Many of these tables, vases and columns had been displayed in the Malachite Saloon at San Donato, and a large group was exhibited to huge acclaim at the Great Exhibition in London in 1851 (where their total value was put at £18,000). But 'the best and most costly' of the objects shown was a pair of doors, over four metres high, on which thirty men had worked 'day and night without ceasing' from May 1850 to May 1851, merely to fit, finish and polish the thousands of malachite slices required to veneer each door. After the exhibition, the doors were placed at the entrance to the Gallery of Modern French Paintings at San Donato. Anatole's eclectic taste was further responsible for the equally remarkable garniture of a clock and two candelabra, c.1840, also sold in 1880. These were of malachite with gilt- and silvered-bronze mounts, in a curious *mélange* of styles, the clock with a rococo base in the style of Jacques Caffiéri which supported a scene derived from Fragonard's *Fountain of Love* (No.22). They too had been placed, appropriately enough, in the Malachite Saloon at San Donato.

Even if Lord Hertford had lived to see the 1880 sale it is unlikely that he would have bid for the huge Empire objects on offer: his taste was for an earlier age. In this respect, he was well served by the 1870 sale, which included several eighteenth-century pieces of the first order. Although he bought only six out of over 150 lots, these included several important items, such as the Boulle clock (No.24), the Rémond candelabra (Nos.29-30), and the Robin clock (No.31).

Lord Hertford did not pay the highest prices. These were achieved by a splendid sixteenth-century Italian crystal chandelier (lot 264, 61,000 fr.) bought by a M. Cornu, and by a pair of grand Boulle *armoires* (lot 267, 111,000 fr.; very similar to F61 and F62 in the Wallace Collection), later acquired by the Duke of Westminster for Grosvenor House. Several of the more expensive items are now at Waddesdon Manor or passed to other members of the Rothschild family. The most important of these was the set of lacquer-veneered furniture by Riesener, once believed to have been delivered in December 1783 to Marie-Antoinette's *cabinet intérieur*. This shares several features with the set which was sent in February that year, of which the *secrétaire* (F303) and

encoignure (F275) are in the Wallace Collection. As with F275, a second, matching corner-cupboard had been made in the early nineteenth century to complete the ensemble. The four pieces cost the dealer Mannheim 105,000 fr., and were later with Alphonse de Rothschild. These were prices which had been equalled only by Lord Hertford's own purchases in the 1860s, and would not be exceeded until the Hamilton Palace sale of 1882.

Although some pieces of Boulle furniture feature in contemporary accounts of San Donato (in the Greuze and Boucher Rooms), it is curious that many of the finest French pieces from the mid- or late eighteenth century are not mentioned. Possibly they were kept in private rooms and therefore were excluded from the public circuit. It is also possible that at least some of them were kept at other properties. The 1870 inventory of Demidoff's *hôtel* at 25 rue de la Pépinière in Paris is remarkable for the complete absence of antique furniture - indeed, few pieces of furniture (or pictures) are mentioned at all in its eleven rooms. Perhaps the more important pieces had been added to the cartloads from San Donato and sold as one collection in 1870.

The 1880 San Donato sale contained numerous pieces of French, but also Italian, furniture, ranging in date from the sixteenth century to the modern malachite pieces mentioned above. The earliest object was probably the *cassone* with painted panels by 'the school of Pinturicchio [1454-1513]', which had stood amid the armour at San Donato. There were also four monumental seventeenth-century cabinets on stands, veneered with ebony and tortoiseshell, and mounted with mythological or biblical scenes painted on silk, attributed to Luca Giordano (1632-1705).

It is difficult to determine which among the other items in that sale had been acquired by Anatole and which by his nephew. Given that Anatole had (according to some accounts) cleared out fourteen of the principal rooms at San Donato for the 1870 sale, it seems safe to assume that the majority of works sold in 1880 had been collected by Paul. Exceptions to this generalisation were the modern fixtures such as wall-lights, chandeliers and chimneypieces (see above) installed by Anatole at San Donato, and the large group of objects inherited or bought from Jérôme, many of which had been sent by Anatole to his Napoleonic museum on Elba. The pieces thus acquired almost certainly included a large suite of Empire giltwood seat furniture, decorated with Napoleonic motifs, some of which can be seen in the 1841 watercolours of the Ballroom at San Donato (figs.13-14).

Of the several hundred lots of furniture in the 1969 Pratolino sale, only a handful can be traced back with any confidence to Anatole. Among these were four sixteenth-century walnut *cassoni*, once in the Malachite Saloon, and a few pieces known to have been made for Jérôme or Anatole. Among the latter were two marquetry-veneered ebony lamp tables, c.1840, also visible in the watercolour views of the Ballroom, and three table lamps, c.1845, applied with the monograms of Anatole and Mathilde, all of which seem to have been commissioned from Italian makers. Another locally-commissioned work (not in the sale, and now lost) was a splendid organ case by Angiolo Barbetti (for whom, see No.67), originally intended for the Ballroom at San Donato. Ordered for the Catholic chapel, were two carved-wood doors, executed by Angiolo's son Rinaldo (1830-1903), which were exhibited at the 1861 National Exhibition in Florence, and which imitated Ghiberti's famous gilt-bronze portals on the Baptistery. Demidoff ordered further pieces from other local makers, such as the two Falcini, whose work much influenced their contemporaries. None of these has been traced.

It is difficult to determine Demidoff's approach to collecting furniture. By way of his marriage he gained many Empire pieces which complemented the hardstone furniture inherited from his father; and he was clearly a significant patron of contemporary Italian makers. The various sale catalogues provide information on what objects Demidoff actually bought, but not on where or how he acquired them. His motives as a collector are also unclear: while much must have been obtained simply to furnish his Villa in a manner befitting a prince, one does not get the sense of a collector concentrating with passion on one particular period or style. With pieces from Germany and Italy as well as France, ranging over a five-hundred year span, Demidoff's collection is perhaps best defined as that of an eclectic acquisitor. He therefore contrasts with Lord Hertford who pursued almost exclusively masterpieces of the *ancien régime*. Lord Hertford did not buy merely to furnish: he accumulated

zealously, beyond practical need, and with a profound appreciation of his chosen period; collecting was the driving force of his life. But although Demidoff's furniture lacked the consistent character of the collection now at Hertford House, it did contain many pieces, including several from eighteenth-century France, of great quality and significance.

REFERENCES: Rappe, pp.205-16; Paris 1986, esp. pp.314-6; Potocka, pp.32-34; Zeck forthcoming (see p.31, n.35 of this catalogue); New York 1978, no.182; Fuchs, pp.147-51; Cantelli, pp.20, 32; Giusti, pp.120, 125, 212-4, 219-20, 260, n.136, 264, nn.46-9 (Stibbert and Pitti pieces); Voronikhina, pp.17-18, 94, pls.60-1; Paris 1991, pp.280 (malachite temple), 498 (1851 exhibition); London 1851, pp.1361, 1366, 1377, 1379; Bellaigue; Archives de Paris (et/LV/482) (1870 inventory); Jervis, pp.68-9 (Barbetti); Gonzales-Palacios, pp.116-23 (contemporary pieces).

24 MANTEL CLOCK
(*'PENDULE À VÉNUS'*) F93

Case:

Attributed to André-Charles Boulle (1642-1732)

French c.1715

Oak veneered with tortoiseshell, ebony and rosewood; the figures of Venus and Cupid, and the spiral shell, of gilt bronze

79 x 53.5 x 42

Clock movement:

Jean Jolly (1691-1748);

repaired in the nineteenth century by Louis Moinet (1768-1853), when the present steel-spring suspension replaced the silk original.

MARKS: engraved on back plate, *Jolly A Paris*;
L.MOINET/A PARIS

PROVENANCE: Anatole Demidoff; his (San Donato) sale, Paris, 24 March 1870 (273, ill.), bt. Mannheim, 46,500 fr., for the 4th Marquess of Hertford.

A.-C. Boulle was an *ébéniste* (cabinet-maker) to Louis XIV, and the leading maker of his time. This model was listed in the 1715 inventory of his workshop when, although clearly unfinished, it was valued at 2,500 *livres*. The model probably

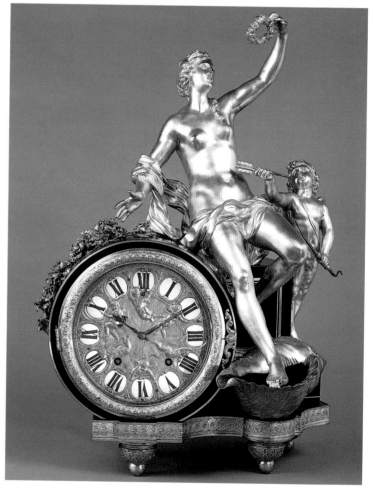

continued to be made at least until Boulle's death. Other surviving examples (which have patinated, not gilt-bronze, figures) show that the clock would originally have had garlands of gilt-bronze flowers running down on both sides from the chaplet held by Venus; these are absent from the photograph in the San Donato catalogue, and must therefore have been removed by 1870.

Demidoff sold just four other eighteenth-century French clocks in 1870, including No.31 (although eighteen more were auctioned in 1880). Lord Hertford, however, is said to have had over one hundred displayed on a special platform in his bedroom in his Paris apartment; there are more than thirty superb examples still in the Collection today.

25-6 CANDLESTICKS F78-9

French 1745-49

Gilt bronze, with silvered-bronze *putti*

24.7 x 15

MARKS: each stamped on base with crowned *C*

PROVENANCE: Probably the pair of candlesticks in the Anatole Demidoff (San Donato) sale, Paris 21 April 1870 (1599, *Deux petits flambeaux en bronze doré, orné de figurines d'Amours en bronze argenté*) [This is not certain since slight variants of this model exist, and the sale catalogue is insufficiently precise for the exact type to be determined (see below)], bt. [?Mannheim], 130 fr.; the 4th Marquess of Hertford.

The *putti* derive from a design of 1728 by J.-A. Meissonnier (c.1693-1750). Several examples and variants of the basic model exist with the figures, themselves of varying forms, used both together and separately, as on this pair. The additional candleholders brazed on top, and the fact that the undersides of the bases are gilded, suggest that these were adapted from the basic model to permit carrying by hand. The crowned *C* marks indicate a date of 1745-9, when the stamp was applied to all new gilt-bronze mounts (but also to those pieces on the market at the time).

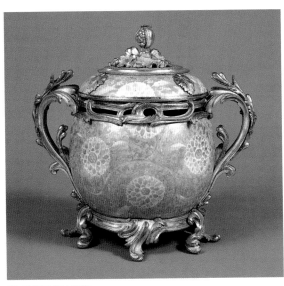

NO. 28 (ONE OF A PAIR)

27-8 POT-POURRI VASES F117-8

Gilt-bronze Mounts:
French c.1745-50

Porcelain:
Chinese, Kangxi period (1662-1772)

(Each) 28 x 29.5

PROVENANCE: Anatole Demidoff; his (San Donato) sale, Paris, 24 March 1870 (233), bt. Mannheim, 5,000 fr., for the 4th Marquess of Hertford.

The porcelain bowls and covers have been cut from sections of much larger vases. Similar mounts on a comparable pair of mounted porcelain jars (New York, Frick Collection), bear the crowned *C* mark for 1745-9, suggesting the date of this pair. Chinese porcelain had been highly prized by Western collectors since the sixteenth century, and pieces were often richly mounted, particularly in the mid-eighteenth century: hundreds of examples of mounted porcelain are recorded in the sales book for 1748-58 of one of the most important *marchand-merciers* (dealers), Lazare Duvaux (c.1703-58). Demidoff himself assembled an impressive array of Chinese and Japanese porcelain, both mounted and unmounted, at San Donato (see pp.71-2). Lord Hertford's only other purchases of mounted Chinese porcelain were three celadon vases (F350-1, and F113) and two ewers (F105-6 also with the crowned *C* mark).

REFERENCE: Washington 1986, pp.15, 72-3

29-30 CANDELABRA F134-5

French c.1782-5

Gilt bronze and blue-painted steel

67.5 x 30.3

PROVENANCE: Anatole Demidoff; his (San Donato) sale, Paris, 24 March 1870 (256, ill.), bt. Mannheim, 35,000 fr., for the 4th Marquess of Hertford.

The same models of friezes of playing *putti*, of palm-leaf candleholders and of scrolling branches can all be found in the documented work of the *ciseleur-doreur* (chaser and gilder of gilt bronzes) François Rémond (master 1774). These

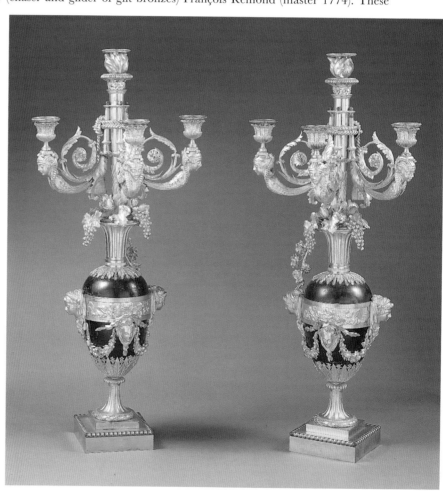

candelabra therefore may be associated with a model of the *'girandole à Vase et Branche à tête'* supplied by Rémond to the *marchand-mercier* Dominique Daguerre (d.1796) on two occasions in 1785; this might, however, have involved the collaboration of other *fondeurs* (casters of gilt bronzes) and *doreurs*, all working for Daguerre.

Other furnishing bronzes bought by Lord Hertford which are attributable (at least in part) to Rémond include: a pair of tripod candelabra with comparable female head-terminals (F130-1); four candlesticks with caryatids (F170-3); six candelabra (F142-7) and a similar pair (F156-7) with patinated-bronze nymphs; a pair of candelabra with Cupid and Psyche (F140-1); and a pair of candelabra mounted with female fauns (F132-3). The latter have retained their looping chains, intended to add intricacy to the design, which are missing from Nos.29-30. Several of these models, or closely related examples, appeared in the 1880 San Donato sale, and (as furnishing bronzes) may originally have been acquired by Anatole Demidoff - or (as with these candlelabra) by his father, who is known to have collected Louis XVI-period pieces.

REFERENCE: Zeck forthcoming (see p.31, n.35 of this catalogue)

31 MANTEL CLOCK
F263

French c.1785

Case:
Gilt bronze, with enamels by Joseph
Coteau (1740-1812)

Clock movement (spring-driven):
Robert Robin (1742-99, master 1767)

60.5 x 39 x 22

MARKS: inscribed on band of vase, *Coteau*;
painted on dial, *Robin*

PROVENANCE: Possibly Monvoisin sale,
Paris, 14-17 December 1841 (59).
Anatole Demidoff (San Donato) sale,
24 March 1870 (255, ill.), bt.
Mannheim, 14,000 fr., for the 4th
Marquess of Hertford.

The winged *putti* represent Astronomy
(telescope) and Geometry (compasses).
The enamelled band is painted with
grisaille scenes of the Seasons, and
with four profile heads including that
of the bearded Zeus. The clock can be
dated quite precisely since it closely
relates to one supplied by Robin (at
3,300 *livres*) for Marie-Antoinette at
Saint-Cloud, the château bought in
1785 by Louis XV. The latter cannot
be the same as this clock, however,
since it carried the attributes of the
Arts and not, as here, of the Sciences.

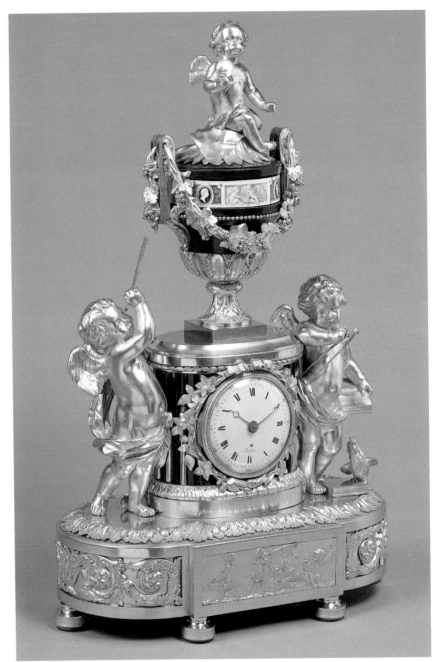

32-3 MALACHITE COLUMNS F522-3

Italian (Florence) c.1850
Columns of igneous rock and bronze veneered with malachite; gilt-bronze lion and shield
288.4 x 48.8 x 37.7
PROVENANCE: By 1862, Anatole Demidoff, Villa San Donato, Florence; San Donato sale, Paris, 31 March 1870 (509), bt. [Mannheim], 17,600 fr., for the 4th Marquess of Hertford.

Although these are reminiscent of the column of St Mark in the Piazzetta at Venice, the lions of these columns support shields bearing the flowering lily of Florence, in reference to Demidoff's city of residence. The Corinthian capitals of each column also bear a malachite flowerhead including the hammer from the Demidoff coat-of-arms; after 1840, the year Demidoff was raised to the status of a prince, he proudly placed his coat-of-arms on his furniture and carriages as well as on his bottles and glasses. The columns are recorded as being placed on either side of the entrance doorway of the Tapestries Room, the first principal room on the public tour of the palace; they would have faced the magnificent malachite chimneypiece with pietre dure plaques now in the Museo Stibbert. These columns might be said to represent in symbolic form the importance of malachite in supporting the Demidoff fortunes.

Whereas the igneous (volcanic) rock was probably local to Florence, the malachite (hydrated green carbonate of copper) for these pieces doubtless came from Demidoff mines in the central Urals. This area was almost the only source of the mineral until the discovery of similar ore in South Australia in the mid-nineteenth century. Copper, as well as iron, was worked at the nine *zavod*s (mining centres) owned by the Demidoff family in the Nijni Taguil district. The *zavod* at Taguil itself alone covered an area of five square *versts* (about 2¼ square miles) with a population of some 22,000, mostly serfs before 1861 (see fig.1). One contemporary account (published in 1845) reported that it was: 'truly a well-ordered town, in which the comfortable dwellings of the workmen, the capacious hospitals for their relief, the schools for the education of the youth, the elegance of the public buildings and houses of the chief managers, and above all the skill with which the machinery, forges and works are conducted, would reflect the highest credit upon any European establishment.'

REFERENCE: Murchison, pp.120, 369-75, 486 (Nijni Taguil).

CERAMICS

natole Demidoff's taste in ceramics must be reconstructed largely from sale catalogues of his collection, since contemporary accounts of San Donato provide an impression of scale, but not detail - they mention a 'rich [and] stunning display of Meissen porcelain' in the Boucher Room and refer to the numerous celadon vases and '*vasi giapponesi*' in other rooms, but are not more precise. Included in the first of his sales (in 1839), apparently largely drawn from Nicolas' collection, were twenty-three lots of Oriental porcelain, sixteen of Meissen, and fourteen of Sèvres. But the generally low prices indicate that, as with the pictures and furniture in this sale, Demidoff was ridding himself of secondary pieces. The twenty-seven lots of Sèvres, Meissen and Berlin porcelain sold in 1863 were also of relatively minor importance, although they did include an 88-piece Sèvres dessert service of simple decoration, and another (tea) service of fifty-two pieces.

The 1870 San Donato sale was a far more significant occasion, with the ceramics section keenly fought over by collectors: '*C'est là que les nababs se sont livrés un combat sans merci*', wrote Jean Ravenal in the *Revue Internationale*. Perhaps the most celebrated items of Sèvres porcelain were the 172 pieces from the 'Prince de Rohan' dessert service (*bleu celeste* ground with reserves of exotic birds painted by Aloncle, Fallot and others). This ambassadorial service, originally of 368 pieces, had been ordered by Louis, prince de Rohan (1734-1803) in 1771, and completed the following year at a cost of 20,772 *livres*. The portion acquired by Demidoff had been expensive enough for him: '*Au temps où l'on avait le sèvres pour rien, M. Demidoff avait encore payé ce service princier et cardinalesque 70,000 francs!*', exclaimed Ravenal. But in 1870, the dealer Rutter, hoping to buy these pieces *en bloc* for Lord Dudley, was only able to outbid baron Achille Seillière by paying the sensational price of 255,000 fr. They are now dispersed, like the rest of the service, with perhaps the largest portion in the Metropolitan Museum of Art, New York (Wrightsman Collection).

The most expensive single lot, however, was the Sèvres vase (No.34) in this exhibition. For this the 4th Marquess of Hertford, after a battle with the Duke of Galliera, paid an astonishing 40,000 fr. It was the last Sèvres purchase by perhaps the greatest of all collectors of Sèvres porcelain. Lord Hertford had a further struggle with Galliera over a large and richly-mounted bowl, dated 1757, before both were trumped by baron Gustave de Rothschild's bid of 13,000 fr.: '*il me semble princièrement payé à 2,000 francs,*' wrote the incredulous Ravenal, '*il y a vingt ans il n'aurait pas dépassé 500 francs.*' The other sixty-seven principal lots of Sèvres porcelain attracted much lower prices; they included a few fine display pieces, mainly of the Louis XV period, and much tableware, including a 198-piece dessert service of simple decoration. There was a further group of eleven lots of later- or re-decorated Sèvres porcelain.

There were many pieces from the Meissen and Berlin factories, including sixteen complete services, although these failed to reach the highest prices attained by the Sèvres porcelain. Among the important group of Chinese wares were a pair of richly-mounted enamelled *jardinières*, one metre high, and two pot-pourri vases (No.27-8). Maiolica and other earthenwares, much more fashionable among a younger generation of collectors (such as Richard Wallace), were of far less number and significance - reflecting Demidoff's conservative tastes. But there was a fine sixteenth-century Urbino oval platter, decorated with a central reserve of an emperor in triumph. Glass was more numerous, with sixty lots of Venetian origin, and several Bohemian pieces.

The 1870 inventory of Demidoff's Paris *hôtel*, although containing no ceramics of any importance (at least

as then perceived), does confirm his taste for Oriental as well as European porcelain. There were four or five items of modern Chinese porcelain and also, in the Dining Room, a 180-piece 'table, tea and coffee' service by Fischer (of the Hungarian Herend factory) in imitation of Chinese porcelain. The Western pieces were similarly quotidien: a Sèvres *'tasse mignonette'*, two modern Sèvres vases, and four imitation-Sèvres cake plates were the highlights. As may be the case with the furniture, perhaps some of the finest pieces in Paris - those for display rather than use - were included in the 1870 sale.

The thirty-six lots of fine eighteenth-century Sèvres porcelain sold in 1880, which included a magnificent *vase 'à Paris'* bought by the King of Sweden for Catherine II in 1780 (London, Victoria & Albert Museum, Jones collection), were probably acquired by Anatole's nephew Paul. But the four large *Vases Médicis* of 1810, given by Napoleon to Jérôme, and a metre-high vase with a scene after David's *Napoleon crossing the Alps*, given by Josephine to Jérôme's wife, were obtained by Anatole at the time of his marriage and later removed by Paul from Anatole's Napoleonic museum on Elba. Less certain are the origins of the numerous pieces from other factories, including Meissen, Worcester, and Vienna (notably a magnificent 107-piece table service with scenes from paintings in the Belvedere galleries). Many further items were sold in 1969 but, in the present state of knowledge, one must assume that these were acquired by Paul or later collectors.

Although Anatole Demidoff shared the taste of Lord Hertford and the Rothschilds for Sèvres porcelain (particularly for grand vases with royal associations) and was similarly indifferent to the developing fashion for Renaissance earthenware, he differed in his enthusiasm for other factories besides that of Sèvres - in both Europe and the East - and by acquiring so many complete services and pieces of simpler decoration and form. Lord Hertford, by concentrating his attention on the most splendid products of one factory, created essentially what is now the greatest museum collection (some 300 pieces) of Sèvres porcelain in the world. Demidoff's collection, however, impressed more by its sheer quantity and range than by consistency of quality - although, as with his furniture, there were certainly many outstanding pieces.

REFERENCES: *Revue Internationale* 1870, p.304; Archives de Paris (et/LV/482) (1870 inventory); Dauterman, pp.261-71; Anon. 1860, pp.49-51

34 VASE AND COVER (*VASE 'À MÉDAILLON DU ROI'*) C305

Vase:

French c.1768

Sèvres porcelain (soft paste, decorated with a dark green ground and gilding; and a biscuit medallion)

37.5 x 21.7

Marks: incised mark, a scrolling *CD*

Clock:

English nineteenth century (retailed by the Le Paute firm of Paris)

Inscribed: *Le Paute à Paris*

PROVENANCE: See below; Anatole Demidoff; his (San Donato) sale, Paris 23 March 1870 (154, ill.), bt. Mannheim, 40,000 fr., for the 4th Marquess of Hertford.

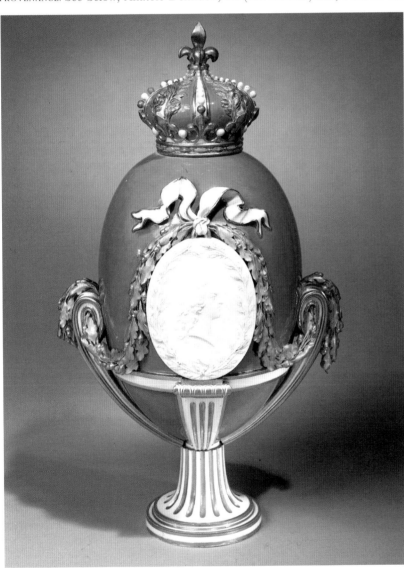

Possibly designed by the goldsmith J.-C. Duplessis *père* (fl.1745/8-74), the leading designer at the factory, who first used the crown on an *écritoire* (inkstand) of the 1750s. The biscuit medallion of Louis XV derives from a design by Edme Bouchardon, first cast in bronze in 1738 and used on coinage and commemorative medals. The vase is perhaps one of two of this design glazed in 1767-8, and may have been part of the garniture presented by Louis XV to Christian VII of Denmark in 1768. The nineteenth-century clock, added by the time of the San Donato sale, replaced a second biscuit medallion of Louis XV.

Other examples of Sèvres porcelain in the Wallace Collection with Russian provenances are a *vase 'à ruban'* (C267) and a *vase 'à glands'* (C310) from the Koucheleff-Bezborodko collection (see also pp.36 and 63), and six pieces from the famous Catherine II service (C474-9). This service, of some 797 pieces, was ordered from the factory in 1776 on her behalf by Prince Bariatinsky, Russian Ambassador to France (1774-85), who also bought many pieces (including C310) in 1782 for her successor, Paul I, then visiting Paris under the pseudonym of 'the comte de Nord'. Other prominent Russian patrons of Sèvres in the eighteenth century included Marshal Razoumovsky (1728-1803) and Count Zernicheff (1726-97), who bought extensively in 1767 and 1775 respectively.

METALWORK

AND

OBJETS DE VERTU

With precious metalwork, the name Demidoff is inextricably linked with the superb 219-piece silver-gilt dessert service which Nicolas bought in 1817 from the Parisian silversmith J.-B.-C. Odiot (1763-1850). It follows designs by A.-L.-M. Cavelier (1785-1867), who also worked for Thomire, and epitomizes the Empire style in its stylized motifs and extensive use of sculptural elements. The technical sophistication of the pieces is particularly remarkable. The complete service is said to have been given by Nicolas to a Mme de la Chapelle, and was sold in 1863 by her descendants (it is now dispersed).

Later products from the Odiot workshop were sold in the 1870 San Donato sale. These included a 95-piece silver table service, a 29-piece silver tea service, a pair of solid silver candelabra and four matching *girandoles*. There had been four cabinets of silver in the Silver Room at San Donato, two of which each contained a table service by the Odiot shop. One, of silver, was decorated with 'animals of every kind', the second, of silver gilt, was in the Empire style. The remaining cases contained a third table service, by Mortimer of London (not readily identifiable in the sale catalogues), and a large group of cups, jugs, vases and basins *'d'antico cesello'*.

Also in this part (19-21 April) of the 1870 sale, were two (unattributed) silver-gilt dessert services and several sculptural groups of animals in chased silver after models by Barye. There were about five hundred further lots of precious metalwork, mounted hardstones and *objets de vertu* in the other sections. The first part (22-24 March) included forty-three lots of silver plate, the majority catalogued as German seventeenth-century silver-gilt hollow ware: tankards, vases and cups. There was also an English seventeenth-century silver covered vase, with embossed grotesque decoration and medallions of scenes from the Trojan wars. The second part (29-31 March) contained another thirty-nine lots of metalwork, with a similar preponderance of seventeenth-century German tableware. Exceptions included two modern Indian pourers, one of which was bought by Lord Hertford (No.37), and a particularly spectacular sixteenth-century nautilus-shell sweetmeat dish.

The fourth part (11-14 April) was devoted entirely to metalwork and *objets de vertu*. There were over eighty further lots of German, Russian, and Italian seventeenth and eighteenth-century silverware, including a pair of chased silver-gilt *écuelles* (bowls) bearing the Imperial arms and marks of Russia and the date 1753, which were bought by Lord Hertford but were not part of Lady Wallace's bequest (see Appendix I). There was a collection of sixty antique and modern cameos and intaglios, which had been displayed in the Mosaics Room at San Donato, and a comparable number of hardstone objects. Another group, listed under *'bijoux'*, consisted mainly of paperweights, bookmarks and similar *bibelots*, such as Nos.35-6.

The last group in this section consisted of modern works. About a third were of anonymous Russian manufacture, among them a small tea service of platinum and a set of cutlery from Tula. Eight lots were catalogued as English, and there were six Scottish pieces, including snuff mulls and a quaich. The French items were more important. They were mostly ostentatious display items, such as four silver salt-cellars in the

form of animals symbolizing the continents, by F.-D. Froment-Meurice (1802-55), or a pair of cups, set with medals of French and Russian monarchs, marked *Fossin et fils, à Paris* (see p.79). On the retirement of Fossin *fils* in 1862, that firm became Morel et Cie.; six sculptural silver-gilt salt-cellars and an elaborate lighter from this later period of the company were also in the sale. Finally, there were three solid silver statuettes: an equestrian pair of *Charles V* and *François I*, and *Peter the Great* by T.-J.-N. Jacques (1804-76), dated 1843, which weighed 17,850 gr. (formerly in the Dining Room at San Donato).

It seems likely that most or all of the metalwork and *objets de vertu* in the 1880 sale came from the collection assembled by Paul, who is known to have bought several fine pieces of French silver at the highly important baron Pichon sale (Paris, 12-13 June 1878). But, despite their strong interest in silver and goldsmiths' work, neither Paul nor Anatole patronized contemporary Florentine craftsmen; even Anatole's commissions to Russian makers were generally for minor objects, such as the pipe-rests (Nos.49-50). And in contrast to the splendours of San Donato, his Paris *hôtel* appears to have contained little metalwork of significance: under 'Argenterie', the 1870 inventory listed items merely for daily culinary use, all valued by weight rather than craftmanship. The only collection as such was a group of '*bijoux*' displayed in the *cabinet de toilette* (see p.78).

Lord Hertford seems to have had no interest in the art of the silversmith. Apart from snuff boxes (see below), he acquired scarcely any examples of precious metalwork - even from his beloved eighteenth-century France. Although he inherited several chests of silver in 1842, most of it seems to have been relatively plain domestic ware for regular use, not display, and much was melted down immediately. It fell to Sir Richard Wallace to form the collection of silverwork now in Hertford House.

REFERENCES: New York 1978, introduction to silver section, cat. nos.156-9; Paris 1991, pp.131-2; Christie's (New York) 1993, lots 357-8; Archives de Paris (et/LV/482) (1870 inventory).

35 COFFEE-CUP HOLDER (*ZARF*) XX A 54

Possibly Swiss early nineteenth century
Enamel on gold set with diamonds (mostly missing) 5.5 x 4.7
MARKS: none
PROVENANCE: Anatole Demidoff; his (San Donato) sale, Paris, 11 April 1870 (994), bt. Mannheim, 200 fr., for the 4th Marquess of Hertford.

Such egg-cup shaped objects were designed to hold tiny cups for coffee or tea. *Zarfs* (or *zarphs*) appear to have originated, like the word itself, in the Ottoman Empire in the eighteenth century, and were particularly fashionable in early to mid-nineteenth century Europe. Many seem to have been made in Geneva.

Demidoff's interest in things Turkish is further evidenced by the existence of a Turkish Room at San Donato (see p.85), and by the group of *objets turcs* - for coffee, shaving and '*le bain turc*' - in the 1870 sale. It was perhaps his visit to Constantinople (Istanbul) in 1837 which first stimulated this particular taste, although 'Orientalism' was fashionable throughout much of Europe in the nineteenth century.

REFERENCE: Arminjon & Blondel, p.196.

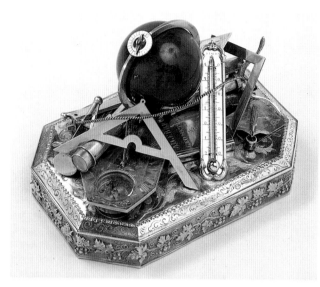

36 PAPERWEIGHT XXIII A 42

French nineteenth century
Silver, chased and parcel-gilt, with lapis-lazuli
7.6 x 11.1 x 7.6

MARKS: none

PROVENANCE: Anatole Demidoff (San Donato) sale, Paris,
11 April 1870 (986), bt. Mannheim, 510 fr., for the 4th
Marquess of Hertford.

Decorated with a group of astronomical and scientific
instruments, *viz.*: a telescope on a stand, a compass-sundial, a
furled chart, a pair of compasses, an (open) book entitled
'TRAITE/D'ASTRONOMIE' (also engraved with the façade
of an observatory), a mercury thermometer (gauged in
Réaumurs), a set-square, a level, a ruler, a book entitled
'ALGEBRE/GEOMETRIE', and a quill pen with inkpot on a sheet incised with geometrical diagrams; the whole surmounted
by a lapis-lazuli globe. The choice of subject reflects Demidoff's strong interest in the sciences (see also No.31). Lord Hertford
bought three more paperweights at this sale, as well as a portable telescope and two magnifying glasses (see Appendix I).

37 POURER OA1667

Probably Indian early nineteenth century
Silver, parcel-gilt, the body embossed and chased
23 x 8.25 x 8.25; wt: 241

MARKS: unidentified (possibly granules and leaf or tree); possibly Paris 'weevil'
mark; Paris *ET* mark, for gold & silver (of unspecified standard) imported from
countries without customs conventions (law decreed 24 October 1864)

INSCRIBED (with cursive letters): *No 118; 56 3; 241 g*

PROVENANCE: Anatole Demidoff, presumably after 24 October 1864; his (San
Donato) sale, Paris 29 March 1870 (352, *Flaçon analogue à celui qui précède* [i.e.:
*à verser, en argent, à panse sphérique ...; le goulet courbe est formé de trois tubes accolés
en spirale se terminant en trèfle. Travail persan ancien*], *mais plus petit. Haut., 22 cent.
Poids: 241 gr.*), bt. Mannheim, 450 fr., for the 4th Marquess of Hertford.

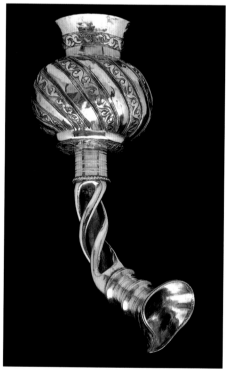

For both Demidoff and Lord Hertford, the principal appeal of such objects
as this highly unusual pourer would undoubtedly have been related to their
more general interest in Oriental works of art (see pp.85 and 91). Although
Demidoff seems to have possessed only one other similar piece of Oriental
metalwork, Lord Hertford assembled a small group of them, including water
vessels with more conventional straight necks, from otherwise unknown
sources. They would have been acquired to complement the weapons and pipes in an exotic and evocative display, rather
than out of a scholarly appreciation of their significance. The precise function of this object is in fact obscure: it appears
to be a pourer or funnel for liquids, but the context of its use is unclear. Its country of origin is also uncertain, although
the shape of the body, and the general character of the decoration and manufacture would strongly suggest India.

REFERENCE: Carré 1931, pp. 212-13.

GOLD BOXES, MINIATURES AND JEWELS

By the mid-nineteenth century, gold boxes were collectors' items *par excellence*. Most, however, had been made in the eighteenth century when the fashion for taking snuff was at its peak: by the time of Anatole Demidoff and the 4th Marquess of Hertford, first cigars and then cigarettes had become far more popular (see p.85), and boxes were collected for aesthetic reasons rather than for use. Boxes were also made for pills and sweets - which Demidoff apparently chewed incessantly at the end of his life. He certainly acquired a large and important group: eighty six 'of precious materials with miniatures, enamels and gems that multiplied their value a hundred-fold' were displayed in the Malachite Saloon at San Donato. Several of these were bought by Lord Hertford, whose collection, augmented by Richard Wallace, ranks with those formed by George IV and the Rothschilds as among the finest of the century.

Among Demidoff's earliest purchases were several from the royal goldsmiths Fossin et fils (see below, and p.75). These included a red-enamelled oval box with a miniature of *Marie Thérèse* attributed to Jean I Petitot (1607-91), costing 1,050 fr. (sold in 1863 for 1,400 fr.) and another oval box with a chased guilloche design (900 fr.); these were both bought on 15 December 1841, with a third, No.41, acquired in January 1842. Indeed Demidoff's particular interest in gold boxes - and characteristic care over the setting of his works of art - is clear from his letter to Jules-Jean-François Fossin (fl.1830-62), written from St Petersburg on 13/29 June 1852:

> My dear Fossin,
> M. Octave Jaunez [Demidoff's secretary] has shown me the different drawings you had given him for some snuffboxes that it is my intention to have made. I shall not bother here with the two enamel portraits by Petitot, as you have found antique boxes that are unquestionably preferable to modern boxes. With regard to the portrait of Vitré by Bordier for which you have not found an antique box large enough, I approve the project you have submitted to me, which seems very pretty; I desire only that the portrait fills the width as indicated in pencil in the drawing I am returning to you. You can then execute this snuffbox for about 2,500 francs.

The enamel portrait of the printer Antoine Vitré (1595-1674), taken from a painting by Philippe de Champaigne, appears to have been acquired by Anatole from the baron Roger collection, c.1841-4. The box was actually made on behalf of Fossin by the prolific Paris maker Alexandre Leferre (fl.1806-52). The complete piece was the star item among the thirty boxes at the 1880 San Donato sale (lot 638, 11,500 lire; Los Angeles, County Museum of Art, Gilbert Collection).

The preceding item in that sale (untraced) was a rectangular enamel and gold box by A.-J.-M. Vachette (fl.1779-1839), inset with a miniature of Louis XIV by Petitot (1607-91), which may have be one of the two boxes mentioned in Demidoff's letter (but see below). Another box, with superb enamels of fruit and flower still lifes, which realized almost as much as that by Leferre, is now known to be by the celebrated maker

Jean Ducrollay (1709-61), and is in the Louvre. In all, over half the boxes were French, in a variety of media, including 'vernis', hardstone, amethyst and Mennecy porcelain. There were also at least two Swiss boxes, a German example, and two from Tula (one with scenes of the armouries at Vologda). Two further boxes had Russian connections: one was mounted with a miniature of Catherine II, the other with one of Peter the Great.

Unfortunately, with the exception of the Leferre box, none of the items in the 1880 sale can be securely identified as from Anatole's collection. There is a similar problem with the sale of 153 snuffboxes held in 1861 (see Appendix II). This was a joint sale between Anatole Demidoff and the 'comte de Potocki', but the catalogue does not specify the owner of each piece. Thus, although three gold boxes now in the Wallace Collection are believed to have come from this sale, it cannot be proved that any of them once belonged to Demidoff; therefore they have not been included in this exhibition (G78, lot 7; G72, lot 35; and G88, lot 60). The precise identity of Count Potocki is also uncertain; he may have been Mieczyslaw (1799-1878), who was extremely wealthy and lived in Paris after 1856, or a descendant of Wincenty (d.1825), whose paintings, drawings and prints were sold in Paris in 1820; alternatively, he may have been another member of this numerous Polish family. Again, the majority of the boxes seem to have been French eighteenth-century pieces, in a wide range of techniques. At least five were mounted with miniatures attributed to Petitot.

All the gold boxes in the 1863 sale, however, were from Demidoff's collection: seventy two in all, of which five were bought by Lord Hertford (Nos.38-42). A sixth in the Wallace Collection (G17) corresponds in all respects with lot 28 in the sale, except for the scene on the front enamel; and since Lord Hertford is nowhere recorded as the buyer, as he is for the other pieces, it has also been excluded from the exhibition. Further boxes can be traced to the Louvre (one set with a miniature after C.-J. Vernet's *A Storm with a Shipwreck* (P135) in the Wallace Collection; see also No.39), and the Los Angeles County Museum of Art (Gilbert Collection).

The earlier provenances of several boxes in this sale were specified in the catalogue. A box mounted with a 'superbe onyx oriental à trois couches' came from the collection of 'don Gennaro de Simoni'; three came from the baron Roger collection (dispersed from 1841; see No.42), and four from the Harrington sale of 1851 (see No.39). As many as seven included mosaic scenes by Barberi of Rome, several of whose mosaic tables had been acquired by Nicolas Demidoff. The catalogue was divided into sections by technique: twenty seven were mounted with either cameos, intaglios, hardstones or mosaic scenes; thirty incorporated miniatures in various media; and there was a group of fifteen boxes in a range of techniques. With the exception of the mosaic pieces, and some of those with cameos, almost all the boxes seem to have been French. The seventy-two lots raised over 180,000 fr. - of which Lord Hertford was responsible for a fifth.

The 1861 and 1863 sales may have included items once kept in Paris. But by the time of the inventory of Demidoff's Paris *hôtel* in 1870 there were just four listed. These were displayed amid a little collection of 'bijoux' in a mahogany vitrine in the *Cabinet de toilette* (which also included ten gold rings mounted with precious stones, and several gold pocket watches with fob chains; their combined value, with the boxes, was nearly 10,000 fr., about a fifth of the valuation of the entire contents of the *hôtel*). Two were described as gold snuffboxes, both with male portrait medallions, one set with 32 diamonds; the third as 'une boîte à mouche [patch box] en or émaillé'; and the fourth as 'une boîte ovale avec plaque en porcelaine de Sèvres tendre avec miniature'. Even in this small selection, therefore, one can see Demidoff's marked preference for boxes mounted with miniatures, a feature of his taste to be found at least as early as 1841.

Demidoff also assembled a small collection of miniatures which, because of their scale, were unsuitable for mounting onto boxes. Twenty five were sold in 1870, of which Lord Hertford bought eight; only two of these (Nos.43-4) were included in Lady Wallace's bequest. Of the whole group, almost all were by artists working in the first half of the nineteenth century and many depicted ladies of the court, actresses or mistresses - some of whom Demidoff doubtless knew. The provenance of these miniatures is obscure; some may have been inherited from his father, others - such as the portrait of Catherine II (No.44) - were probably commissioned by Anatole Demidoff himself.

He may well also have bought miniatures from Fossin et fils, which certainly numbered him among its most important clients. The firm had been founded by Étienne Nitot and his son, François-Regnault, goldsmiths to Napoleon; they were later joined by Jean-Baptiste Fossin (1786-1848; retired 1845) and, in 1830, his son, Jules; in the years 1834-42, Jean-Valentin Morel also worked for them, and it was *his* son, Prosper, who took over ownership on Jules' retirement in 1862 (when the firm became Morel et Cie.). Demidoff's most valuable purchases from the firm were for jewellery, with the setting for the Renaissance *Incredulity of St Thomas* pendant (No.45), bought in April 1837, being among his first recorded acquisitions. Many of Demidoff's commissions - certainly the most spectacular - fall into the period 1840-5, and were made for Princess Mathilde. One of the most lavish was a bracelet set with a *'magnifique rubis d'orient de 33 grams ½'* and no less than seventy-four *'brillants'*, at a total cost of 20,000 fr. (9 November 1841). Other items had specifically Napoleonic associations. These included two pieces bought in the same month: a lavish *sevigné* (bow-shaped ornament) incorporating 'a fragment of the Emperor's coffin, surmounted by the imperial crown ...'; and a bracelet with two medallions containing locks of hair of Napoleon and his son (the King of Rome). The Fossin et fils accounts also reveal that the firm supplied Demidoff with decorations and orders at this time, as well as jewellery in diverse styles: besides the Renaissance pieces (see No.45), there were 'Indian', 'Algerian' and 'Gothic' items (all bought in October 1839).

Demidoff's many acquisitions of jewellery were not matched by Lord Hertford, who is not documented as having any interest at all in the subject. Sir Richard Wallace, however, assembled the nucleus of a fine collection in the 1870s, and it is therefore appropriate that the *St Thomas* jewel (No.45) should be the one object he bought from the Demidoff collection. Both father and son, on the other hand, were keen collectors of gold boxes and miniatures, although it is not always possible to determine who bought what. Together they assembled a superb group of eighteenth-century French boxes (perhaps the finest museum collection in the world) and a similarly fine representation of French miniatures, with important examples in both cases from the other major European centres, across a broad range of techniques and styles.

REFERENCES: Corti; Truman, pp.158-63; Archives de Paris (et/LV/482) (1870 inventory); Maison Chaumet archives; Grandjean, pp.68-9, 96, 139-40, 204-5.

38 GOLD BOX G37

Mathieu III Coiny (1723-after 1788)
French (Paris) 1763-4
Painted enamels on gold
4.2 x 8.5 x 6.4; wt: 240.4
MARKS: Paris, 1763-4; J.-J. Prevost, *fermier* 1762-8; A.-J.-M. Vachette (repairer, 1819-39); Paris excise mark, 1819-38; Paris warranty, 1838-47
PROVENANCE: Anatole Demidoff; his [San Donato] sale, Paris, 15 January 1863 (23), bt. by the 4th Marquess of Hertford, 11,500 fr.

The sources of five of the six scenes can be identified. Those on the base and front are taken from drawings by Greuze, engraved by J.-F. Beauvarlet: *La Marchande de Marrons* (exh. Salon 1761) and *La Maman*.

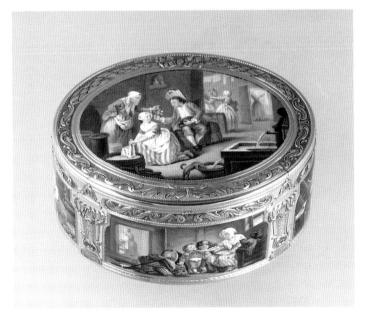

The two end scenes are from drawings by Boucher, engraved in 1754 by Claude Duflos: *Le Petit Pasteur* and *La Petite Fermière*. The scene on the back is a poor copy of J.-B.-M. Pierre's *Les Jardinières Italiennes au Marché* (?exh. Salon 1745), engraved by Jean Ouvrier. Five of the scenes are repeated on another box made by Coiny, 1761-3 (Paris, Musée du Louvre). Mathieu Coiny, the third recorded Parisian goldsmith of that name, was received as master in 1755, and described as *orfèvre du roi* in 1776. The box in the Louvre has a prominent diamond-studded thumb-piece, and the patch on the Wallace Collection's box suggests that Vachette's repairs included the replacement of a similar thumb-piece.

REFERENCE: Savill 1980, pp.307, 309, nn.23-7.

39 GOLD BOX, SET WITH A MINIATURE G51

Box:

Jean-François Breton (fl.1737-91)

French (Paris) 1770-1

Enamel on gold

3.5 x 8.3 x 6.7; wt: 200.7

MARKS: J.-F. Breton; Paris, 1770-1; J. Alaterre, *fermier*, 1768-75; Paris warranty, 1838-47

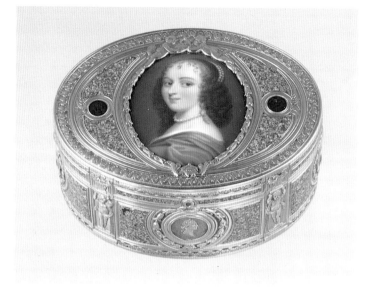

Miniature:

Ninon de Lenclos (1615-1705)

Henry Bone (1755-1834), after Jean I Petitot (1607-91)

English (London) 1807

Enamel on copper 4.5 x 3.8

Signed and dated, on back of enamel: *Ninon de Lenclos/Painted by Henry Bone A.R.A.,/Enamel painter to His R.H. the Prince of Wales/Feby. 1807*

PROVENANCE: Possibly George IV; Charles, 4th Earl of Harrington (1780-1851); his sale, London (Farebrother), 7-18 July 1851, 6th day (933); Anatole Demidoff; his [San Donato] sale, Paris, 15 January 1863 (22), bt. by the 4th Marquess of Hertford, 4,200 fr.

The later, English miniature after Petitot's *Ninon de Lenclos* (of which many versions are known) possibly replaces a miniature of Louis XV or his family removed during the Revolution. De Lenclos was one of the most notorious beauties at the court of Louis XIV. The *Allegory of Music* on the base was adapted from Huquier's engraving after a drawing by Boucher. The green enamelling is in imitation of hardstone, possibly a granite or porphyry; the replacement panel on the back wall is now discolouring.

Lord Hertford missed the chance to buy the box at the Harrington sale; as he wrote to his agent in London, Samuel Mawson, on 13 July, 'I owe you a grudge for not having written me about Lord H's sale. I knew nothing about it'. In both the Harrington and Demidoff sale catalogues the sitter was wrongly described as the duchesse de Montpensier, another of the ladies at the court of Louis XIV. The box may have belonged to George IV since the title page of the Harrington sale states that 'many' of the snuffboxes 'came from the Cabinet of George IV'. Indeed the top item in that sale, an octagonal gold and enamel box by Ouizille (see No.41) and Rinderhagen (master 1781) with an enamel of *Louis XIV* by Petitot, which was specifically identified as from George IV's collection, was also bought by Demidoff (along with two other boxes) and then sold in 1863 (now Paris, Musée du Louvre).

40 GOLD BOX G53

Pierre-François Drais (1726-88)

French (Paris) 1774-5

Enamel on gold, set with medallions of classical subjects, painted *en camaïeu gris*, probably by J. de Gault (c.1738-after 1812)

3.2 x 7 x 5.4; wt: 140.4

MARKS: P.-F. Drais; Paris, 1774-5; J. Alaterre, *fermier*, 1768-74, and J.B. Fouache, *fermier*, 1774-80

PROVENANCE: Anatole Demidoff; his [San Donato] sale, 16 January 1863 (39), bt. by the 4th Marquess of Hertford, 2,699 fr.

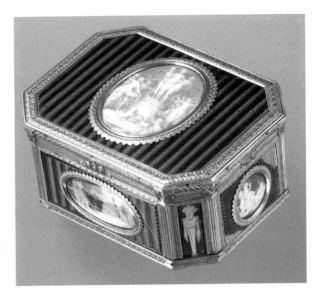

The subjects of the medallions, which resemble (in miniature) the then fashionable Wedgwood plaques, include *The Festival of Graces* (top) and *Pygmalion and Galatea* (base).

41 GOLD BOX, SET WITH A MINIATURE G54

Box:

Louis Ouizille (c.1731-1821)

French (Paris) 1775-6

Enamel on gold

3.2 x 7.6 x 5.8; wt: 154.5

MARKS: L. Ouizille; Paris, 1775-6; J.-B. Fouache, *fermier*, 1774-80

Miniature:

Marie-Adélaïde, duchesse de Bourgogne (1685/6-1712)

French c.1705

Enamel on copper 3.5 x 3.2

PROVENANCE: The goldsmiths Fossin et fils ('*Une Tabatière ancienne à pan, émail bleu saphir, dessus portrait sur émail de la D^{esse} de Bourgogne, entré de roses*'); from whom bt., 8 January 1842, by Anatole Demidoff, 2,000 fr.; his [San Donato] sale, Paris, 15 January 1863 (19), bt. by the 4th Marquess of Hertford, 6,520 fr.

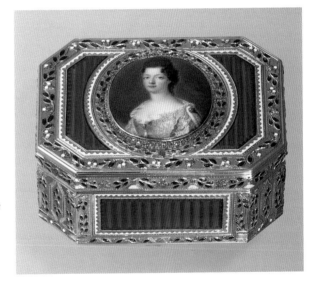

Marie-Adélaïde of Savoy, daughter of Victor Amadeus II, Duke of Savoy, and of Anne-Marie d'Orléans, married in 1696 the duc de Bourgogne, grandson of Louis XIV; she was the mother of Louis XV. The taste for miniatures depicting celebrated mistresses, actresses (then often synonymous), and ladies of the court, as well as kings and emperors, whether mounted on costly gold boxes or simply in frames (such as Nos.43-4), was a feature of collecting in the nineteenth century generally, but seems to have been particularly enjoyed by Demidoff (see pp.77-8). This box was one of several acquired by him in 1841-2, either from the baron Roger collection or from Fossin et fils (see pp.77-8 and No.42).

REFERENCE: Maison Chaumet archives.

42 GOLD BOX, SET WITH SIX MINIATURES G62

Box:
Unidentified maker
French (Paris) 1781-3
Gold
3.2 x 8.1 x 6.4; wt: 165.6
MARKS: Paris, 1781-2 (side), 1782-3 (lid and base)

Miniatures:
Six views of the château and park of Romainville
L.-N. (1716-94) or H.-J. (1741-1826) van Blarenberghe
French (Paris) 1782
Gouache on vellum 5.2 x 7.5 (top)
Signed and dated, top scene, bottom edge: *van Blarenberghe/1782*

PROVENANCE: Presumably commissioned by Phillippe-Henri, marquis de Ségur (1724-1801), c.1781 (see below). Baron Roger (d.1841) collection (assembled c.1800). Anatole Demidoff; his [San Donato] sale, Paris, 16 January 1863 (31, *'provient de la collection de feu M. le baron Roger'*), bt. by the 4th Marquess of Hertford, 11,000 fr.

The six gouache scenes depict the park of the château de Romainville, which had been converted to a garden in the fashionable English style, c.1780-1, by the marquis de Ségur, then Minister and Secretary of State for War. The buildings have been identified from engravings of the park in Le Rouge's *Les Jardins Anglo-Chinois* (1781). The top shows the south-west façade: the marquis de Ségur, owner of the château, with members of his family, welcomes the young peasant woman chosen by the *Société de la Rosière* to receive a marriage dowry. The front scene presents a view of the gardens towards an octagonal pavilion, a 'Medici' vase and a statue to the right. On the left side is a view from the terrace, with a Chinese bridge in the left middle-distance. On the right side, a view from the north-east: a Chinese pavilion in the right middle-distance, the Chinese bridge on the extreme right. (On the base is a view from the north, with the Chinese pavilion, a Roman temple, and the octagonal pavilion. On the back, a view looking north-west: the temple in the left foreground, the statue and Chinese bridge beyond; in the temple is a garlanded altar, probably the tomb of Zizi, the marquis de Ségur's favourite dog.)

Two further boxes sold by Demidoff in 1863 were specified as from *'la collection de feu M. le baron Roger'*, both set with eighteenth-century miniatures. The dispersal (from c.1841) of the baron Roger collection was among the earliest occasions at which Demidoff is thought to have acquired gold boxes, although he had also bought examples from the goldsmiths Fossin et fils late in 1841 (see p.77). The same firm debited 25 fr. from his account on 25 December 1841 for having added *'un cristal'* to a large oval box *'peinture de Blarenberghe ... sous lequel on a démonté & remonté la boîte'* - quite possibly a reference to the present box.

REFERENCES: Marie, pp.18-23; Maison Chaumet archives.

43 MINIATURE:
MADEMOISELLE ADÈLE M305

Jean-Baptiste Singry (1782-1824)
French (Paris) 1823
Gouache on ivory 15.0 x 11.4
Signed and dated, left: *Singry 1823*
PROVENANCE: Anatole Demidoff; his (San Donato) sale, Paris, 8 March 1870 (420, *Mlle Adèle*) bt. by the 4th Marquess of Hertford, 105 fr.

The identification of the sitter is dependent on the catalogue of the San Donato sale in 1870 at which the miniature was bought by Lord Hertford. He acquired two further miniatures by Singry at this sale (neither part of Lady Wallace's bequest), one of *Mlle Vigneron as a bacchante*, the other of *Mme Mainville Fodor*, an actress (See Appendix 1). Mlle Adèle was also an actress and indeed many of Singry's sitters were from the stage. The artist was a pupil of Isabey, perhaps the greatest French miniaturist of the period, who is superbly represented in the Wallace Collection.

44 MINIATURE:
CATHERINE II, EMPRESS OF RUSSIA M175

Johann Baptist Göstl (1813-95) after D.G. Levitsky (1735-1822)
Austria (Vienna) 1850
Gouache on ivory 19.0 x 14.3
Signed and dated, lower left: *Göstl/850*
PROVENANCE: Anatole Demidoff; his (San Donato) sale, Paris, 8 March 1870 (427) bt. by the 4th Marquess of Hertford, 395 fr.

This miniature is copied from one of many versions of the portrait by Levitsky, the earliest of which is dated 1783. Göstl was a largely employed in painting ceramic plaques for the Vienna porcelain factory. Demidoff had a prodigious enthusiasm for images of royalty, whether painted or sculpted, which he indulged to the full at San Donato: in the 1870 sale alone there were three oil portraits of Catherine II and four of Peter the Great. The appeal of this portrait to Lord Hertford was perhaps related to his ownership of part of the sitter's spectacular Sèvres porcelain service (see No.34). The frame is almost certainly Demidoff's original.

45 PENDENT JEWEL: *THE INCREDULITY OF ST THOMAS* XII A 72

Figures:

German (probably Augsburg) late sixteenth century

Enamel in the round on gold (*émail en ronde bosse*)

Setting:

Fossin et fils

French (Paris) c.1837

Enamelled gold, with rubies, pearls, emeralds and a sapphire

7 x 11.6 x 1.1

PROVENANCE: Fossin et fils, Paris; from whom bt., 13 April 1837, by Anatole Demidoff, 1600 fr.; possibly given by him to Mathilde, princesse Bonaparte, 1840-46; possibly given by her to Alfred-Émilien, comte de Nieuwerkerke (1811-92), and certainly with him by 3 October 1870 (when lent to the South Kensington Museum, and unsuccessfully offered to it for £400; see below); 19 August 1871, bt., with the greater part of the Nieuwerkerke collection *en bloc* (for 400,000 fr.), by Sir Richard Wallace (and loaned by him to the South Kensington Museum by 24 October 1871)

The Incredulity of St Thomas (*John* 20: 19-29): the Apostle Thomas, absent when Christ first appeared to the disciples after his crucifixion and showed them his wounds, refused to believe until Christ asked him to 'reach your hand here and put it into my side'. In this jewel, Thomas kneels in awe before Christ, with the remaining ten disciples grouped around.

The figure group itself appears to be high quality Augsburg (or Nuremberg) work of c.1590. Digby Wyatt, Art Referee for the South Kensington Museum in 1870, before baulking at the price, commended the piece as 'a magnificent specimen and quite worthy of the hand of Caradosso of Milan' (Caradosso (c.1452-1526/7) was one of the most famous Renaissance goldsmiths, but none of his work is known to have survived). This high regard for the object persisted until the 1980s when inconsistencies and anachronisms in the setting led several commentators to doubt that particular part, or even the whole jewel. Indeed the hand of the Aachen faker Reinhold Vasters (1827-1909) has been suspected. However, the identification by Diana Scarisbrick in November 1993 of this jewel with an entry in the archives of the goldsmiths Fossin et fils (now Maison Chaumet) would seem to settle the debate. Their Day Book 1822-1838 includes the entry for 13 April 1837: '*C^te A Démidoff: p[our] une plaque de chatelaine de Benvenuto Cellini portant 11* [sic] *figures en or ciselées & émaillées reprit. l'Incrédulité de S. Thomas ... 1600* [fr.]'. The Wallace Collection jewel appears to be the only example of the subject with so many figures (the twelfth head is easily missed) and in the late-Renaissance style then generically associated with Benvenuto Cellini (1500-71), the most famous of all goldsmiths (Demidoff also bought a bracelet in '*le style Benvenuto*' in 1844; and see p.90). There is a small group of very similarly-mounted *émail en ronde bosse* figures, of which three are in the British Museum, which should now be re-assessed in the light of this discovery.

The dramatic, indeed almost theatrical grouping of the enamel figures doubtless appealed to Demidoff as much as the great skill apparent in their execution. Although the jewel was described as a plaque for a chatelaine, he probably kept it for display rather than for a mistress (given its inappropriate subject). It is not clear when - or even if - it passed to Princess Mathilde, whom he did not marry until 1840. It is also uncertain how the piece came to Nieuwerkerke, although the fact that he was the lover of Princess Mathilde after her separation from Demidoff provides an attractive link between the two.

REFERENCES: Maison Chaumet archives; Scarisbrick; Tait, pp.109-19, especially pp.114-6.

PIPES AND SMOKERS' REQUISITES

Demidoff was an inveterate smoker. When he stayed at Thomas's Hotel in London, an establishment '*aussi select que cher*', where those who returned after 10 p.m. or who smoked in their rooms were usually frowned upon, the management was obliged to turn a blind eye to his activities. Even in his last days of chronic ill-health he seems to have maintained the habit: the 1870 Paris *hôtel* inventory lists three cigar boxes in the *petit salon* alone, and another in the *cabinet de travail*. And this passion for smoking naturally extended to collecting. Despite the general decline in pipe-smoking (as well as snuff-taking) before the advance of the cigar and the cigarette in the nineteenth century, he built up a large collection of pipes, some of the best of which Lord Hertford bought in 1870.

Demidoff's early interest in them is indicated by the depiction of a group of six meerschaums and five long-stemmed North African pipes on a rack, in Carl Kollman's 1834 watercolour of a small room in his Paris *hôtel*. A whole session (8 April) of the 1870 sale was devoted to smokers' requisites. There were nearly one hundred pipes, including forty meerschaums, a similar number of North African (or Middle Eastern) pipes, a few narghili (water pipes), and many smokers' requisites - such as Nos.49-50. To judge from the catalogue descriptions, and from Nos.46-8, they were of elaborate and often very rich craftsmanship, doubtless their main appeal.

Unlike Demidoff, Lord Hertford seems to have been interested only in the long-stemmed North African pipes; both men acquired and displayed these objects essentially as exotica, as part of the general fashion for things Oriental or Islamic (see also Arms and Armour). Demidoff kept his collection in the Turkish Room (rather than in the designated smoking rooms) at San Donato, where a contemporary visitor saw an 'enormous number of superb pipes, displayed in two cupboards, which have a curiosity, a character and a richness that one is unable to describe, with their long and massive amber mouthpieces decorated with bands of gold and encrusted with countless precious stones'. When Sir Richard Wallace re-arranged the collections at Hertford House in the 1870s, he kept the pipes in circular racks in the Oriental arms and armour gallery, rather than in his purpose-built tiled smoking room (present Gallery 7). Both Demidoff and Lord Hertford accumulated Oriental and North African weaponry, costumes, textiles, and *objets d'art* as well as pipes (and Orientalist paintings). Demidoff went further, also acquiring Chinese paintings and furniture, which he displayed in a Chinese Room (there were also Arabian and Indian Rooms). All these were sold in the 1870 sale.

REFERENCES: Corti; Lemoisne, p.125 (Thomas's Hotel); Archives de Paris (et/LV/482) (1870 inventory); Gonzales-Palacios, pp.116-23 (Kollman watercolour).

46 PIPE MOUTHPIECE *(PART OF)* Uncatalogued

North African nineteenth century

Around a wooden core, a band of three-coloured gold, with three principal mounts of silver set with diamonds and a single ruby, emerald and sapphire; turquoises (one missing) alternate between each mount. At each end, three opals alternate with three rubies; flowers of lilac, green and orange-red enamel between the rubies of the outer band and the turquoises

5.4 x 2.5 x 2.5

MARKS: none

PROVENANCE: Anatole Demidoff; his (San Donato) sale, Paris, 8 April 1870 (842), bt. Mannheim, 405 fr., for the 4th Marquess of Hertford.

The complete pipe, as described in the 1870 catalogue, consisted of a mouthpiece of two amber parts, with this section inserted between them, a stem of cherry wood, a sheath of white silk and blue velvet, and a clay bowl.

47 PIPE MOUTHPIECE Uncatalogued

North African nineteenth century

Around a wooden tube, a mouthpiece of coral in three sections, with two inserts of jade inlaid with gold and rubies

5.7 x 1.7 x 1.7

MARKS: none

PROVENANCE: Anatole Demidoff; his (San Donato) sale, Paris, 8 April 1870 (844), bt. Mannheim, 605 fr., for the 4th Marquess of Hertford.

The complete pipe, as described in the 1870 catalogue, had a stem decorated with pearls of various colours, and a clay bowl. The remains of a label, with the printed inscription 7†\, is stuck with wax to the middle coral band.

48 PIPE Uncatalogued

North African nineteenth century

Around a wooden tube, a Russian rose-coloured manganese mouthpiece, a white agate insert between two Oriental sardonyx cameos set in gold and enamel mounts; plain ebony stem with a single chased-gold mount; and clay bowl

Mouthpiece: 22.1 x 2.1 x 2.1; *Stem*: 102.1 x 2 x 2; *Bowl*: 7.5 x 5 x 5; *Total length*: 131.7

PROVENANCE: Anatole Demidoff; his (San Donato) sale, Paris, 8 April 1870 (845), bt. Mannheim, 685 fr., for the 4th Marquess of Hertford.

NO.46 (RIGHT); NO.47 (LEFT); NO.48 DETAIL (MIDDLE)

The pipe would appear to be complete (and unsmoked). On the smaller cameo is carved a standing figure wearing a pleated kilt and a *nemes* headdress and (on the reverse) a canopic jar with a lid in the form of a human head (also wearing a *nemes*). On the larger cameo is a seated crowned cup-bearer, with another standing figure on the reverse and terms on the narrow sides. Both cameos are incised with various hieroglyphs which, like those on the mounts, although in the form of true hieroglyphs, are apparently random and meaningless. The bowl is decorated with a stylized papyrus-bud motif.

49-50 PAIR OF PIPE-RESTS Uncatalogued

Sazikov

Russian (St Petersburg) 1851

Silver, chased and gilt

6.8 x 21.8 x 21.8; wt: c.170 (each)

MARKS: St Petersburg, 1818-64; P.P. Dmitriev, assayer (St Petersburg 1841-51); Sazikov; *titre* of 84 *zolotniki* (i.e. 21 carats or 87.5% pure silver)

PROVENANCE: Presumably commissioned by Anatole Demidoff; his (San Donato) sale, Paris, 8 April 1870 (930), bt. Mannheim, 175 fr., for the 4th Marquess of Hertford.

These rests were intended for long-stemmed Oriental pipes, such as Nos.46-8. Four of the eight ogee projections on the rim of each platter bear the repeated initials *AD*, in cyrillic capitals, for Anatole Demidoff. 84 *zolotniki* was the legal minimum standard *titre* (proportion of precious metal to alloy) for Russian silver from 1798 to 1917.

The firm of Sazikov was founded by the engraver Pavel Fedorovitch Sazikov in Moscow in 1797. His son Ignati Pavlovitch (1793-1868), the most celebrated silversmith in the family, controlled the production of silver and gold objects between 1830 and 1868. A sister business was established in St Petersburg in 1842. Sazikov ranked with Khlebnikov (with which it merged in 1887) and Fabergé among the most important mechanised factories in nineteenth-century Russia, being noted especially for its technical perfection and for promoting *le style russe*. The firm had a special section for up to eighty apprentice craftsmen, employed several eminent painters and sculptors, and was in the vanguard in using new technology. In 1837 Nicolas I made it supplier to the Court, enabling it to include the Imperial eagle in its mark. Its participation in the 1851 Great Exhibition in London established its fame and fortune internationally.

REFERENCES: Paris 1993, pp.236, 241-6, 252; Goldberg, pp.13, 15, 190 (mark no.971), 198 (mark no.1179), 199 (mark no.1206), 202 (mark no.1301).

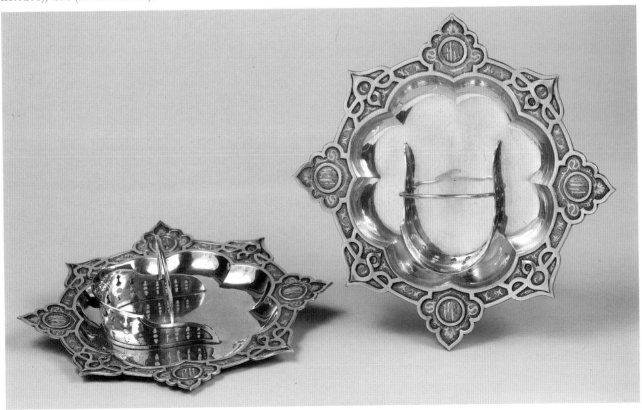

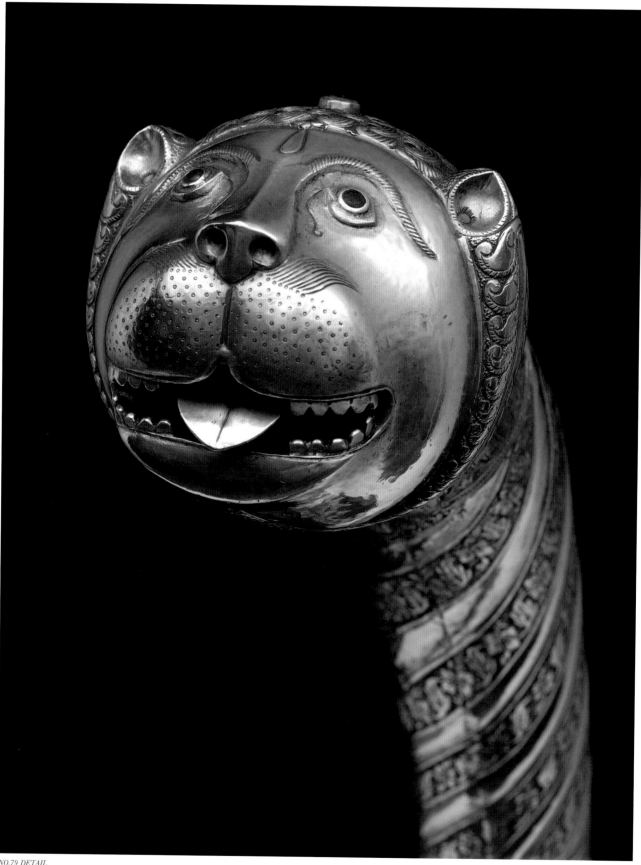

NO.79 DETAIL

ARMS AND ARMOUR

The vast family fortune of the Demidoffs had been founded in part on their expertise in arms manufacture, and it therefore seems appropriate that an integral part of Anatole's art collection should have been his magnificent armoury. In fact this was probably no more than coincidence, since most art collectors in nineteenth-century Europe regarded arms and armour as worthy of admiration, and therefore a suitable subject for study and acquisition. Artists too shared this interest: Bonington, Vernet and Delacroix studied and painted arms and armour, and even owned some examples themselves. In Delacroix's portrait of the comte de Mornay and Anatole Demidoff (fig.7) arms and armour in typical salon arrangements feature prominently in the background, complementing the rich fabrics and paintings on the walls. Since then, of course, two World Wars have done much to alter European society's perception and appreciation of this area of collecting, but in recent years there has been a revival of interest in arms and armour as an expression of the culture and taste of earlier ages.

For centuries the great ruling dynasties of Europe had accumulated huge and impressive armouries, not only to keep their armies supplied but as part of a political and social requirement for conspicuous consumption and display, indicating both personal and dynastic wealth, power and taste. As individuals too, many European rulers became keen collectors. Napoleon III (1808-73) showed little interest in fine art, but assembled an armoury of the finest European medieval and Renaissance pieces, notably by purchasing *en bloc* the Soltikoff collection in 1861. It is said that Sir Richard Wallace subsequently offered the Empress Eugénie two million francs for this collection. Although later dispersed, some of the most important items can still be seen today in the Louvre and the Musée de l'Armée in Paris. The comte de Nieuwerkerke (1811-92), *Surintendant des Beaux-Arts* under Napoleon III, amassed a similarly fine collection of medieval and Renaissance objects including arms and armour of the finest quality, which in 1871, following the fall of the Second Empire, he was obliged to sell to Sir Richard Wallace. The Russian Prince Alexander Basilevsky (b.1829) also formed a magnificent art collection, incorporating arms and armour of princely quality, mainly in Paris between 1850 and 1884. At the San Donato sale in 1870 he bought (for 20,200 fr.) one of the finest items from Demidoff's armoury: a richly-decorated glaive (ceremonial staff-weapon) reputedly of the thirteenth century. In 1884 the best pieces of medieval and Renaissance decorative art from Basilevsky's collection were bought by Tsar Alexander III for the museum at Tsarskoé Sélo, which later formed part of the Hermitage Museum. At the time there was no comparable collection anywhere in Russia.

Few of the great individual art collections assembled in the nineteenth century escaped subsequent dismemberment. Those that survive are remarkably similar in nature, and still have a nineteenth-century 'feel' to them, giving us a good idea of the rationale and taste that shaped their formation. The Poldi Pezzoli collection in Milan was brought together by a wealthy industrialist, Giacomo Poldi Pezzoli (1822-79), while the Stibbert collection in Florence was begun in the 1880s by an emigré Englishman Frederick Stibbert (1838-1906). Sir Richard Wallace assembled most of his collection in the early 1870s, mainly in France, although he continued to collect on a small scale thereafter. Even as they appear today, these collections with their varied content and extraordinary opulence are certainly representative of their era; significantly, princely arms and armour form a major element in all three. Indeed, numerically the Wallace Collection contains more items of

arms and armour than any other single area of interest, including paintings.

In the nineteenth century all these armouries were displayed in a similar way, predominantly in the form of trophies arranged in symmetrical patterns covering the walls, sometimes with items casually leaning in the corners of the room, and the remainder in glass cases, often in carefully jumbled heaps rather than the sparse and symmetrical displays more usual now. Much of the plate (body) armour was mounted on dummies placed around the room, with equestrian armours positioned to make an eye-catching centrepiece. At San Donato the room containing Demidoff's armoury followed this general convention, although nothing was hung upon the walls; his trophies of arms were all contained within four large glass cases, except apparently for some armours standing by the doors. The walls instead were covered with gilded leather in a style 'characteristic of the magnificence of the Middle Ages', and the coffered ceiling of richly-carved walnut incorporated 'emblems of war'.

Anatole Demidoff, like his father Nicolas, collected both European and Oriental armour and weapons, as well as costumes and decorative metalwork. Anatole's purchases, like those of most of his contemporaries, reveal a fondness for the richest and most splendid workmanship, and a desire to possess works of art with a particularly impressive provenance. Unfortunately, the immediate sources of his arms and armour can now only rarely be traced, and (apart from a few instances in which we know for whom they were originally made) none of the pieces in this exhibition has a known provenance before Demidoff.

The armoury at San Donato contained a very large and varied assortment of European and Oriental weapons, some decorated armour, and a small collection of Pacific Islands, South American and Australasian material. Surprisingly, perhaps, there were only five complete standing figures. Two of these were in early sixteenth-century 'Maximilian' style, and two more were described merely as 'German, sixteenth century'; all four were sold in 1870. The fifth armour, which was richly embossed and gilt, does not appear in the 1870 sale catalogue but may well have been that sold earlier by Demidoff for 22,500 fr. in his Paris sale of 1863. From the catalogue entry it was obviously a very fine sixteenth-century parade armour, although its description may not be entirely reliable (it was said to have been made by Benvenuto Cellini for François Ier; in the nineteenth century Cellini's name was often applied to works of art as a mark of approbation rather than on firm art-historical evidence; see also No.45).

Probably the plain armours were acquired by Demidoff more for their impressive, almost architectural, decorative effect in his armour room than for their place in the historical development of European plate armour. The remainder of his numerically-small armour collection seems to have consisted mostly of richly-decorated individual pieces of ornate parade armour, of which perhaps the most outstanding example remaining after the 1863 sale was the magnificent embossed, damascened, silvered and gilt Italian parade shield, signed by Giorgio Ghisi of Mantua, and dated 1554. At the San Donato sale in April 1870 it was bought by baron Ferdinand de Rothschild for the extraordinary sum of 160,000 fr., with the 4th Marquess of Hertford the underbidder. This shield is now in the British Museum, part of the Rothschild (Waddesdon) bequest of 1888.

Items like these were no doubt collected by Demidoff in the same spirit that led him to purchase the considerable number of similarly ornate (but far less important) European and Oriental edged weapons and firearms which comprised most of the remainder of his collection. These ranged in date from the sixteenth century (some swords with chiselled and damascened hilts, and guns described as being from the time of Christopher Columbus) to the mid-nineteenth century (represented by some contemporary firearms and a few modern swords, the hilts invariably decorated in the Renaissance style and some mounted on fine early blades). A number of French Napoleonic weapons, and some relics of the battle of Waterloo and Napoleon's exile on Elba, testify to Demidoff's connections by marriage to the Bonaparte family, and particularly to his enthusiasm (shared by many of his contemporaries including Lord Hertford) for the Napoleonic Legend.

The 1870 San Donato sale catalogue also contains some arms that were probably souvenirs collected during Demidoff's travels abroad. Thus a plain Russian military musket and bayonet (regulation pattern of

1832) could perhaps have been acquired during his Crimean trip in 1837, while the equally plain Spanish-made percussion sporting guns (one dated 1842 and another 1846), not to mention the large number of ordinary Spanish peasant knives, may well have been souvenirs of his visit to Spain in 1847. His collection of knives and other objects is likely also to be a reflection of his interest in local customs and folklore.

Some of the edged weapons in the armoury section of the San Donato sale were probably originally associated with Demidoff's large collection of exotic European and Oriental costumes, of which nearly thirty were sold in 1870. These ranged from Spanish matadors' outfits (two toreadors' swords were included in the armoury sale) to the clothing and personal possessions of a Russian peasant, including a balalaika. Demidoff's fascination with folklore seems to have been combined with a sincere and scholarly interest in what could perhaps be described today as 'ethnography', but undoubtedly the more exotic costumes in his collection also reflect his passion for 'dressing up'.

Particularly evident is Demidoff's love of all things Spanish: one of the four large display cases in the armoury was devoted exclusively to Spanish weapons, including those used for bullfighting. Much of the Spanish collection (though not the weapons) was displayed in its own special room. More rooms were devoted to works of art from other countries (see fig.4), or set aside for medieval and Renaissance works of art and furnishings, but arms and armour seem to have been excluded from these displays. Turkish weapons, for example, seem to have been unrepresented in the Turkish room at San Donato, although Demidoff had a large collection of them.

In contrast to the wide scope of the Demidoff armoury, the 4th Marquess of Hertford concentrated on buying Oriental arms and armour (largely Indian and Persian, with some Turkish), together with other decorative Oriental works of art and Orientalist paintings. Some of the weapons he bought (for example No.51) were actually European, but made in imitation of the Eastern styles it had become fashionable for European officers to wear. It is likely that Lord Hertford never knew this of individual pieces in his collection, and probably would not have been particularly concerned anyway, being attracted more to their flamboyant decoration and form than to their history. Demidoff may well have regarded his own collection in a similar light.

Other contemporary collectors shared this interest in Oriental objects. The duc de Morny, for example, who seems to have collected almost everything else, showed little interest in European arms as works of art, but collected ornate Oriental weapons (sold at auction in 1865, the 4th Marquess being an active bidder). Demidoff was unusual among European collectors (including Lord Hertford) in acquiring artefacts from the Pacific Islands, New Zealand and South America, but here his interest may have been more ethnographical than artistic. Sir Samuel Meyrick (1783-1848), founder of the serious study of arms and armour in England, had also collected such items as part of his own wider interest in all forms of armour and weapons. When his extensive collection was dispersed in 1871, the best of his European medieval and Renaissance pieces were purchased by Sir Richard Wallace through the dealer Frédéric Spitzer (1815-90); neither of them were interested in the 'ethnographical' items.

Part of the 4th Marquess of Hertford's already extensive art collection (including also some of his pictures, furniture, porcelain and sculpture) was exhibited at the 1865 Musée Rétrospectif exhibition in Paris, five years before his purchases at the 1870 Demidoff sale. Of the 380 items he lent to this exhibition, 249 were Oriental arms and armour. So impressed was Napoleon III by the display that a few days after the opening he offered to lend his own collection of European and Oriental arms and armour. It is likely that in this area of collecting the 4th Marquess of Hertford was following the prevailing 'Orientalist' fashion in Europe, one aspect of which was the furnishing of a Smoking Room in Turkish taste, or as an Oriental armoury (see p.85). Demidoff may have been similarly influenced, although there is no evidence that his Billiard/Smoking Room (see fig.4) ever contained arms and armour.

Over a dozen further items from Demidoff's armoury are known to have been purchased by Lord Hertford; these are itemized in his agent Mannheim's receipts, but the vague descriptions make it difficult to

identify them today (see Appendix I). Even when the description is fairly precise there are too many similar items now at Hertford House to permit certain identification. For example, in one of his four armoury cases Demidoff displayed a 'starburst' trophy of yataghans (a form of short sword, predominantly Turkish in origin). At least three of the six or more sold in 1870 were bought by Lord Hertford, but due to the similar decoration of nearly thirty such weapons in the Wallace Collection, none can be positively identified. On the other hand, one entry in the Demidoff 1870 sale catalogue can be matched with an item whose provenance was not previously known (see No.71).

Richard Wallace shared his father's interest in arms and armour, but concentrated more on European medieval and Renaissance armour and weapons. He did, however, purchase some eighteenth and early-nineteenth century sporting arms and edged weapons, all of the very finest quality, and remarkably similar in nature and decoration to some of his father's San Donato purchases (Nos.52, 55, 58-66). Before he inherited Lord Hertford's collection, the sale in 1857 of his first art collection (assembled independently, and probably sold to pay debts) included seventeen lots of arms and armour. Six at least of these were Oriental, most of the rest being richly decorated European daggers and pistols. Of the very few European arms purchased by the 4th Marquess, almost all were acquired from Demidoff. Richard Wallace acted as his father's secretary and sale-room agent, and it is tempting to see in some of Lord Hertford's purchases at the San Donato sale the influence of his son's taste. Wallace himself, judging by his early collecting activities, appreciated Oriental arms and armour, but on inheriting his father's vast collection (three times the size of Demidoff's own) presumably felt little need to add to it further, and concentrated instead on acquiring items for his European armoury. His purchase in 1871 of the comte de Nieuwerkerke's collection and the best of Sir Samuel Meyrick's (assembled early in the century at the height of the 'Gothic' fashion) largely achieved this aim. The remainder of his armoury purchases until his death in 1890 amounted to a tiny fraction of these early acquisitions.

REFERENCES: Norman, p.1 (Empress Eugénie); Kryzanovskaya.

EUROPEAN EDGED-WEAPONS

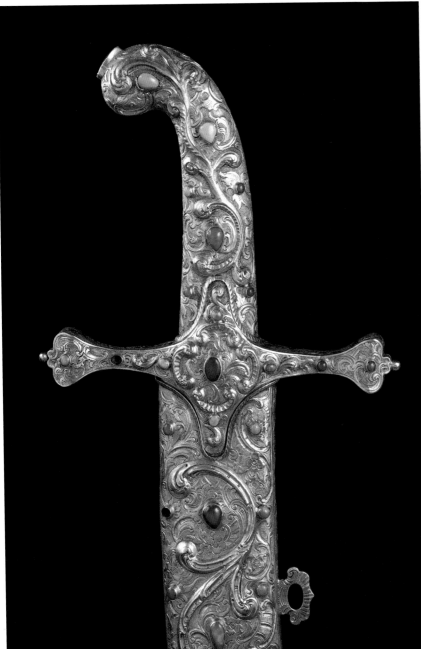

51 SABRE OA1753

Austrian (Vienna) c.1846
Overall length 96.6, blade 78.3,
weight 168

MARKS: On the hilt and each scabbard
mount are: the standard Vienna mark
for silver of 13 *lötiges* (R^3 7860);
unidentified Austrian maker's mark
(Habsburg eagle and initials *HH*); the
Paris '*ET*' mark for gold and silver (of
unspecified standard) imported from
countries without customs conventions
(law decreed 24 October 1864).

PROVENANCE: Anatole Demidoff; his
(San Donato) sale, Paris, 5 April 1870
(606), bt. Mannheim, 340fr., for the
4th Marquess of Hertford.

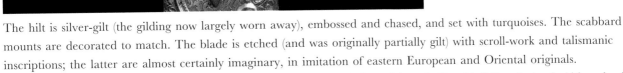

The hilt is silver-gilt (the gilding now largely worn away), embossed and chased, and set with turquoises. The scabbard
mounts are decorated to match. The blade is etched (and was originally partially gilt) with scroll-work and talismanic
inscriptions; the latter are almost certainly imaginary, in imitation of eastern European and Oriental originals.

This is the sword that appears in the equestrian portrait by Briullov of Anatole Demidoff (frontispiece). Although of
Austrian manufacture it is very much in the Oriental style, and had it not been for the silver marks would perhaps have
passed for Turkish even today.

REFERENCES: Carré 1931, p.213; Rosenberg 1928, no.7860 (marks)

52 MILITARY SMALL-SWORD WITH AN EXPANDING STEEL HILT A693

Probably French c.1750-60

Overall length 99, blade 82, weight 89

MARKS: The blade is stamped in brass 'Berlin' near the hilt; another brass stamp bears the crowned eagle of Prussia holding an orb and sceptre.

PROVENANCE: Anatole Demidoff; his (San Donato) sale, Paris, 6 April 1870 (646), bt. Mannheim, 545 fr., for the 4th Marquess of Hertford.

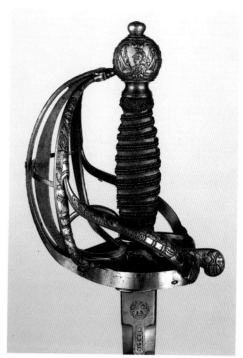

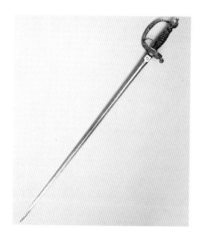

The blade has been slightly reduced in width by over-grinding, probably during nineteenth-century restoration. The pommel, outer surfaces of the bars of the hilt, and the shell guards are decorated with trophies and foliage, chiselled in low relief on a matted gold ground. The scabbard is missing.

It was not unusual for sword manufacturers to use imported German blades. This was probably an officer's (non-regulation) weapon, obtained by private purchase; with the hilt collapsed it could be worn as a dress sword, but in action the guard would be expanded to afford its owner better protection for the hand.

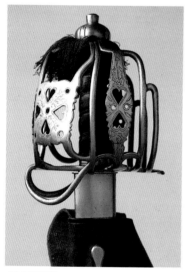

NO.53 DETAIL

53 BASKET-HILTED CAVALRY SWORD
(PROBABLY FOR DRAGOONS) A696

Hilt:

British c.1750-75

Blade:

Probably German nineteenth century (or earlier)

Overall length 102.1, blade 86.3, weight (without scabbard) 125

MARKS: The triple-fullered blade is struck on both sides:

SOLIDIO/ANDRIA/FERARA/GLORIO.

PROVENANCE: Anatole Demidoff; his (San Donato) sale, Paris, 5-8 April 1870 (713, and shoulder-belt, 714), bt. Mannheim, 201 fr., for the 4th Marquess of Hertford.

The hilt resembles a Scottish basket-hilted claymore, having been made to appear more Scottish by the (presumably nineteenth-century) addition of crudely engraved decoration incorporating thistles. The silver buckle on the shoulder-belt for the sword is from the same workshop as that on the belt of the dirk (No.54), with which it was associated in the Demidoff sale; both the leather belts, and the sword scabbard, are of nineteenth-century manufacture.

By the seventeenth and eighteenth centuries the name of the famous sixteenth-century Italian bladesmith Andrea Ferrara (spelt in a variety of ways) was being applied to many blades, more as a mark of quality than to counterfeit his work. The name is especially common on broadsword blades, particularly those of Scottish claymores. Since this blade

differs from the usual British military pattern, it may be a nineteenth-century replacement intended to reinforce the Scottish appearance of the weapon.

Mannheim also purchased the Scottish dirk (No.54), as well as a *sgian dubh* (small Scottish knife), lot 716, and a sporran, lot 733, neither of which is now in the Collection. Demidoff's close friend Fox Maule, 11th Earl of Dalhousie (1801-74) was himself an important collector of arms and armour, and may have inspired his interest and even supplied him with such items. In another section of the Demidoff sale there were two complete Scottish costumes, perhaps once associated with these lots. Scottish costume, weapons and other souvenirs were very popular with European collectors (for example Stibbert) and there are many nineteenth-century portraits of German princes in full Highland dress.

REFERENCES: *The Times*, 23 May 1870 (Dalhousie).

54 SILVER-MOUNTED DIRK A735

Scottish (Edinburgh) early nineteenth century
Overall length 48.7, blade 33.1, weight 37
MARKS: The blades of the knife and the dirk are each stamped with the name of the cutler: *MOYES*
PROVENANCE: Anatole Demidoff; his (San Donato) sale, Paris, 5-8 April 1870 (715), bt. Mannheim, 118 fr., for the 4th Marquess of Hertford.

The leather waist-belt, frog and silver buckle are of similar workmanship to those of the previous item (No.53), and all were probably made to match in the mid-nineteenth century. The wooden sheath, decorated with carved Celtic interlace, contains a silver-mounted byeknife and fork each set with a cairngorm, as is the haft of the dirk.

John Moyes is recorded at 11, Nicholson Street, Edinburgh, from 1793 to 1796, and at College Street from 1797 to 1823/4. This weapon was never intended for use as such, but is a fairly standard item of nineteenth-century Scottish ceremonial dress.

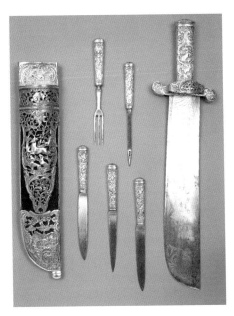

55 HUNTING TROUSSE A704

German early nineteenth century
Overall length 57.7, blade 38.7, weight 203
MARKS: The blades of the small skinning knives are stamped with a crowned *H*, the mark of an unidentified cutler.
PROVENANCE: Anatole Demidoff; his (San Donato) sale, Paris, 6 April 1870 (650), bt. Mannheim, 300 fr., for the 4th Marquess of Hertford.

The hilt and sheath mounts are of silvered and gilt bronze, and the blade is of burnished steel, broadly etched with a figure and other decoration in pseudo-Oriental style. In addition to the large butchering knife, the sheath contains a set of five small eviscerating and skinning implements. There are three knives, a fork and a file, the latter pierced at the end for use as a needle.

Such sets of knives, carried during boar and deer hunts, were popular throughout the eighteenth and early nineteenth centuries in the German lands; this particular example is a late version of a continuing tradition.

56 PARTIZAN A1008

French after 1667
Overall length 240, head 53.3, weight 291
PROVENANCE: See below. Anatole Demidoff; his (San Donato) sale, Paris, 6 April 1870 (641), bt. Mannheim, 1,900 fr., for the 4th Marquess of Hertford.

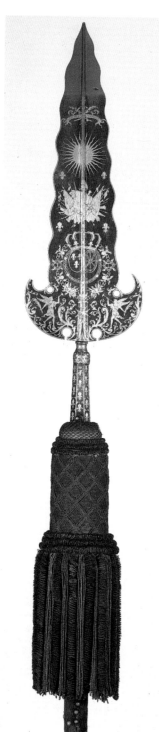

NO.56 DETAIL

The blade is blued, and damascened in gold with the arms of France and Navarre surrounded by the collars of the Orders of St Michel and St Esprit (incorporating the Royal initial *H*, for Henri IV, founder of the order) surmounted by a crown. Above this is a trophy of arms, the sun in splendour, and a scroll with the Royal motto *NEC PLURIBUS IMPAR* ('equal to anything'). The tassel is probably original, although the green velvet covering of the staff may be later (in the Demidoff sale catalogue it is described as being blue); blue cloth dyes, however, have been known to degrade through time, becoming green.

This ceremonial staff-weapon, probably designed by Jean Berain, was made for the *Gardes du Corps* (personal bodyguard) of Louis XIV (1638-1715, reigned from 1643).

EUROPEAN FIREARMS

57 WHEEL-LOCK PISTOL A1179

French (North-Eastern) c.1620
Overall length 84.7, barrel 63.9, bore 1.0, weight 152
MARKS: Both the lock and the stock are stamped *III* inside (probably construction marks). The number *128* (presumably an inventory number) is engraved on the breech-strap of the barrel.
PROVENANCE: Anatole Demidoff; his (San Donato) sale, Paris, 6 April 1870 (657, although illustrated as lot 656), bt. Maillet de Boullay, 500 fr.; the 4th Marquess of Hertford.

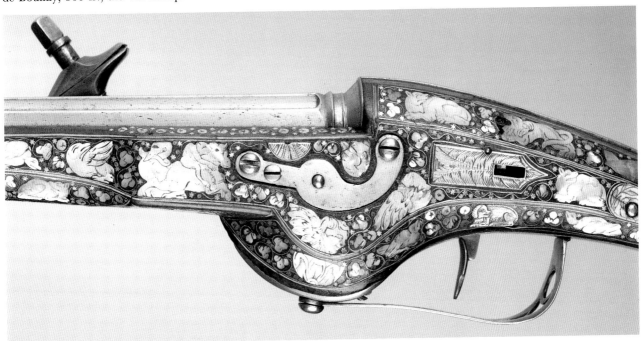

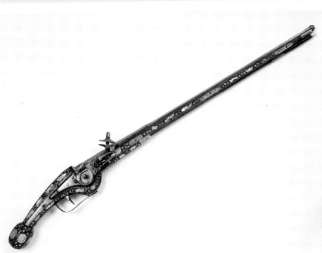

The stock, of French form, is richly decorated with engraved mother-of-pearl and stag's horn inlays depicting monsters, cherubs, birds and animals, with a background of small mother-of-pearl insets and floral ornament of inlaid brass wire. Some of the mother-of-pearl insets have been replaced, and the ramrod is not original.

Several of these guns are known, but this one is of especially fine quality. An interesting feature is the extended sear, protruding through a slot in the left side of the stock. This shows, by its position, whether or not the lock is spanned and ready to fire.

58 FLINT-LOCK SPORTING GUN A1119

Attributed to Johann Christoph Stockmar (1719-47)

German (Saxon) c.1745

Overall length 137.5, barrel 99.7, bore 1.6, weight 298

MARKS: The barrel mark (FG), under the breech, is recorded as 'possibly Suhl about 1730'.

PROVENANCE: See below. Anatole Demidoff; his (San Donato) sale, Paris, 6 April 1870 (658), bt. Mannheim, 1,750 fr., for the 4th Marquess of Hertford.

The steel mounts are finely chiselled in relief on a matted gold ground; the smooth-bore, blued barrel is decorated to match. The carved walnut stock is inlaid with elaborately chased panels of silver-gilt and rows of studs, alternately of ivory and gold.

The escutcheon bears the initials of either Ernst Augustus I of Saxe-Weimar (d.1748), or possibly of Ernst Augustus II (d.1758). This gun may have been made by J.C. Stockmar, although other craftsmen also worked in this style. Johann Christoph was the son of Johann Nikolaus Stockmar, the Saxon court engraver (fl.1719-45); the family were famous craftsmen, working chiefly at Heidersbach near Suhl for the Saxon court.

REFERENCE: Heer, I, p.476, no. A2480 (mark).

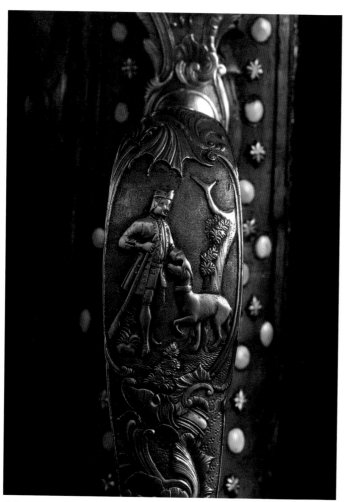

No.59 DETAIL (TRIGGER GUARD)

59 FLINT-LOCK SPORTING RIFLE A1120

Johann Christoph Stockmar (1719-47)

German (Saxon) c.1745

Overall length 103.0, barrel 64.5, bore 1.5, weight 334

Signed, on the barrel: J.C. Stockmar

PROVENANCE: Anatole Demidoff; his (San Donato) sale, Paris, 6 April 1870, lot 659, bt. Mannheim, 1,600 fr.; for the 4th Marquess of Hertford.

The mounts are of chiselled and engraved silver with rococo decoration on a matted gold ground; the stock is of carved walnut with similar decoration to No.58. The hair trigger has been broken off and only the setting lever remains.

Although such fine guns were usually made in sets, there are differences in the decoration of these two pieces which indicate that they do not belong together. For the maker J.C. Stockmar, see No.58 above.

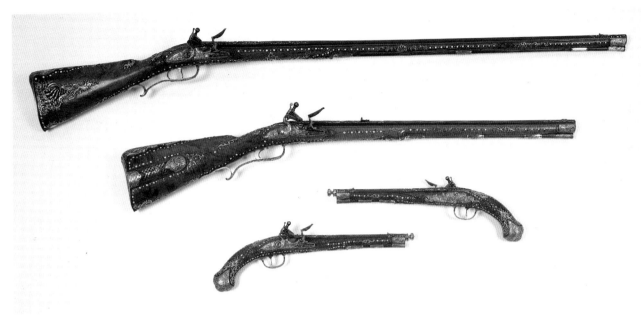

NO.58 (TOP); NO.59 (MIDDLE); NOS.60-61 (BOTTOM)

60-1 PAIR OF FLINT-LOCK PISTOLS A1203-4

Attributed to Johann Christoph Stockmar (1719-47)

German (Saxon) c.1745

Overall length 43.2, barrel 25.7, bore 1.40, weights 87 (No.60) and 92 (No.61)

PROVENANCE: See below. Anatole Demidoff; his (San Donato) sale, Paris, 6 April 1870 (660), bt. Mannheim, 2,300 fr., for the 4th Marquess of Hertford.

The mounts are of finely-chiselled and gilt steel, and like the other guns (Nos.58-9) are of the very best quality. Each pistol retains its original (and rare) full-length barrel-tompion, designed to keep the bore clean while the weapon was not in use.

The monogram on the silver-gilt escutcheons of these pistols differs from that on the long gun (No.58), so they are unlikely to be from the same set (although presumably they were believed to be, by both Demidoff and Lord Hertford). Nonetheless, these pistols were made for the same ruling house of Saxe-Weimar, and although unsigned were probably made by J.C. Stockmar (see No.58 above).

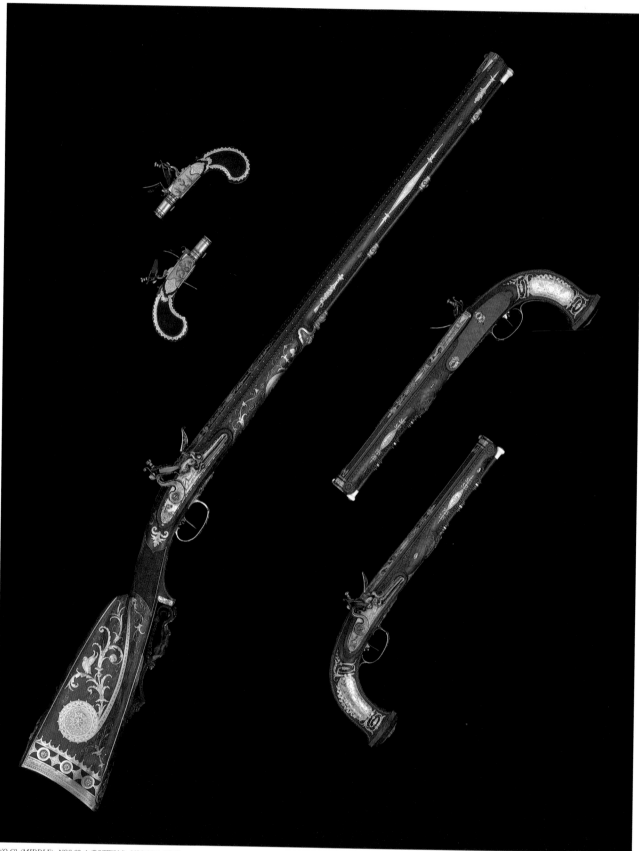

NO.62 (MIDDLE); NOS.63-4 (BOTTOM); NOS.65-6 (TOP)

62-6 Set comprising:

FLINT-LOCK SPORTING RIFLE A1131
PAIR OF FLINT-LOCK HOLSTER PISTOLS A1219-20
PAIR OF FLINT-LOCK POCKET PISTOLS A1221-2

Nicolas-Noël Boutet (1761-1833)
French (Versailles) c.1805

No.62 (A1131): Overall length 105.5, barrel 65.3, bore 1.5, weight 291

Nos.63-4 (A1219-20): Overall length 40.7, barrel 26.4, bore 1.7, weights 91 (No.63) and 92 (No.64)

Nos.65-6 (A1221-2): Overall length 13.8, barrel 2.4, bore 1.3, weight 27 (each)

MARKS: The barrel mark *(DB)* under the breech of the rifle No.62 is also to be found in the same place on the holster pistols Nos.63-4. These barrels are struck with Boutet's proof marks as used at the Versailles factory, and are engraved *Manufacture à Versailles* and *Boutet Directeur Artiste*. The standard and excise marks struck on the silver-gilt furniture of the rifle are for the period 1790-1809. The *petite garantie* mark (also present on the pistols) is for 1819-38, indicating that these weapons were on the market in France at that time. The pocket pistols bear no marks at all, but *BOUTET DIRECTEUR ARTISTE* is engraved on the top plate of each. The barrel lugs are numbered *1* and *2* respectively.
PROVENANCE: Anatole Demidoff; his (San Donato) sale, Paris, 6 April 1870 (661, the set), bt. Mannheim, 5,000 fr., for the 4th Marquess of Hertford.

The rifle (No.62) and pair of holster pistols (Nos.63-4) are stocked in carved walnut and ebony, inlaid with gold; their mounts are of finely-chiselled silver, parcel-gilt. All three have multi-groove rifled barrels. The pocket pistols (Nos.65-6) are of engraved and burnished steel, their ebony butts inlaid with gold. The short, smooth-bore barrels unscrew for loading, each being furnished with a small lug underneath designed to engage with a separate barrel-key (now lost). The trigger folds away as a safety measure, springing out automatically when the pistol is brought to full cock. Unlike the holster pistols, the pocket pistols have seen very little use, and the rifle may never have been fired at all.

Nicolas-Noël Boutet was gun-maker to the Royal, and then Imperial, Court of France at Versailles and is generally recognized as being the finest Continental gun-maker of his time. Although his factory at Versailles did manufacture high-quality regulation military arms (including edged weapons), it is for his presentation - quality cased firearms that he is best known. In 1870 this rifle (No.62) was sold in its (presumably original) box with a complete set of tools, together with the pair of holster pistols (Nos.63-4) and pair of pocket pistols (Nos.65-6); the set is established by provenance rather than by uniformity of decoration. This case, now lost, does not appear to have ever entered the Wallace Collection.

REFERENCES: Versailles 1993; Støckel, no. A2360 (barrel mark).

67 CANNON A1245

Barrel:
Giovanni Mazzaroli (fl.1660-1710)
Italian (Venice) 1688
length 139, bore 3.8, weight 8300
INSCRIBED, on muzzle: *IO. MAZZAROLI. F. 1688*

Carriage:
woodwork: Angiolo Barbetti (1803-80)
ironwork: G. Ciani
Italian (Florence) 1853-4

Overall length 193, maximum height (excluding barrel) 64.2, width between wheel hubs 84
INSCRIBED: *F. QUESTO CARRO/A. BARBETTI. IN. FL./L'. 1853* (on axle); *G. CIANI FERRO/QUESTO CARRO/L⁰ 1854*
(on front brace of carriage)
PROVENANCE: Anatole Demidoff; his (San Donato) sale, Paris, 6 April 1870 (633), bt. Mannheim, 12,100 fr., for the 4th
Marquess of Hertford.

The cast-bronze barrel, intended for ceremonial use, is decorated in high relief with scenes from classical legend: Jupiter
and the Titans, Hercules and Cacus, and the Rape of the Sabines. It is both signed and dated by the maker. A similar
cannon barrel (possibly its pair) is in the Hermitage Museum, St Petersburg.

The ornate nineteenth-century carriage, of carved walnut enriched with gilding, bears on each side an oval shield
painted with the arms of Demidoff as Prince of San Donato: *Per fesse argent, in chief a couped barrulet dancetty sable; in base*
sable a hammer proper; over all a devise or. It was commissioned by Demidoff in Florence, and designed by his friend and
secretary Auguste de Sainson, who used as his model a miniature cannon once belonging to Cosimo III de' Medici. The
ironwork was fashioned by G. Ciani, and the remainder by Angiolo Barbetti, an eminent wood-carver who won many
international awards for his work. His comparable walnut cabinet in the Renaissance style, sent to the London Great
Exhibition of 1851, was much praised and won a prize of £400 (see also p.65).

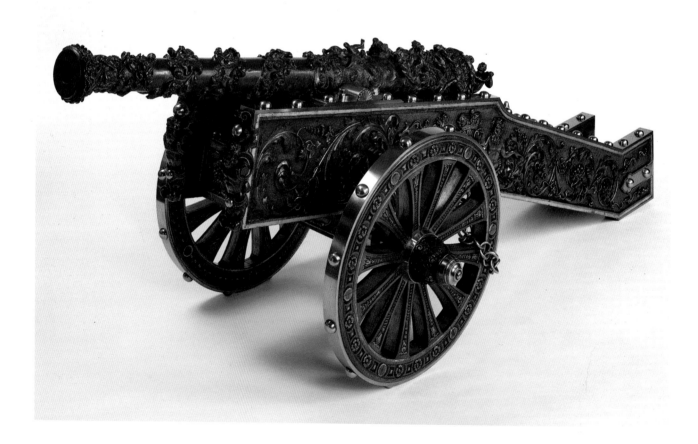

ORIENTAL ARMS

68 PATHAN KNIFE OA1387

Indian seventeenth century

Overall length (complete) 31.2, blade 17.4, weight (complete) 25

PROVENANCE: See below. Anatole Demidoff; his (San Donato) sale, Paris, 5 April 1870 (555), bt. Mannheim, 6,000 fr., for the 4th Marquess of Hertford.

The hilt is of pale green jade encrusted with gold and set with table diamonds (a popular Oriental style of gemstone-cut, in which flat planes rather than faceted surfaces are used), outlined with a chequered design in jade and table rubies. The fine blade is of crystalline-watered steel (*wootz*), delicately inlaid at the hilt with gold. The gold mounts of the sheath are richly enamelled, the top locket pierced to reveal the diamond settings of the grip.

According to the Demidoff sale catalogue, this knife belonged to Tipu Sultan of Mysore (1753-99, ruled from 1782), one of the richest and most powerful of the late-eighteenth century Indian ruling princes. Inevitably coming into conflict with the interests of the British East India Company, he was killed at the conclusion of the Fourth Mysore War during the storming of his palace fortress at Seringapatam. Widespread looting followed, and much of the booty found its way back to England. The Wallace Collection contains one other item from Tipu's armoury (a sword, OA1402).

NO.68 DETAIL

69 MOGHUL DAGGER OA1384

Dagger:

Indian seventeenth century

Sheath:

Probably Turkish early nineteenth century
Overall length 39.3, blade 25, weight (complete) 50

PROVENANCE: Anatole Demidoff; his (San Donato) sale, Paris, 5 April 1870 (558), bt. Mannheim, 1,650 fr., for the 4th Marquess of Hertford.

Both the hilt and the sheath mounts are of carved jade, inlaid with leaves of coloured agates set in gold. The high quality blade is of crystalline-watered steel. The wooden sheath is overlaid with embossed and chased silver-gilt, of typical Turkish workmanship. It was presumably made to replace the original; the inlay of the mounts is of lesser quality, and may even be of hard green wax rather than agate.

It is rare for the dendritic pattern of the crystalline-watered steel to be as evident as it is here, since this was usually removed during the initial forging, polishing and colouring of the blade.

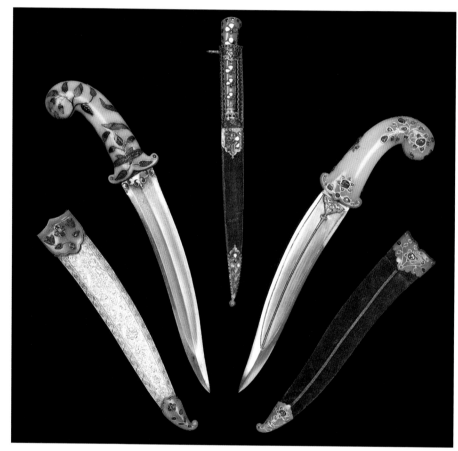

NO.68 (MIDDLE); NO.69 (LEFT); NO.70 (RIGHT)

70 DAGGER OA1424

Indian (Delhi) eighteenth century
Overall length 38.8, blade 23.3, weight (complete) 49

PROVENANCE: Anatole Demidoff; his (San Donato) sale, Paris, 5 April 1870 (545), bt. Mannheim, 2,750 fr., for the 4th Marquess of Hertford.

The hilt is of pale green jade, encrusted in gold, and set with large cabachon rubies, emeralds, and a single table diamond. The blade is of crystalline-watered steel, inlaid near the hilt with gold. The jade mounts of the sheath are decorated to match the hilt.

71 KNIFE *(KUKRI)* OA2186

Indian (Nepalese) late eighteenth or early nineteenth century
Overall length (complete) 49.5, blade 32.5, weight (complete) 70
PROVENANCE: Anatole Demidoff; his (San Donato) sale, Paris, 5 April 1870 (556); bt. for 710 fr; probably the 4th Marquess of Hertford (there is no receipt for this purchase and it is not indicated in Lord Hertford's marked-up copy of the sale catalogue).

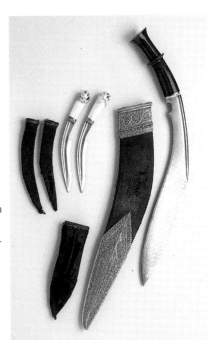

The haft is of carved horn, with an intricately pattern-welded blade comprising individual swirls contained within a chequered pattern, the latter delineated with inlaid brass lines. The wooden sheath, covered with green velvet, is mounted with silver filigree. In separate small pockets on the back of the sheath are two skinning knives each with an ivory grip carved at the top to resemble the head of a lion; these are similar but not a pair, one probably being a contemporary replacement, perhaps from another similar set. A larger third pocket is empty, its contents unrecorded in 1870 so presumably missing already.

For centuries the *kukri* has been the national weapon of the Ghurkas; this example is a very fine specimen, its pattern-welded blade being particularly unusual in fighting knives of this type.

72 KNIFE *(PIA KHAETTA)* OA1706

Cingalese late eighteenth century
Overall length (complete) 32.2, blade 15, weight (complete) 32
PROVENANCE: Anatole Demidoff; his (San Donato) sale, Paris, 5 April 1870 (547), bt. Mannheim, 1,680 fr., for the 4th Marquess of Hertford.

The grip scales are of finely carved horn, elaborately mounted with pierced and chased gold scroll-work of typical Cingalese form, extending over the heavy back-edge of the blade. The gold pommel-cap is set with rubies. The wooden sheath is overlaid with silver, parcel-gilt at the tip and further enriched with two bands of gold filigree.

73 DAGGER OA1949

Turkish early nineteenth century

Overall length (complete) 38, blade 23.5, weight (complete) 46

MARKS: Paris '*ET*' mark for gold and silver (of unspecified standard) imported from countries without customs conventions (law decreed 24 October 1864), struck on the tip of the chape.

PROVENANCE: Anatole Demidoff; his (San Donato) sale, Paris, 5 April 1870 (578), bt. Mannheim, 115 fr., for the 4th Marquess of Hertford.

The grip is of dark green agate, mounted with a guard and pommel-cap of silver-gilt; the blade is of crystalline-watered steel. The wooden sheath is covered in silver-gilt, chased to match the mounts of the hilt.

REFERENCE: Carré 1931, p.213 (mark)

74 DAGGER OA1967

Turkish nineteenth century

Overall length (complete) 42, blade 23.5, weight (complete) 45

PROVENANCE: Anatole Demidoff; his (San Donato) sale, Paris, 5 April 1870 (570), bt. Mannheim, 285 fr., for the 4th Marquess of Hertford.

The grip is of spirally-carved chalcedony with a pommel-cap of chased silver-gilt. The crystalline-watered steel blade is decorated at the hilt with silver-gilt chased similarly to the pommel-cap, and is inlaid in gold with a cartouche framing an illegible inscription. The wooden sheath is overlaid with embossed and chased silver-gilt.

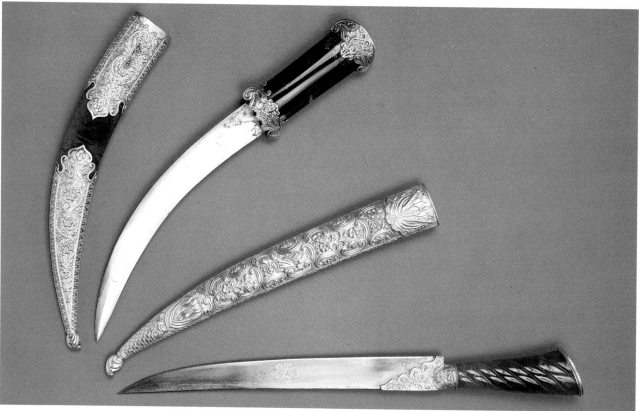

NO.73 (TOP); NO.74 (BOTTOM)

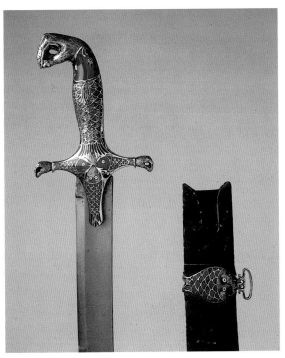

NO.75 DETAIL

75 SCIMITAR OA1405

Indian (possibly Lucknow) early nineteenth century
Overall length (complete) 100.2, blade 81.8, weight (complete) 150
PROVENANCE: Anatole Demidoff; his (San Donato) sale, Paris, 5 April
1870 (544), bt. Mannheim, 800 fr., for the 4th Marquess of
Hertford.

The hilt is of solid silver enamelled in translucent blue and green.
The grip and quillons, together with the scabbard mounts, are
formed as the bodies of fishes (emblems of Buddistic significance
and also the symbol of Lucknow). The pommel and quillon ends
are shaped as human hands, in the position of blessing.

Although the blade is of Indian crystalline-watered steel, its
profile and cross-section are reminiscent of a British regulation
1796 pattern light cavalry sword-blade, indicating European
influence and an early nineteenth-century date.

76 SWORD *(KHANDA)* OA1496

Indian (Lahore) eighteenth century
Overall length 111.8, blade 86.5, weight 177
PROVENANCE: Anatole Demidoff; his (San Donato) sale, Paris, 5 April 1870 (542), bt. Mannheim, 1,800 fr., for the 4th
Marquess of Hertford.

The hilt is of blued steel decorated with gold *cuftgari* (a form of counterfeit-damascening). The crystalline-watered steel
blade is strongly reinforced at the hilt where it is decorated with gold and set with red and green coloured stones. One
setting on the blade is missing. The scabbard is missing.

This type of hilt (see also No.77) enabled the weapon to be used either with one hand, or as a 'hand-and-a-half'
sword. The style and comparative freshness of the gold damascening on this and the following item suggest that on both
weapons the decoration was added later, probably in the nineteenth century, for the European market.

77 SWORD *(KHANDA)* OA1869

Indian eighteenth century
Overall length 108.5, blade 86.2, weight 179
PROVENANCE: Anatole Demidoff; his (San Donato) sale, Paris, 5 April 1870 (543), bt. Mannheim, 1,500 fr., for the 4th
Marquess of Hertford.

The steel hilt is decorated with gold *cuftgari* (see above, No.76); the blade is reinforced at the forte, and decorated with
silver-gilt rosettes set with cabochon garnets. The hollow-ground blade, an unusual form in this type of weapon, is of
particularly fine quality crystalline-watered steel. The scabbard is missing.

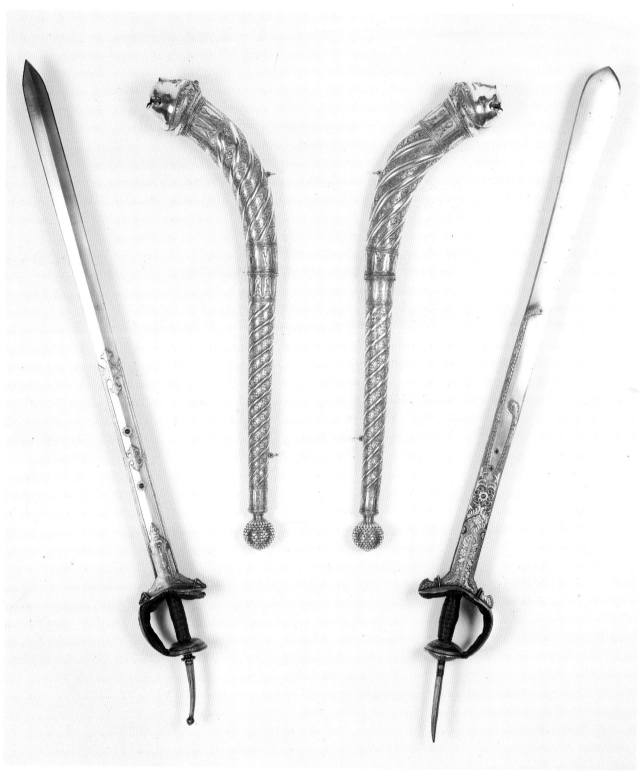

NO.76 (RIGHT); NO.77 (LEFT); NOS.78-9 (MIDDLE)

78-9 TWO MACES *(SOTA)* OA1760 AND OA1776

Indian late eighteenth century

No.78 (OA1760): Overall length 77.1, weight 240

No.79 (OA1776): Overall length 77.3, weight 275

MARKS: French import mark for gold and silver 1838-64, struck under the head and on the terminal of each mace.

PROVENANCE: Anatole Demidoff; his (San Donato) sale, Paris, 5 April 1870 (597, the pair), bt. Mannheim, 4,800 fr., for the 4th Marquess of Hertford.

Both are of silver, parcel-gilt, terminating in an embossed and chased tiger's head. The eyes are set with garnets, and a single large green stone surmounts each forehead. They may not be a pair; the suspension loops on each one are fixed at slightly different points.

These impressive maces were purely ceremonial in function; although heavy, the silver is hollow, probably filled with pitch or a similar material. Other examples are known, sometimes depicting different animals' heads (horses, bulls or elephants, for example). They were carried in procession by harbingers.

REFERENCE: Carré 1931, p.212 (mark).

APPENDIX I

WORKS OF ART FORMERLY IN THE ANATOLE DEMIDOFF AND HERTFORD-WALLACE COLLECTIONS

Reference is made to inventories of the Hertford-Wallace properties of Hertford House (London), Bagatelle (Paris) and 2 rue Laffitte (Paris). On the death of Lady Wallace in 1897, her residuary legatee, Sir John Murray Scott (1847-1912) received the Paris properties and their contents, together with those parts of the London collection excluded from Lady Wallace's bequest to the Nation. Murray Scott's inheritance was then dispersed by sale or bequest from 1904.

PAINTINGS

French Nineteenth Century

E. Lami (1800-90), *Le Galop au bal de l'Opéra* (1854)
oil on canvas 68 x 91
PROVENANCE: Anatole Demidoff; his (San Donato) sale, 21 February 1870 (54), bt. Mannheim, 2,000 fr., for the 4th Marquess of Hertford; recorded at Bagatelle 1871 (994), rue Laffitte 1912.

E. Lami (1800-90), *Prince et princesse en costume de cour sous l'Empire* (1810)
watercolour
PROVENANCE: Anatole Demidoff; his (San Donato) sale, 9 March 1870 (375), bt. Mannheim, 200 fr., for the 4th Marquess of Hertford; recorded at Bagatelle 1871 (962), [probably] Hertford House 1890 (annotated as, *'given by* [Sir John Murray Scott] *to HRH Prince of Wales 1898'*).

E. Lami (1800-90), *L'escalier du Parlement*
watercolour
PROVENANCE: Anatole Demidoff; his (San Donato) sale, 8 March 1870 (279), bt. Mannheim, 2,050 fr., for the 4th Marquess of Hertford; recorded at Bagatelle 1871 (1011), [probably] Hertford House 1890; [probably] with Sir John Murray Scott 1903; Murray Scott sale, 27 June 1913 (31), bt. Arnold & Tripp, 62gns.

F.-H.-E. Philippoteaux (1815-84) &
É.-J.-H. Vernet (1789-1863), *Fugitive Arabs* (Arabes en fuite)
oil on canvas 45.7 x 37.5
PROVENANCE: Anatole Demidoff; his (San Donato) sale, 26 February 1863 (15), bt. 4th Marquess of Hertford, 1650 fr.; recorded at rue Laffitte 1871 (399); with Sir John Murray Scott 1903; Murray Scott sale, 27 June 1913 (94), bt. Hill, 12gns.

Dutch and Flemish

G. ter Borch (1617-81), *The Swearing of the Oath of Ratification of the Treaty of Münster* (fig.12)
oil on copper 45.4 x 58.5
(LATER) PROVENANCE: Anatole Demidoff; his (San Donato) sale, 18 April 1868 (18), bt. 4th Marquess of Hertford, 182,000 fr.; recorded at rue Laffitte 1871 (412); presented by Richard Wallace to National Gallery of London 1871; London, National Gallery (no.896). (See p.50)

Knip, *Tête de chien*
oil on panel 18 diam.
PROVENANCE: Anatole Demidoff; his (San Donato) sale, 21-2 February 1870 (51), bt. Mannheim, 319 fr., for 4th Marquess of Hertford. (There were a number of artists named Knip active in Holland in the early nineteenth century; the 1870 catalogue does not further identify the painter of this oil.)

Isack van Ostade (1621-49),
Travellers outside an Inn (Le village) (1646)
oil on panel 75 x 109
PROVENANCE: With the dealer Pieter Fouquet (Amsterdam); sold by him to Randon de Boisset; his sale, Paris, 27 February 1777 (118), bt. Radix Saint-Foix (Paris). D'Arney collection, sold Paris 1791. Robit collection. By 1805, Séguin collection (Paris). Duc de Berry (Galerie du Palais de l'Elysée, Paris); his sale, Paris (Paillet), 4 April 1837 (18); Anatole Demidoff; his (San Donato) sale, 18 April 1868 (9), bt. Mannheim, 104,000 fr.; the 4th Marquess of Hertford, recorded at rue Laffitte 1871 (359), at Hertford House 1890; given by Lady Wallace to Alfred de Rothschild in exchange with P73 c.1891. Almira, Countess Carnarvon; by whom, sold to the dealers Kleykamp (The Hague) 1925; The Hague, Mauritshuis (no.789).

French Eighteenth Century

J.-B. Greuze (1725-1805), *Les Oeufs cassés* (1756)
oil on canvas 73 x 94
PROVENANCE: Anatole Demidoff; his (San Donato) sale, 21 February 1870 (107), bt. Mannheim, 126,000 fr., for 4th Marquess of Hertford; recorded at rue Laffitte 1871 (364); sold by Sir Richard Wallace to Lord Dudley 1875; New York, Metropolitan Museum Art (no.20.155.8).

SCULPTURE

J.-J. Pradier (1790-1852), *Satyre et Bacchante* (1834)
Marble 120 x 100 x 65
PROVENANCE: Exh. at 1834 Salon, bt. Anatole Demidoff; his (San Donato) sale, 26 February 1870 (136), bt. Mannheim, 10,300 fr., for the 4th Marquess of Hertford; by descent to Sir Richard Wallace, at Bagatelle (Paris), then to Lady Wallace (1819-97); bequeathed by her to Sir John Murray Scott; Bagatelle sale (Chevallier), 22 June 1904 (9), bt. G. Pontin, 9,200 fr.; Mme Julien Pontin sale, Paris (Ader & Ledoux-Lebard), 29 November 1940, bt. Edouard Labouchère; Paris, Musée du Louvre (no.R.F. 3475).

METALWORK AND OBJETS DE VERTU

Magnifying Glass
Rosewood and gold
Box for sealing-waxes
Rosewood and gold braid, enclosing a magnifying glass
PROVENANCE: Anatole Demidoff; his (San Donato) sale, 12 April 1870 (1081 [the two]), bt. Mannheim, 186 fr., for the 4th Marquess of Hertford.

Two Cups
Ruby glass, mounted on platters in the shape of petals, with openwork decoration, and with repoussé silver-gilt covers
PROVENANCE: Anatole Demidoff; his (San Donato) sale, 13 April 1870 (1176), bt. Mannheim, 130 fr., for the 4th Marquess of Hertford.

Handled Cup or Bowl
Chased and gilt silver, with the Arms of Russia and the monogram of Empress Elizabeth: Dated 1753; wt: 494
PROVENANCE: Anatole Demidoff; his (San Donato) sale, 13 April 1870 (1177), bt. Mannheim, 710 fr., for the 4th Marquess of Hertford.

Handled Cup or Bowl
Similar to the preceding, with the Arms of Russia and the imperial crown. Dated 1753; wt.: 490
PROVENANCE: Anatole Demidoff; his (San Donato) sale, 13 April 1870 (1178), bt. Mannheim, 710 fr., for the 4th Marquess of Hertford.

Lady's Shoe
Silver, with gilded flowers in relief; the heel and toe also gilded; the buckle encrusted with turquoises
PROVENANCE: Anatole Demidoff; his (San Donato) sale, 14 April 1870 (1244), bt. Mannheim, 250 fr., for the 4th Marquess of Hertford.

Small Screen
With seven leaves in carved wood, enriched with carved and painted hardstones, applied against a blue ground
height: 65
PROVENANCE: Anatole Demidoff; his (San Donato) sale, 27 April 1870 (1846), bt. Mannheim, 350 fr., for the 4th Marquess of Hertford.

Lampshade
Brown silk, embroidered with glass pearls
PROVENANCE: Anatole Demidoff; his (San Donato) sale, 27 April 1870 (1875), bt. Mannheim, 12 fr., for the 4th Marquess of Hertford.

Three Paperweights
White marble, decorated with paintings:
Temple of Theseus, Temple of Victory and the Parthenon
PROVENANCE: Anatole Demidoff; his (San Donato) sale, 27 April 1870 (1876), bt. Mannheim, 10 fr., for the 4th Marquess of Hertford.

Portable Telescope
Mery of Munich
Mahogany box enclosing accessories. Sleeve in black-lacquered leather
PROVENANCE: Anatole Demidoff; his (San Donato) sale, 28 April 1870 (1894), bt. Mannheim, 400 fr., for the 4th Marquess of Hertford.

Fifteen Guipure Covers
For sofas, armchairs and chairs (sold in part lots)
PROVENANCE: Anatole Demidoff; his (San Donato) sale, 28 April 1870 (1931-43), twelve bt. Mannheim, 492 fr., for the 4th Marquess of Hertford.

MINIATURES

I. d'Esmenard (fl.1814-51), *Mademoiselle Mars*
oval 15 x 12
PROVENANCE: Anatole Demidoff; his (San Donato) sale, 9 March 1870 (416), bt. Mannheim, 1,020 fr., for 4th Marquess of Hertford.

J.-B. Singry (1782-1824), *Madame Mainvielle Fodor: Artiste des Italiens*
oval 16 x 12
PROVENANCE: Anatole Demidoff; his (San Donato) sale, 9 March 1870 (424), bt. Mannheim, 200 fr., for 4th Marquess of Hertford.

J.-B. Singry (1782-1824), *Mademoiselle Vigneron: Costume de bacchante*
oval 14 x 11
PROVENANCE: Anatole Demidoff; his (San Donato) sale, 9 March 1870 (426), bt. Mannheim, 270 fr., for 4th Marquess of Hertford.

J.-B. Isabey (1767-1855), *Jeune fille tenant une colombe morte*
19 x 15
PROVENANCE: Anatole Demidoff; his (San Donato) sale, 9 March 1870 (428), bt. Mannheim, 1,140 fr., for 4th Marquess of Hertford.

A. Theer (1811-68), *Jeune Miss*
17 x 13
PROVENANCE: Anatole Demidoff; his (San Donato) sale, 9 March 1870 (432), bt. Mannheim, 115 fr., for 4th Marquess of Hertford.

A. Theer (1811-68), *Jeune Miss*
17 x 11
PROVENANCE: Anatole Demidoff; his (San Donato) sale, 9 March 1870 (433), bt. Mannheim, 80 fr., for 4th Marquess of Hertford.

ARMS & ARMOUR

Small Dagger-Knife
The blade of damascus steel, with a chased and embossed silver hilt and sheath, embellished with a small silver chain
PROVENANCE: Anatole Demidoff; his (San Donato) sale, 5 April 1870 (552), bt. Mannheim, 155 fr., for 4th Marquess of Hertford. (Possibly OA1932)

Afghan (Kabul) Dagger-Knife
The blade of damascus steel, with a green jasper hilt, and green velvet sheath decorated with chased and embossed silver
PROVENANCE: Anatole Demidoff; his (San Donato) sale, 5 April 1870 (561), bt. Mannheim, 350 fr., for the 4th Marquess of Hertford.

Small Albanian Yataghan
The blade of damascened damascus steel, with a chased silver hilt and sheath, with gilt flowers and ornaments
PROVENANCE: Anatole Demidoff; his (San Donato) sale, 5 April 1870 (562), bt. Mannheim, 220 fr., for the 4th Marquess of Hertford.

Algerian Yataghan
The blade of damascus steel bearing an arab inscription, and with a hilt of walrus ebony; the sheath of chased and embossed silver with filigree-work
PROVENANCE: Anatole Demidoff; his (San Donato) sale, 5 April 1870 (568), bt. Mannheim, 510 fr., for the 4th Marquess of Hertford.

Algerian Yataghan
The blade of damascus steel and a sheath of embossed silver and gilt ornaments
PROVENANCE: Anatole Demidoff; his (San Donato) sale, 5 April 1870 (569), bt. Mannheim, 305 fr., for the 4th Marquess of Hertford.

Turkish Dagger
The blade of damascus steel with inscriptions and ornaments in relief, the hilt and sheath of silver with embossed and gilt flowers
PROVENANCE: Anatole Demidoff; his (San Donato) sale, 5 April 1870 (577), bt. Mannheim, 140 fr., for the 4th Marquess of Hertford.

Mameluke Sabre
The straight blade of damascus steel from Khorassan, the hilt of horn with a red sword-knot, the sheath of shagreen, both decorated with embossed, engraved and gilt silver
PROVENANCE: Anatole Demidoff; his (San Donato) sale, 5 April 1870 (600), bt. Mannheim, 100 fr., for the 4th Marquess of Hertford.

Mameluke Sabre
A short, damascened blade, the hilt and sheath of chased, engraved and gilt silver
PROVENANCE: Anatole Demidoff; his (San Donato) sale, 5 April 1870 (601), bt. Mannheim, 200 fr., for the 4th Marquess of Hertford.

Sabre

The short blade, of damascus steel, with inscriptions incised in gold. The hilt and sheath of embossed and gilt silver

PROVENANCE: Anatole Demidoff; his (San Donato) sale, 5 April 1870 (603), bt. Mannheim, 400 fr., for the 4th Marquess of Hertford.

Polish Sabre

The short blade, of damascus steel, with a damascened inscription; a grip of horn with a green sword-knot; the sheath of shagreen decorated with gilt silver, embossed with ornaments and pierced by openwork

PROVENANCE: Anatole Demidoff; his (San Donato) sale, 5 April 1870 (605), bt. Mannheim, 260 fr., for the 4th Marquess of Hertford.

Sabre

A short blade of damscus steel; the hilt and scabbard of horn with silver-gilt mounts

PROVENANCE: Anatole Demidoff; his (San Donato) sale, 5 April 1870 (609), bt. Mannheim, 160 fr., for the 4th Marquess of Hertford.

Sword

The knuckle-guard and pommel chiselled with figures and ornaments.

'A crude piece of the sixteenth century.'

PROVENANCE: Anatole Demidoff; his (San Donato) sale, 6 April 1870 (645), bt. Pillet, 125 fr., for the comte de Nieuwerkerke; August 1872, bt. by Sir Richard Wallace, with most of the Nieuwerkerke collection *en bloc*.

Pair of Small Pistols

Hamburger *et Cie*.

The mounts of engraved silver; small model

PROVENANCE: Anatole Demidoff; his (San Donato) sale, 7 April 1870 (711), bt. Mannheim, 100 fr., for the 4th Marquess of Hertford.

Scottish Sporran

Of fox pelt, with a silver fox-head mount in relief, and six tassels and a strap. Leather belt with a silver buckle.

PROVENANCE: Anatole Demidoff; his (San Donato) sale, 7 April 1870 (733), bt. Mannheim, 69 fr., for the 4th Marquess of Hertford. See Nos. 53-4

PIPES & SMOKERS' REQUISITES

North African Pipe

Yellow amber mouthpiece, mounted with engraved and enamelled gold; pipe of cherry wood, sheath of blue and gold velvet, clay bowl.

PROVENANCE: Anatole Demidoff; his (San Donato) sale, 8 April 1870 (840), bt. Mannheim, 160 fr., for the 4th Marquess of Hertford.

North African Pipe

Amber mouthpiece of elongated form in two sections, with an insert of gold enamelled with turquoise ribbons; cherry wood pipe, sheath of flecked black velvet, clay bowl.

PROVENANCE: Anatole Demidoff; his (San Donato) sale, 8 April 1870 (852), bt. Mannheim, 200 fr., for the 4th Marquess of Hertford.

Cigar Mouthpiece

Of amber, the mother-of-pearl tube decorated with gold mounts enriched with circles of turquoises.

PROVENANCE: Anatole Demidoff; his (San Donato) sale, 8 April 1870 (920), bt. Mannheim, 513 fr., for the 4th Marquess of Hertford.

APPENDIX II

DEMIDOFF FAMILY ART SALES

1839, 8-13 April, Paris (Bataillard, *et al.*)
Anatole Demidoff (but mainly the collection of his father,
Nicolas)
245 paintings, 62 sculptures, 53 ceramics, 30 furniture, 35
arms and armour, 44 other.
It can be demonstrated that at least one painting (now well-
known) in this sale was not from Nicolas Demidoff's
collection. Lot 174 was Vermeer's *Lady with her Maidservant*
(New York, Frick Collection), bought two years earlier by the
dealer Paillet at the duchesse de Berry sale (405 francs), and
sold in this sale for 212 francs. As Paillet was one of the
auctioneers in 1839 there is a possibility that he included the
picture from his own stock.
(Lugt 15370)

1861, 15-16 February, Paris (Mannheim)
Anatole Demidoff and the 'comte de Potocki'
153 gold boxes.
(Lugt 26002)

1863, 13-16 January, Paris (Laneuville)
Anatole Demidoff [San Donato]
34 paintings, 43 drawings, 38 ceramics, 72 gold boxes, 1
. ˙e of armour.
 .gt 27065)

1863, 26 February, Paris (Petit)
Paul Demidoff
17 modern paintings.
(Lugt 2714)

1863, 1 June, London (Christie's)
Anatole Demidoff (Villa di Quarto)
237 prints.
(Lugt 27380)

1864, 25-26 May, Paris (Petit, Mannheim)
Paul Demidoff
15 modern paintings, 37 gold boxes.
(Lugt 27964)

1868, 3 February, Paris (Petit)
Paul Demidoff
44 paintings, 6 drawings.
(Lugt 30192)

1868, 18 April, Paris (Petit)
Anatole Demidoff San Donato
23 paintings.
(Lugt 30437)

1869, 1-3 April, Paris (Haro, *et al.*)
Paul Demidoff (35 rue Jean-Goujon)
33 paintings, 2 drawings, 12 sculptures, 9 ceramics, 169
other.
(Lugt 31127)

1870, 21-2 February, Paris (Petit)
Anatole Demidoff (San Donato)
93 modern paintings.
(Lugt 31764)

1870, 26 February, Paris (Petit)
Anatole Demidoff (San Donato)
39 French paintings, 11 marbles.
(Lugt 31781)

1870, 2-4 March, Paris (Petit)
Anatole Demidoff (San Donato)
80 Old Master paintings, 17 marbles.
(Lugt 31800)

1870, 8-10 March, Paris (Petit)
Anatole Demidoff (San Donato)
312 drawings and watercolours.
(Lugt 31814)

1870, 22-24 March, Paris (Mannheim)
Anatole Demidoff (San Donato)
294 sculptures, ceramics, etc.
(Lugt 31863)

1870, 29-31 March, Paris (Mannheim)
Anatole Demidoff (San Donato)
247 sculptures, etc.
(Lugt 31887)

1870, 5-8 April, Paris (Mannheim)
Anatole Demidoff (San Donato)
400 arms & armour, costume.
(Lugt 31908)

1870, 11-14 April, Paris (Mannheim)
Anatole Demidoff (San Donato)
356 jewels, cameos, etc.
(Lugt 31928)

1870, 19-21 April, Paris (Mannheim)
Anatole Demidoff (San Donato)
343 bronzes, metalwork.
(Lugt 31942)

1870, 26-28 April, Paris (Mannheim)
Anatole Demidoff (San Donato)
325 ceramics, furniture, etc.
(Lugt 31975)

1873, 6 May, Paris (Haro)
second part: Paul Demidoff and baron de Nagler
(first part: 24 paintings from 'B***').
77 watercolours
(Lugt 33990)

1875, 2 July, Paris (Féral)
Paul Demidoff (San Donato; all inherited from Anatole)
61 watercolours by Lami.
(Lugt 35783)

1880, 15 March-10 April, San Donato (Pillet, *et al.*)
Paul Demidoff (but including many objects inherited from Anatole)
261 paintings, 15 pastels and watercolours, 1660 other.
(Lugt 39995)

1891, 19 December Paris, (Mannheim)
Paul Demidoff (San Donato; sold by his heirs)
142 various, 14 furniture.
(Lugt 50358)

1909, 6 July, Paris (Paulme, *et al.*)
Prince Paul Demidoff (d. 1925)
8 gouaches and prints, 140 silver, objets d'art, carpets and furniture, 8 books.
(Lugt 67817)

1918, 29-30 March, Budapest
Cornelia Demidoff, *et al.*
171 paintings, miniatures and watercolours, 350 sculptures, ceramics, carpets and furniture.
(Lugt 77748)

1919, 6 May, Amsterdam (Muller)
'Demidoff'
23 sculptures, 25 silver, 23 ceramics, 14 glass and furniture.
(Lugt 78843)

1921, 28 February, Paris (Blée)
Princesse Demidoff (San Donato)
182 ceramics, ivories and enamels.
(Lugt 81769)

1921, 13-16 October, Amsterdam (Muller)
'Demidoff', *et al.*
987 lots (various).
(Lugt 82889)

1925, 11-16 May, Rome (Geri)
'Demidoff', *et al.*
492 lots (various).
(Lugt 88594)

1931, 18 December, London (Christie, Manson & Woods)
Prince Demidoff (Villa les Perles, Drap, Nice), *et al.*
16 paintings, 1 print

1969, 21-24 April, Pratolino (Sotheby's)
Prince Paul of Yugoslavia (Villa Demidoff)
702 lots (various).

1992, 5 December, Monaco (Sotheby's)
'An Eastern European Royal Family', *et al.*
16 paintings.

BIBLIOGRAPHY

A comprehensive Demidoff bibliography would be immense. Only included below are publications referred to in the text and a number of other major printed sources.

BOOKS AND ARTICLES

[Anon.], *Voyage pittoresque et archéologique en Russie executé en 1839. Dessins fait d'après nature et lithographiés par André Durand* (Paris [1840-9])

[Anon.], *École Hollandaise et Flamande* (Florence 1850)

[Anon.], *Musée de San Martino à l'île d'Elbe: Catalogue ...* (Florence 1860)

[Anon.], *L'Île d'Elbe. Album monumentale et pittoresque* (Paris 1862)

Arminjon, C. & Blondel, N., *Objets civils domestiques* (Paris 1984)

Arquié-Bruley, F., 'Debruge-Duménil (1778-1838) et sa collection d'objets d'art', *Annali della Scuola Normale Superiore di Pisa* xx/1 (1990)

Bandera, L., 'Due ebanisti per il principe Demidoff', *Arte Illustrata* II (May-June 1969), pp.66-9

Bartolini (ed. C. del Bravo), *Il genio di Lorenzo* (Prato December 1977 - February 1978)

Bellaigue, G. de, *The James A. de Rothschild collection at Waddesdon Manor: Furniture, Clocks and Gilt Bronzes*, 2 vols. (London 1974)

Berezina, V. N., *The Hermitage. French Painting. Early and Mid-Nineteenth Century* (Moscow & Florence 1983)

Bisogni, F., 'I Demidoff in Toscana', *L'Idea di Firenze: Temi e interpretazioni nell' arte straniera dell' Ottocento* (Florence 1989), pp.67-84

Blanc, C., 'Une visite à San-Donato', *Gazette des Beaux-Arts* 2/XVI (1877), pp.5-14, 201-10, 410-21

Boime, A., *The Art of the Macchia and the Risorgimento* (Chicago 1993)

Broude, N.F., 'The Troubetzkoy Collection and the Influence of Decamps on the Macchiaioli', *Art Bulletin* LXII (September 1980), pp.398-408; and Mosby/Broude correspondence, *Art Bulletin* LXIII (September 1981), pp.502-5

Bry, A., *Raffet. Sa Vie et ses Oeuvres* (Paris 1874)

Burty, P., 'Collection San Donato: Les Curiosités', *Gazette des Beaux-Arts* II/3 (1870), pp.261-8

Cadot, M., *La Russie dans la vie intellectuelle française, 1839-1856* (Paris 1956)

Cantelli, G. (ed.), *Il Museo Stibbert a Firenze*, vol.II (Milan 1974)

Carré, L., *A Guide to Old French Plate* (London 1931)

Cherkasova, A.C., *Demidovi* (Ekaterinburg 1992)

Corti, E., *A History of Smoking* (London 1931)

Dandolo, T., *Panorama di Firenze: La esposizione nazionale del 1862. La villa Demidoff a San Donato* (Milan 1863)

Dauterman, C.C., *The Wrightsman Collection*, vol.IV: *Porcelain* (New York 1970)

Delacroix, E. (ed. A. Joubin), *Correspondance*, 5 vols. (Paris 1936-8)

[Demidoff, A.], *Esquisses d'un voyage dans la Russie Méridionale et la Crimée* (Paris 1838)

[Demidoff, A.], *Lettres sur l'empire de Russie* (Paris 1840)

[Demidoff, A.], *Voyage dans la Russie Méridionale et la Crimée par la Hongrie, la Valachie et la Moldavie. Executé en 1837 par Mr. Anatole de Demidoff*, 4 vols., quarto (Paris 1840-2)

[Demidoff, A.], *Voyage dans la Russie Méridionale ...*, folio (Paris 1842)
(colour plates of natural history, mostly after Raffet)

[Demidoff, A.], *Voyage dans la Russie Méridionale ...*, folio (Paris 1848)
(lithographs by Raffet)

[Demidoff, A.], *Etapes maritimes sur les côtes d'Espagne de la Catalogne à l'Andalousie*, 2 vols. (Paris 1858)

[Demidoff, A.], *La Toscane. Album pittoresque et archéologique sous la direction de M. le Prince Anatolie Démidoff* (Paris 1862-3)

[Demidoff, A.] (ed. O. Jaunez-Sponville), *Les prisonniers de guerre des puissances belligérantes pendant la Campagne de Crimée. Extraits de la correspondance du Prince Anatole Démidoff* (Paris 1870)

Du Perron, M. C., *La Princesse Mathilde* (Paris 1963)

Dupré, G., *Pensieri sull'arte e ricordi autobiografici* (Florence 1914)

Esper, T., 'The Demidov Family in the Nineteenth Century', *The Modern Encyclopedia of Russian and Soviet History* (ed. J.L. Wieczynski), vol. IX, pp. 51-4, bibl., p. 54

Fitzgibbon, T., *The Food of the Western World* (London 1976)

Fuchs, D.S., 'Acquisisti dalle collezioni Demidoff e Favard nelle raccolte del Museo Stibbert', *L'Idea di Firenze: Temi e interpretazioni nell' arte straniera dell' Ottocento* (Florence 1989), pp.147-51

Galichon, E., 'La Galerie de San Donato', *Gazette des Beaux-Arts* II/3 (1870), pp.5-13, 97-110

Gallet de Kulture, A., *Le Tzar Nicolas et la Sainte Russie* (Paris 1855)

Gautier, T., 'Collections de San Donato', *L'Illustration* vol. LV, n.1406, 5 February 1870, pp.100-2; vol. LV, n.1407, 12 February 1870, pp.125-7; vol. LV, n.1408, 19 February 1870, pp.145-7

Gautier, T., *Voyage en Russie* (Paris 1867)

Giusti, A.M., *Pietre Dure: Hardstone in Furniture and Decorations* (London 1992)

Goldberg, T., et al., *L'Orfèvrerie et la Bijouterie Russes aux XV-XX siècles* (Moscow 1967)

Goncourt, E. & J. (ed. R. Ricatte), *Journal-Memoires de la Vie Littéraire*, 4 vols. (Paris 1956)

Gonzales-Palacios, A., 'La Vendita Demidoff', *Arte Illustrata* II/17-18 (May-June 1969), pp.116-23

Grandjean, S., *Les tabatières du musée du Louvre* (Paris 1981)

Guiterman, H. and Llewellyn, B., *David Roberts* (London 1986)

Heer, E. (ed.); *Der Neue Stöckel*, 3 vols. (Schwäbisch Hall 1978-82)

Hudson, H.D., Jnr, 'The Demidov Family in the Eighteenth Century', *The Modern Encyclopedia of Russian and Soviet History* (ed. J.L. Wieczynski), vol.IX, pp. 46-51, bibl., pp.50-51

Hughes, P., *The Founders of the Wallace Collection* (2nd. ed., London 1992)

Hughes, P., *The Wallace Collection: Catalogue of Furniture* (forthcoming)

Ingamells, J., *The Hertford Mawson Letters* (London 1981)

Ingamells, J., *The 3rd Marquess of Hertford as a Collector* (London 1983)

Ingamells, J., *The Wallace Collection: Catalogue of Pictures*, 4 vols. (London 1985-92)

Janin, J. (ed. Mergier-Bourdeix), *735 Lettres à sa femme*, vol.I: 1842-50 (Paris 1973), vol.II: 1851-5 (Paris 1975), vol.III: 1856-76 (Paris 1979)

Jervis, S., et al., *Art and Design in Europe and America 1800-1900* (New York 1987)

Johnson, L., *The Paintings of Eugène Delacroix, A Critical Catalogue*, 6 vols. (Oxford 1981-9)

Kryzanovskaya, M., 'Alexander Petrovich Basilevsky: a great collector of medieval and Renaissance works of art', *Journal of the History of Collections* II/2 (1990), pp.143-55.

Kühn, J., *Prinzessin Mathilde Bonaparte* (Berlin 1929)

Labarte, J., *Description des objets d'art qui composent la collection Debruge-Duménil* (Paris 1847)

La Coste-Messelière, M.G. de, 'La villa Demidoff', *L'Oeil* CLXXI (March 1969), pp.41-7, 75

Laking, G.F., *The Wallace Collection: Oriental Arms and Armour* (London 1913, Supplement 1964)

Lemoisne, P.-A., *Eugène Lami* (Paris 1912)

Leroi, P., 'Le Palais de San Donato et ses collections', *L'Art* XVI (1879), pp.323-5, XVII (1879), pp.305-10, XIX (1879), pp.151-7, 184-6, 245-8, 293-300, XX (1880), pp.3-10. 41-6, 68-73, 93-100, 137-46, 205-15, 233-42, 265-7, 304-15

Levinson-Lessing, V.F., *Istoria Kartinnoi Galerei Ermitaja (1764-1917)* (Leningrad 1985)

Lubbers, L., *Palais de San Donato. Catalogue de plantes rares garnissants les serres* (Paris 1880)

Mann, J.G., *The Wallace Collection: European Arms and Armour*, 2 vols. (London 1962)

Marie, A., 'The Château de Romainville and a snuff-box in the Wallace Collection', *The Connoisseur* CXXVIII (August 1951), pp.18-23

Maskovchev, N.G., *K.P. Briullov v Pis'mach, Dokumentach, I Vospominaniyach Sovremennikov* (Moscow 1952)

Mergier-Bourdeix, *Les Amours de Jules Janin* (Paris 1968)

Murchison, R.I., et al., *The Geology of Russia in Europe and the Ural Mountains*, 2 vols. (London & Paris 1845)

Nemilova, I. S., *The Hermitage. French Painting. Eighteenth Century* (Moscow & Florence 1986)

Noon, P., *Richard Parkes Bonington 'On the Pleasure of Painting'* (New Haven and London 1991)

Norman, A.V.B., *The Wallace Collection: European Arms and Armour Supplement* (London 1986)

Nouvelle Biographie Générale (Paris 1855)

Ogarkova, V.V., *Demidovi* (St Petersburg 1891)

Pellegrini, G. 'Anatolio Demidoff principe di San Donato', *Nuova Antologia* (May 1976), pp.65-82.

Pointon, M., *The Bonington Circle. English Watercolour and Anglo-French Landscape 1790-1855* (Brighton 1985)

Potocka, A., *Voyage d'Italie 1826-1827* (Paris 1899)

Pradier, J. (ed. D. Siler), *Correspondance*, 2 vols. (Geneva 1984)

Prato, C. da, *Firenze ai Demidoff. Pratolino e San Donato* (Florence 1886)

Raffet, D.-A.-M., *Notes et Croquis de Raffet mis en ordre et publiés par Auguste Raffet* (Paris 1878)

Rappe, T., 'The History of the Furniture Collections in the Hermitage', *Furniture History* 29 (1993), pp.205-16

Remington, P., 'The Story of a Malachite Vase', *Metropolitan Museum of Art Bulletin* n.s.3 (February 1945), pp.142-5.

Reynolds, G., *The Wallace Collection: Miniatures* (London 1980)

Richardson, J., *Princess Mathilde* (London 1969).

Risaliti, R., *Russia e Toscana nel Risorgimento* (Pistoia 1982)

Robert, H., 'Le destin d'une grande collection princière au XIXe siècle: l'exemple de la galerie de tableaux du duc d'Orléans, Prince royal', *Gazette des Beaux-Arts* 6/CXVIII (July-August 1991), pp.37-60.

Robert, H. (ed.), *Le Mécénat du duc d'Orléans 1830-1842* (Paris 1993)

Rosenberg, M., *Der Goldschmiede Merkzeichen*, vol.IV (3rd edition, Berlin 1928)

Russkaya Starina Eschemcyachnnoi Istorichekoe Izdanie (St Petersburg 1900)

Salvadori, F. Borroni, 'I Demidoff collezionisti a Firenze', *Annali della Scuola Normale Superiore di Pisa* XI/3 (1987), pp.937-1003

Savill, R.J., 'Enamelled snuff boxes in the Wallace Collection - some newly identified problems', *Apollo* CXI (April 1980), pp.304-9.

Savill, R.J., *The Wallace Collection: Sèvres Porcelain*, 3 vols. (London 1988)

Savill, R.J., *The Wallace Collection: French Gold Boxes* (London 1991)

Scarisbrick, D., *The History of Chaumet* (London, forthcoming [1995])

Scott, B., 'The Duchess of Berry as a Patron of the Arts', *Apollo* CXXIV (October 1986), pp. 345-51

Sensier, A., *Souvenirs sur Théodore Rousseau* (Paris 1872)

Støckel, J.F., *Haandskydevaabens Bedommelse*, vol.I (Copenhagen 1938), vol.II (Copenhagen 1943)

Tait, H., *Catalogue of the Waddesdon Bequest in the British Museum*, vol.I: *The Jewels* (London 1986)

Tinti, M., *Lorenzo Bartolini*, 2 vols. (Rome 1936)

Truman, C., *Los Angeles County Museum of Art: The Gilbert Collection of Gold Boxes* (Los Angeles 1991)

Valery, M., *Voyages Historiques, Littéraires et Artistiques en Italie*, (2nd edn., Paris 1838)

Valery, M., *Florence et ses environs* (Brussels 1842)

[Vandoni, B. de?], *Le meraviglie di San Donato* (Florence 1858)

Viel-Castel, H. de, *Mémoires sur le Règne de Napoléon III (1851-1864)* (Paris 1883)

Vigée Lebrun, E., *Souvenirs de Mme Vigée Lebrun* (Paris Bibliothèque Charpentier [no date])

Vigne, G., 'Ingres a-t-il peint un second exemplaire du *Bain turc*?', *Revue du Louvre* XLII/3 (July 1992), pp.56-63

Voronikhina, A.A., *Malachite dans la Collection de l'Ermitage* (Leningrad 1963)

Waddesdon Bequest, The (London 1899)

Whiteley, J., *Ingres* (London 1977)

Whitley, W.T., *Art in England 1821-37* (Cambridge 1930)

EXHIBITION AND SALE CATALOGUES

Dijon 1993 *L'Age d'or flamand et hollandais: Collections de Catherine II. Musée de l'Ermitage, Saint-Pétersbourg* (Musée des Beaux-Arts)

Florence 1972 *Cultura neoclassica e romantica nella Toscana Granducale. Collezioni lorenesi, acquisizioni posteriori, depositi* (Palazzo Pitti)

London 1851 *Great Exhibition of the Works of Industry of all Nations* (Official Descriptive and Illustrated Catalogue), vol.III

London 1988 *French Paintings from the USSR. Watteau to Matisse* (National Gallery)

New York 1978 J.D. Draper & C. Le Corbeiller, *The Arts of Napoleon* (Metropolitan Museum of Art)

New York 1993 Christie's sale, 22 April (Odiot service)

Paris 1986 A. Angremy, *et al.*, *La France et la Russie au Siècle des Lumières* (Grand Palais)

Paris 1991 D. Alcouffe, *et al.*, *Un âge d'or des arts décoratifs 1814-1848* (Grand Palais)

Paris 1993 *Splendeurs de Russie* (Petit Palais)

Prato 1977-8 See Bartolini

Versailles 1993 *La Manufacture d'armes de Versailles et Nicolas-Noël Boutet* (Musée Lambinet)

Washington 1986 F.J.B. Watson, *Mounted Oriental Porcelain*

PICTURE AND OTHER CREDITS

Moscow, Historical Museum: fig.1; Florence, Palazzo Pitti: figs.2-3, 11, 13-14; Fratelli Alinari: fig.5; The Trustees of the National Gallery, London: figs.6, 12, 15; Archives photographiques, Paris: fig.7; Musée Carnavalet, Paris: fig.8; The Trustees of the British Library, London: figs.9-10, 17; Collection Georges Sirot (Mme H. Angel): fig.16; Sotheby & Co.: fig.19.

Quotation from the Eastlake diaries and information from the marked copy of the 1837 duchesse de Berry sale catalogue: courtesy of the Trustees of the National Gallery, London.

We are also grateful to Maison Chaumet and the Archives de Paris for permission to quote from their archives.